Sacred Calligraphy of the East

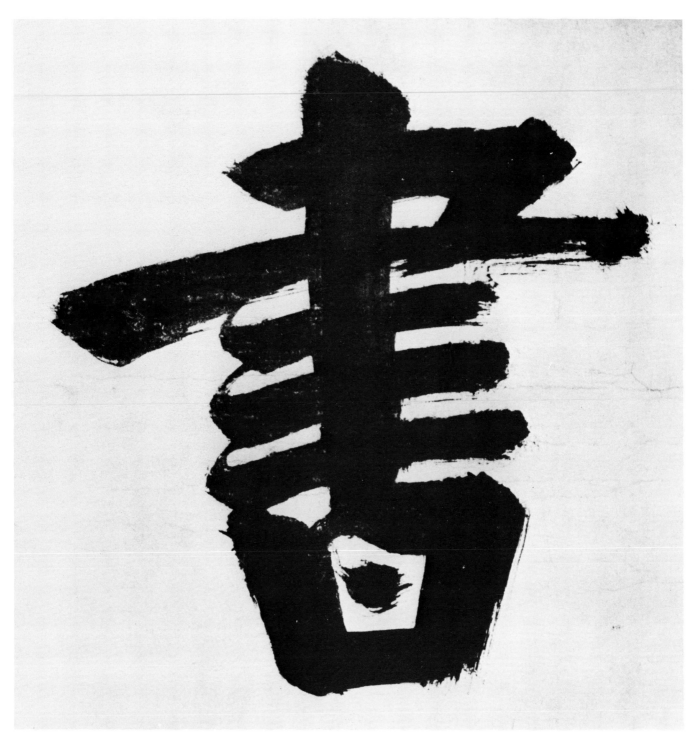

Sho, the Chinese character for writing, by Zhang Jizhi (Chō
Sokushi; 1186–1266). From a signboard at Tōfukuji Zen Mon-
astery in Kyoto.

SACRED CALLIGRAPHY OF THE EAST

Third Edition, Revised and Expanded

John Stevens

SHAMBHALA
BOSTON & LONDON
1995

SHAMBHALA PUBLICATIONS, INC.

Horticultural Hall
300 Massachusetts Avenue
Boston, Massachusetts 02115
www.shambhala.com

9 8 7 6 5 4 3 2

Printed in Canada

∞ This edition is printed on acid-free paper that meets
the American National Standards Institute Z39.48 Standard.

Distributed in the United States by Random House
and in Canada by Random House of Canada Ltd

The Library of Congress catalogues the revised paperback edition of this book as follows:

Library of Congress Cataloging-in-Publication Data

Stevens, John, 1947–
 Sacred calligraphy of the East.

 Bibliography: p.
 Includes index.
 1. Calligraphy—Asia. 2. Art and religion—Asia.
 3. Calligraphy—Philosophy. 4. Calligraphy—Technique.
 I. Title.
 NK3632.S74 1988 745.6′199 88-15826
 ISBN 0-87773-458-5 (pbk.)
 ISBN 1-57062-122-5 (1995 pbk.)

CONTENTS

For Edward and Florence Norbuth.

PREFACE

Throughout the Orient writing is held to be a gift from the gods; the divinely inspired letters and characters are objects of the highest veneration. Over the centuries sacred calligraphy in the East has continued, primarily through the vehicle of Buddhism, to develop different forms of expression right up to the present day.

Although there are other types of religious calligraphy in the East this book presents mainly Buddhist calligraphy, not only because it is the most widespread and influential, but also because it is the most dynamic. Buddhism quickly adapted itself to the cultures where it happened to spread, modifying its teachings to incorporate local languages and customs, thus revitalizing old ways as it created new paths.

The primary scripts of India, Tibet, China, and Japan are represented here with a focus on the forms surviving in Japan. That nation has faithfully preserved the ancient traditions it inherited from India and China, simultaneously synthesizing fresh approaches to the appreciation, study, and display of calligraphy. The practice of sacred calligraphy has drastically declined in other countries of the Far East, and even in the Theravādin countries of Southeast Asia the number of calligrapher-monks has greatly decreased. Japan, the most modern of any, has met the challenge of the twentieth century without abandoning its heritage; in fact, sacred calligraphy flourishes there today as never before.

This book seeks to portray that vitality. Sacred calligraphy is not something dead, to be confined to a museum storeroom, but something living, with a long and glorious history. The illustrations are both for example and inspiration. While I have attempted to include illustrations from all eras and areas, the vast scope of the subject itself and limitations of space prevented me from covering every aspect of sacred calligraphy. Also, because certain styles of calligraphy are better documented than others, treatment of individual sections ranges from fairly complete to a general outline. Availability of photographs was another important factor; in some cases photographs of desired illustrations were not as clear as had been hoped but they are nonetheless included to illustrate important points in the text.

Each section has an introduction containing a history of the tradition together with a short explanation of its spirit. Since many have expressed interest in the actual practice of calligraphy, manuals of instruction have been provided for each section. They introduce the basic elements of the respective methods and are structured for those who have little or no knowledge of the languages. However, linguists, scholars, and artists should also be able to benefit from these manuals and the illustrations since they contain much information that is not readily available elsewhere.

In sacred calligraphy proper attitude is more important than artistic ability. The majority of illustrations in this book were not executed by ''professional'' calligraphers. To the Chinese, calligraphy is the ultimate art form, and it is always best when brushed for one's own pleasure rather than on commission or for purchase. Most of the fine calligraphic wood blocks of Tibet were carved by anonymous village craftsmen; and in Japan works by monks, samurais, poets, and statesmen

are more highly valued than those of professional calligraphers.

Therefore, leaving aside all pleas of inability or lack of talent, the reader is encouraged to practice the form of calligraphy which attracts his or her interest. There is something innately divine about these sacred scripts that can transform even those without religious pretentions. Merely copying one of the sacred alphabets makes the mind clearer, the heart more calm. Enjoy the illustrations, but also pick up a brush and try drawing a Zen circle. Ultimately, there will be a blending of inner and outer beauty, linked to the past yet vigorously alive in the present.

NOTE ON ROMANIZATION

All Sanskrit and Pāli words are given with their complete diacritical apparatus. Tibetan words are transcribed for the sake of pronunciation, and the orthographic transliteration of all Tibetan words appears in parentheses after the first occurrence of a word. This transliteration is based on the system proposed by Turrell Wylie. Chinese is romanized in accordance with the modern Pinyin system and Japanese by the standard Hepburn system.

ACKNOWLEDGMENTS

I am deeply indebted to the following people: (Siddhaṃ) Tokuyama Kijun Sensei for allowing me to extensively reproduce illustrations from his books; Professor Nagao Gadjin for providing numerous illustrations; Rev. Matsumoto Shunshō for illustrations and valuable information; Suzuki Michiya for professional photographs of *itabi*; Ajit Mookerjee for permission to reproduce several works from his collection of Tantric art; (Tibet) Nik Douglas for providing photographs of calligraphy in his collection; Nik Ribush for locating some unusual pieces and other help; Pema Gyalpo for general information; Lobsang Gyatso and Ugyen Shenpen for much of the material in the manual; Professors Lobsang Lhalungpa and Ngawang Thondup Narkyid for correcting the text; (Shakyō) Kishimoto Isoichi Sensei for illustrations, instruction, and information; Professor Inoguchi Daijun for illustrations of Silk Road shakyō; David Schneider and Richard Levine for examples of English shakyō; Russell Webb for information on shakyō in Southeast Asian countries; (Zensho) Professor Terayama Katsujō for illustrations and invaluable help; Usui Shiro for assistance in gathering many photographs; Tanaka Akira for permission to reproduce pieces from his Hakuin collection; Professors Kinami Takuichi and Miura Yasuhiro for illustrations and information on Jiun; Belinda Sweet for illustrations and enthusiastic encouragement; Professor Stephen Addiss for illustrations and an original work; Jill Bell for her contribution of an original composition; Don Ed Hardy for continual support; and Mike McCabe and Tim LaMount for the "Sacred Tattoo" illustration.

Special thanks to Edward Norbuth for his kind help with many of the photographs.

To all the fine people who assisted me but are not listed above, my sincere thanks. Everyone at Shambhala has my gratitude, especially Editor-in-Chief Samuel Bercholz, Carolyn Rose, Larry Mermelstein, and Ron Suresha for their kind support and excellent editorial supervision.

Joyce Stevens spent nearly as much time as I did on this project; her kindness, patience, and hard work deserve special praise.

SACRED CALLIGRAPHY
OF THE EAST

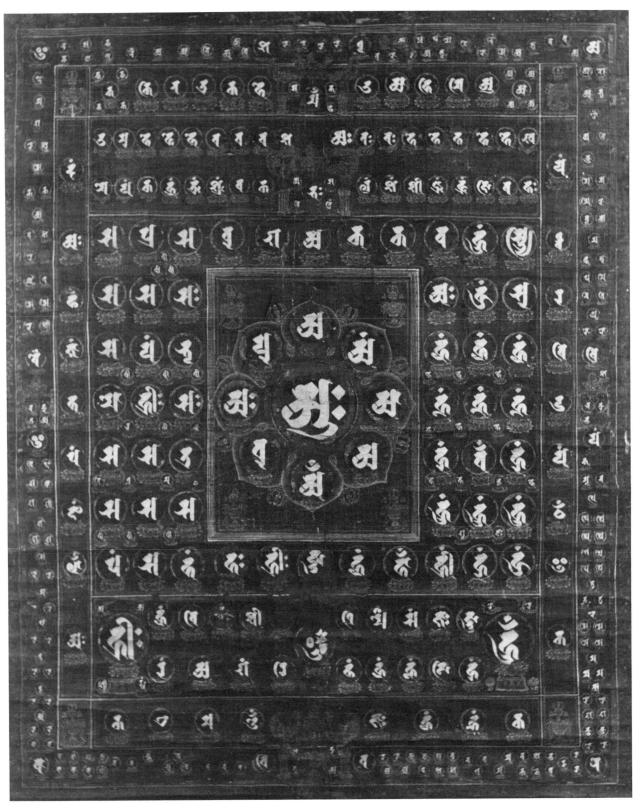

1. Siddhaṃ *bīja* (seed syllable) maṇḍala of the *Gar-bhadhātu*, womb matrix of the universe. Each letter personifies a different cosmic force as a Buddha, Bodhisattva, or other manifestation. Japan, c. 17th century. Gold ink on dark blue paper.

SIDDHAṂ:
SCRIPT OF GODS
AND BUDDHAS

The letters from a to kṣa cross the Indus River, migrate to other countries, travel to other islands, go to other worlds, always displaying the holy, abiding in the hearts of all.

<p style="text-align:right">—AKṢAMĀLIKOPANIṢAD</p>

HISTORY OF SIDDHAM

One origin or many? Did writing begin in one area and then spread to other countries or did the great writing systems—Sumerian, Egyptian, Cretan, Hittite, Indic, Chinese—arise independently? Western scholars surmise that an alphabet first appeared among a Semitic people, perhaps the Assyrians or Hebrews; the Hindus maintain that the source of writing lies in mother India; the Chinese assert that their written characters are the oldest, the best, and the most beautiful. The problem of the origin of writing is unlikely to be solved since the necessary clues are lost in antiquity.

All ancient systems, however, hold one idea in common: writing is divine, inherently holy, with powers to teach the highest mysteries; writing is the speech of the gods, the ideal form of beauty. The Egyptians were taught writing by Toth, the scribe of the gods, and named their script "the divine"; Jehovah engraved the letters with his finger when he gave the Commandments to the Hebrews; the Assyrian god Nebo revealed the nature of cuneiform to his people; Cangjie, the four-eyed dragon-faced wizard, modeled the Chinese characters after the movements of the stars, the footprints of birds, and other patterns that occurred in nature; and in India the supreme god Brahmā himself gave knowledge of letters to men.

During the period 2500–1500 B.C. an urban civilization flourished in northwest India, the two most well-known centers being Mohenjo-Daro and Harappā.

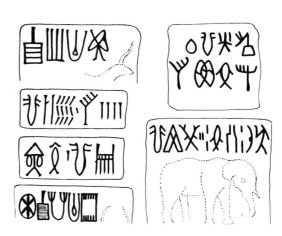

2. Indus Valley script dating from the 3rd millennium B.C.

A large number of steatite (soft stone) seals excavated from these sites depict various animals, symbols, or deities with brief inscriptions across the top. Similar inscriptions were found on stone and copper tablets, pottery, bronze implements, and ivory and bone rods. General use of the script appears to have been discontinued within a few centuries and decipherment remains uncertain (although some modern Indian scholars claim both to have successfully deciphered the script and traced its development into other alphabets, Eastern and Western).

During the second millennium B.C. the Āryans, a nomadic warlike people, entered the valley and quickly displaced the indigenous inhabitants. The wandering invaders, who had come to India via Afghanistan from their homeland in the

Turkestan, put down roots and established a new civilization.

A sacred tradition known as *Veda* (knowledge) appeared among these Indo-Āryans. The earliest portion, dating from perhaps 1400–1000 B.C., is the *Ṛg Veda*, comprised of hymns (*sūkta*) to the gods. Ritual (*Brāhmaṇa*) and philosophical (*Upaniṣad*) texts evolved somewhat later. The *Vedas* were said to have been "heard" rather than composed by the Āryan seers; that is, they are authorless. Despite the fact that Brahmā had inscribed the holy text on leaves of gold the authority of Sanskrit, the language of the *Vedas*, lies principally in proper recitation and oral communication—"Things from books are not as good as things from the living and abiding voice." The grammar of Pāṇini (c. 400 B.C.), which defined the classical language, was to be memorized after hearing its recitation from an instructor. *Saṃskṛta* means that which is perfectly constructed, cultivated.

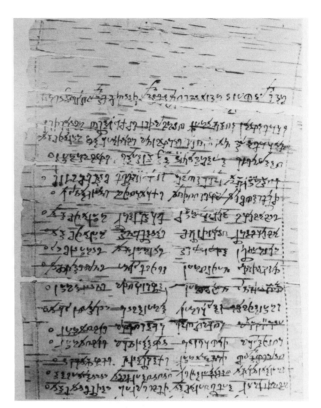

4. The earliest extant version of the *Dhammapada*. Written in Kharoṣṭhī script on birch bark. Central Asia, 2nd or 3rd century A.D.

inscriptions are generally considered to be the oldest extant examples of Indian script. Aśoka's efforts established writing as a medium of expression among diverse segments of the population and provided the impetus for the diffusion of the divine alphabet throughout Asia.

3. Brāhmī-lipi inscription from an Aśokan pillar, c. 250 B.C.

The holy script Brāhmī-lipi was utilized sparingly, if at all, until the advent of Buddhism and, to a lesser extent, Jainism. Buddha (c. 565–486 B.C.) insisted that his teaching be given to all people in their own languages. Emperor Aśoka the Great (273–236 B.C.) took this precept to heart after finding refuge in the Three Jewels. He constructed pillars all over the land announcing his conversion and the glories of the Buddhist Law. The edicts are in a vernacular Prākṛt, most in Brāhmī script with some in Kharoṣṭhī—a syllabic script in Aramaic style, probably introduced from Persia—and a few in Aramaic and Greek. These

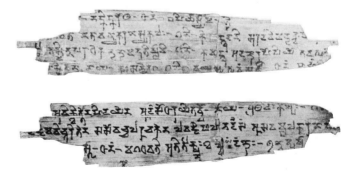

5. A tāla-leaf manuscript in a variant of the Brāhmī script. Central Asia, 2nd or 3rd century A.D.

Brāhmī-lipi is the forerunner of most of the scripts used in India, Tibet, and Southeast Asia. North Indian variants of the Brāhmī script gave

	300 B.C.	350 A.D.	350–800 A.D.	800–1200 A.D.	
a					
ā					
i					
ī					
u					
ū					
e					
a i					
o					
a u					

6. Development of Brāhmī into Siddhaṃ script.

birth to the Gupta, Siddhaṃ, Devanāgarī, Tibetan, and Khotanese writing systems. From the Tibetan system sprang the Rong (Lepcha) alphabet of Sikkim and the Passepa script used in the Chinese Imperial Chancery of the Yuan Dynasty (1279–1368).

Southern forms of Brāhmī-lipi inspired the Grantha alphabet, still in use, which in turn developed into the scripts used for the Dravidian languages (Tamil, Malayalam, Telegu). Through the efforts of Buddhist missionaries these scripts were introduced into Southeast Asia, forming the basis of the Khmer, Sinhalese, Mon, Burmese, and Thai writing systems. One exception is the Mongolian alphabet, distinctly Semitic in character, which was derived from the Aramaic alphabet carried to the East by Nestorian monks.

Siddhaṃ and Devanāgarī, the two major scripts, are both derived from the western branch of the Gupta alphabet. The Gupta era (A.D. 320–647) was the golden age of Indian Buddhism: art reached its classical perfection, great monasteries flourished, and many outstanding literary works were created. In the first days of the Buddhist order few monks knew how to read or write so the teaching was imparted orally. Gradually, as more and more of the canon was committed to writing, literacy became a requirement for the monks.

Buddhist education in the Gupta region began with a primer of twelve chapters which dealt with the letters of the alphabet and the ten thousand combinations of vowels and consonants. Before copying out the letters for the pupils on his writing board, the teacher wrote the word *siddhaṃ* for them to copy. The root of this word is *sidh*, which means accomplished, successful, perfected, with the connotation of being sacred. The letters them-

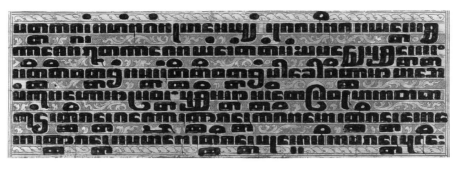

7. Page from the *Kamavācā*, summary of monastic rules, written in Burmese square script on gilded and lacquered palm leaves, c. 18th century.

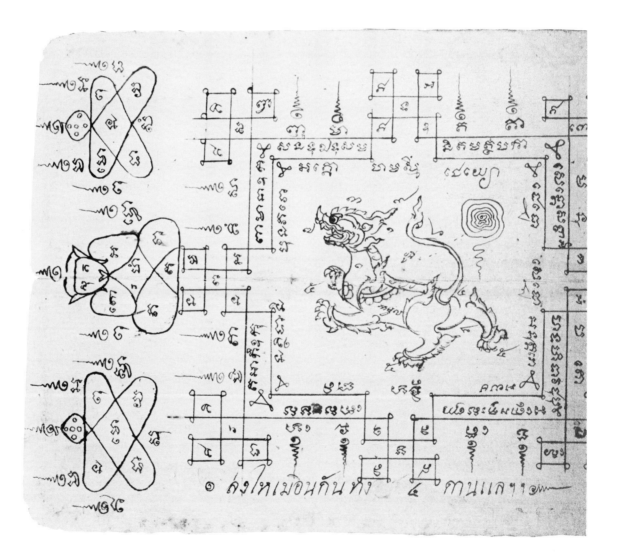

8. Thai charm manual. In Thailand, monks are occasionally taught a special kind of sacred script to be used for charms and tattoos. Thailand, c. 19th century.

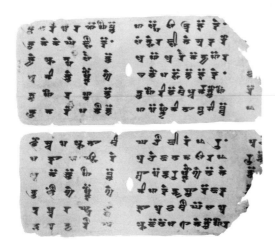

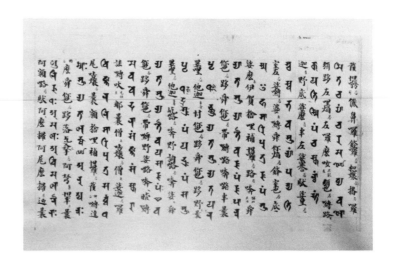

9. A Khotanese Buddhist text in Gupta script. Central Asia, 4th century.

10. The *Heart Sūtra* in Siddhaṃ script with Chinese equivalent pronunciation.

selves are perfect, having been created by Brahmā. Alternatively, *siddhir-astu* (May there be perfection!) or *namaḥ sarvajñāya siddhaṃ* (Homage to the all-knowing. Perfection!) was written at the head of the book or letter-list. Thus the word siddhaṃ became synonymous with both the letters and the primer. This primer was to be mastered within six months; then the student moved on to the sūtras of Pāṇini (eight months), the *Book of Dhātu* (three years), and finally the *Three Khilas*. A reed pen was used to write the letters and manuscripts were written on birch bark or, more commonly, palm leaves (tāla). Long strips of tāla leaves were treated with a preservative. After being inscribed with the text, the leaves were gathered together, two holes were drilled through them, and they were bound with string. Inscriptions were sometimes made on copper.

The large number of Sanskrit sūtras and commentaries introduced into China during this period were mainly in the Siddhaṃ script. These texts were quickly translated into Chinese, with emphasis on those themes deemed most suitable for the native mentality. There was comparatively little interest in the correct pronunciation or composition of Sanskrit in China. The written word was more valued than the spoken largely because the great number of dialects in China made oral communication difficult. Hence, more attention was paid to the form of the Siddhaṃ letters. Use

of the reed pen was abandoned in favor of the Chinese brush or wooden stylus; Siddhaṃ script assumed its place in Chinese culture as a special branch of calligraphy. Particular importance was placed on the efficacy of mantras and seed syllables composed in Siddhaṃ script and no attempt was made to create original works. Thus, in contrast to the Devanāgarī of India, Siddhaṃ in China and Japan was never used for anything but sacred writing.

Familiarity with the Siddhaṃ alphabet led to the formation of the thirty phonetic radicals (*zima*) of the Chinese language devised by the monk Shouwen. He divided the sounds following the Siddhaṃ pattern: labials, languals, gutturals, dentals, and glottals. In addition, between six and seven thousand Sanskrit terms entered the Chinese language. Via China, Siddhaṃ was carried to Korea where it perhaps influenced the development of the Hangul script. It was in Japan, however, that the study and practice of Siddhaṃ reached its zenith.

The two men responsible for establishing Siddhaṃ in Japan were Saichō (Dengyō-Daishi; 767–822) and Kūkai (Kōbō-Daishi; 774–835). Both studied in China at approximately the same time (c. 805). Saichō trained at Mt. Tiantai (Tendai) bringing the doctrines of that school with him when he returned to his temple on Mt. Hiei near Kyoto. He taught his disciples the fundamentals

阿本不生卽般若　啊行萬行卽三昧　前之六字前短後長

阿上　啊去　伊上　咿去

烏上　嗚去　曀去　愛入

11a. Part of the Siddham alphabet (*varṇapāṭha*) taken from the Korean *Mantra Collection*.
Note the unusual form of certain of the letters.

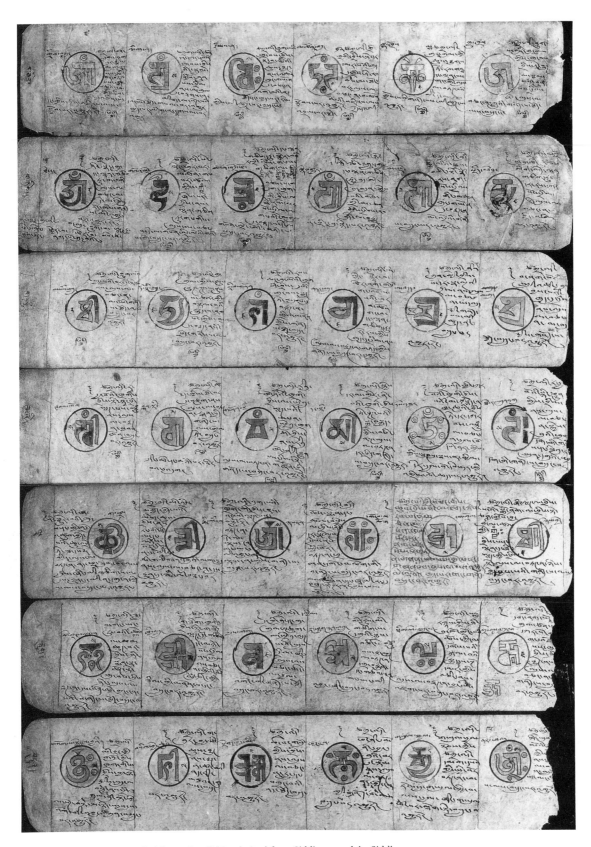

11b. Tibetan charm manual with mystic syllables derived from Siddhaṃ models. Siddhaṃ
script was reproduced almost exclusively in black throughout most of Asia, but in
Tibet frequently each of the characters was given a particular hue, which was believed
to infuse the syllables with special powers.

of Siddhaṃ and encouraged several to continue their studies in China. Kūkai was initiated into the mysteries of the True Word (Shingon) school by Huikuo (746–805) and learned Siddhaṃ from the Indian monk Prajñā (who, it is said, also collaborated with the Christian monk Adam in constructing the Nestorian Stone).

Huikuo's master was the famed Amoghavajra (705–774), a monk from north India who came to China in 720 with his teacher Vajrabodhi (d. 741). Amoghavajra advocated the esoteric use of Siddhaṃ mantras and seed syllables. One of the texts he translated, the *Uṣṇīṣa-vijaya-dhāraṇī*, was especially popular. By imperial decree all monks and nuns were required to recite it twenty-one times a day, and it was printed on prayer sheets and engraved on pillars in the Siddhaṃ script throughout the empire. After Amoghavajra's death the True Word school gradually declined in China; the transmission passed to the Japanese monk Kūkai.

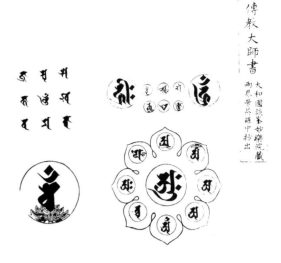

13. Siddhaṃ calligraphy attributed to Saichō.

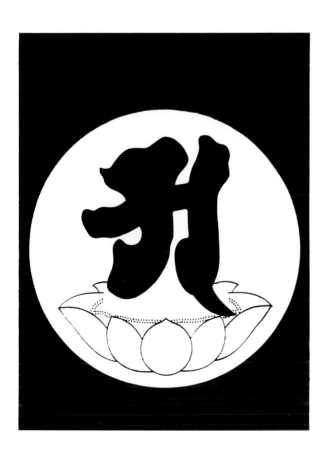

12. The Siddhaṃ letter A. Attributed to Amoghavajra.

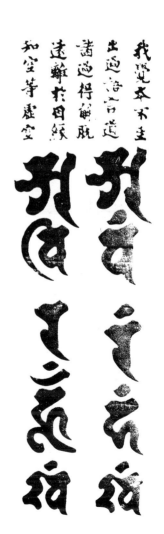

14. Two mantras, A VAM RAM HAM KHAM and A VI RA HŪM KHAM, by Huikuo.

SIDDHAṂ: SCRIPT OF GODS AND BUDDHAS 9

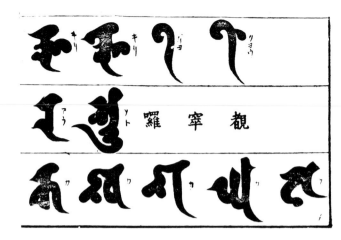
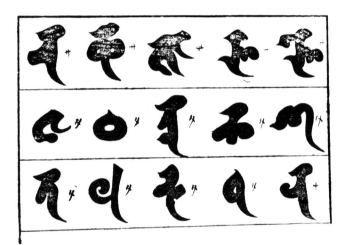
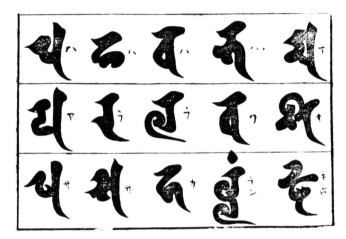

15. The Siddhaṃ alphabet (varṇapāṭha) by Kūkai.

Upon his return to Japan, Kūkai enthusiastically promoted the study of Siddhaṃ. He outlined the subject in his works *Bonji shittan jimo narabi shakugi* (*Brāhmī and Siddhaṃ Script Together with an Explanation of Their Principles*) and *Ungi-gi* (*Principles of the Syllable hūṃ*). Kūkai probably brought along a copy of the authoritative manual *zitan ziji* (*Shittan jiki*) compiled by the Chinese monk Zhiguang (d. 806). This book together with the last major work on Siddhaṃ produced in China, the *Jinyao Tianzhu Ziyuan* (*Keiyu tenjiku jigen*; *Compendium of Indian Writing*) by Dharmarakṣa (983–1058), became the two standard Siddhaṃ textbooks. There are some differences between them, however, which added to the already confused situation. For example, Siddhaṃ was, and is, written as *siddhāṃ* and *siddhaṃ* ; *siddhaṃ* is perhaps more grammatically correct.

In the Tendai school, Saichō's tradition of Siddhaṃ was continued by Ennin (Jikaku-Daishi; 794–864), Annen (d. 889), and Enchin (d. 891). Ennin and Enchin learned Siddhaṃ in China, while Annen produced the first comprehensive study of Siddhaṃ in Japan, the *Shittanzō* (*Treasury of Siddhaṃ*), in 880.

It was the Shingon school, however, which produced the largest number of Siddhaṃ master calligraphers. Shōhō (832–909), Kangan (853–925), Shunyu (890–953) in the Heian period, and

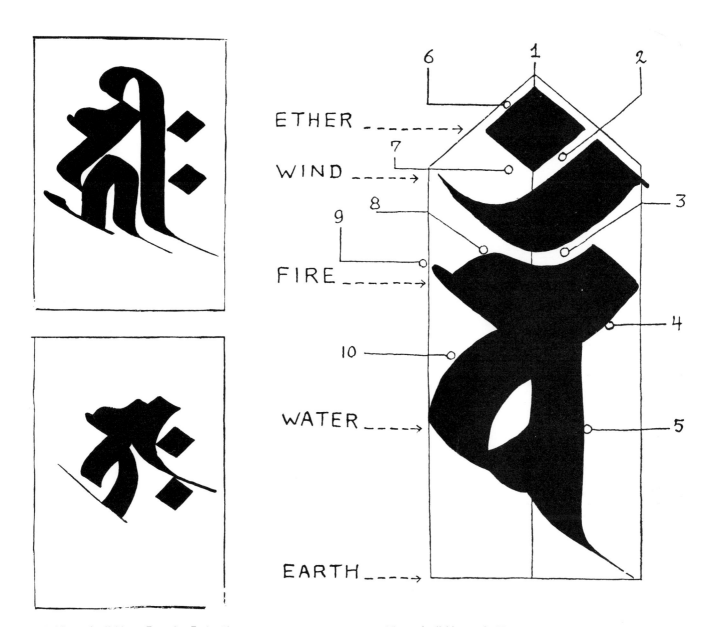

ETHER

WIND

FIRE

WATER

EARTH

16. The seed syllables HRĪḤ and TRĀḤ by Chōzen.

17. The seed syllable VAṂ by Yūzan
showing proper balance and interpretation.

Kakuban (1095-1143), Shinkaku (1117-1180), Seigen (1162-1231), Kōben (Myōe; 1173-1232), and Kikai (1174-1250) in the Kamakura period made valuable contributions. Siddhaṃ study declined somewhat thereafter (virtually disappearing in China) until the Tokugawa period (1615-1867). The Shingon priests Chōzen (d. 1680), Yūzan (c. 1700), and Jōgon (1639-1702) revitalized Siddhaṃ in this era. Yūzan's *Bonsho bokuhitsu shūkan* (*Manual for Writing Siddhaṃ with a Wooden Stylus*) gives detailed instructions

for writing seed characters. Chōzen wrote half a dozen books on Siddhaṃ and his *Shūji shu* (*Collection of Seed Syllables*) is still a standard text. *Shittan sanmitsu sho* (*Notes on the Three Secrets of Siddhaṃ*) by Jōgon was also influential. The itinerant monk-sculptor Mokujiki Shōnin (1718–1810) created a number of unusual Siddhaṃ calligraphies during the same era.

Jiun Sonja (1718-1804), founder of the Saddharma-vinaya sect, is the father of modern Siddhaṃ study. Not only was he a master of the

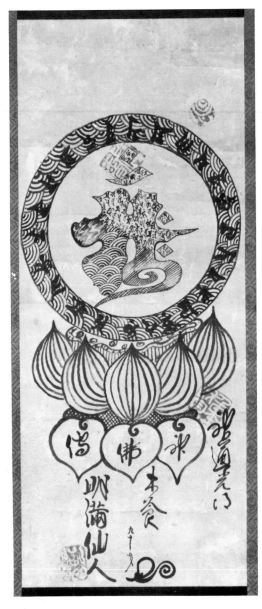 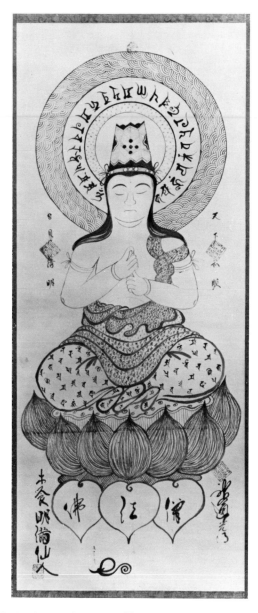

Two pieces by Mokujiki, both created when he was ninety years old.

18. The seed syllable ĀṂḤ surrounded by the kōmyō mantra (see p. 67); the characters in the flowers at the base read, respectively from the left, "Confucianism," "Buddhism," and "Shintō," indicating the essential unity of the three great religions.

19. Dainichi (Mahāvairocana), his halo shaped from the kōmyō mantra and his robe composed of tiny Siddhaṃ characters. The characters in the flowers here read: "Buddha," "Dharma," and "Saṃgha."

script, creating a unique type of calligraphy, he was the first Japanese monk to systematically study Sanskrit grammar and composition. His *Bongaku shinryō* (*Ford of Sanskrit Studies*) includes one thousand volumes. Jiun's religious and artistic genius is treated at length in the section on Zen calligraphy.

Jiun's style of calligraphy has been preserved in the works of such people as Wada Chiman (1835–1909), and his quest for the reconstruction of correct Sanskrit inspired the first generation of Japanese Sanskrit scholars, especially Ogiwara Unrai and Kawaguchi Ekai.

At present, Siddhaṃ is enjoying a renaissance. Tokuyama Kijun, the greatest Siddhaṃ calligrapher today, is a layman. His bold interpretations of Siddhaṃ in various traditional and modern styles clearly demonstrate its unlimited possibilities.

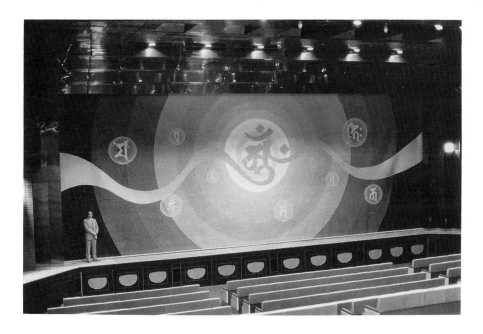

20. Gigantic Dainichi Nyorai Siddham maṇḍala designed by Tokuyama Kijun and hung as an auditorium curtain in Shitennō-ji High School, Osaka.

21. (Below) Tokuyama Kijun (right) with a collection of his calligraphy to be installed in the temple ceiling.

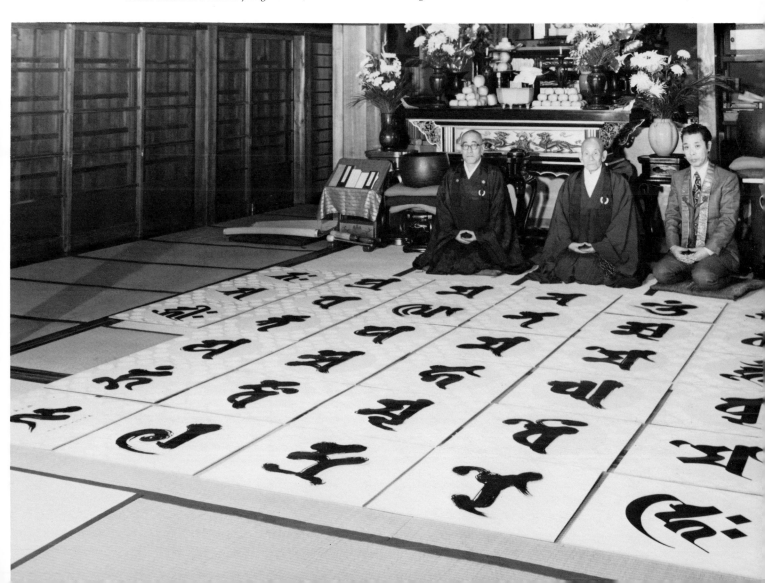

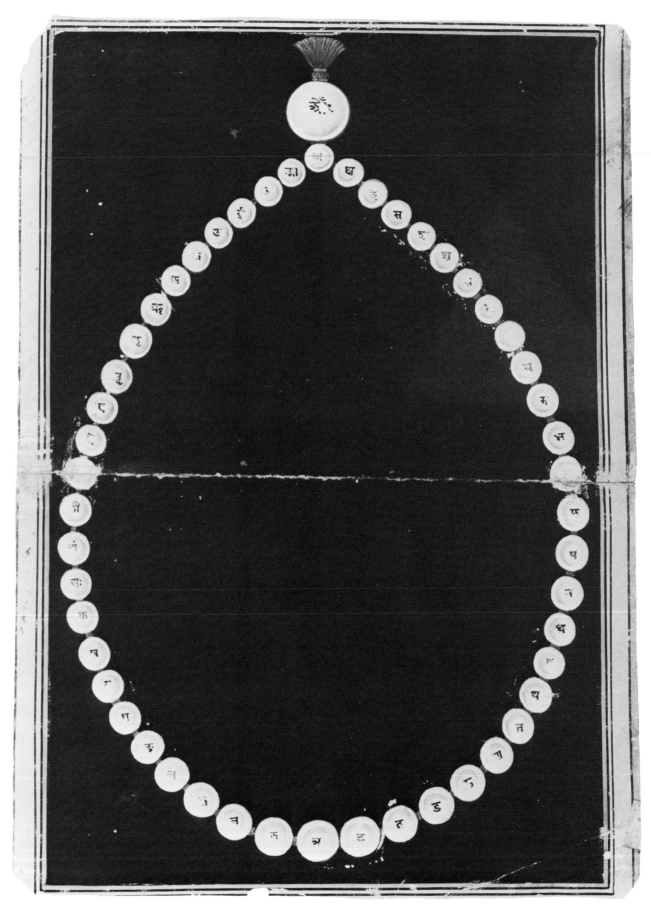

22. The Garland of Letters. Each jewel has one letter of the Sanskrit alphabet.

THE GARLAND OF LETTERS

Parallel to the historical development of the sacred script was an elaboration of Sanskrit's mystical significance. The Hindu tantric philosophers of India devoted a large portion of their vast literature to the explanation of sacred sound, symbol, and worship.

These Hindu tantras declare that the universe is sound. The supreme (*para*) stirs forth the multiple forces of existence through the Word (*Śabda Brahman*). Creation proceeds from the subtle to the gross as cosmic vibrations (*nāda*). The degree of vibration varies in concentration and wave length thus giving birth to what we perceive as light, volume, and structure. The purest vibrations are the *varṇa*, the imperishable (*akṣara*) letters which are revealed to us, imperfectly, as audi-

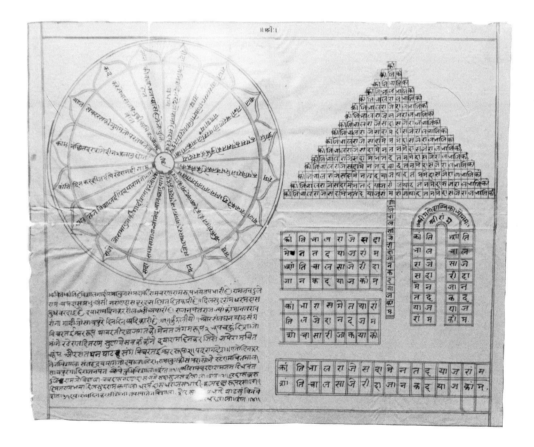

23.

23.–24. Letters of the Sanskrit alphabet arranged for meditation and worship.

24.

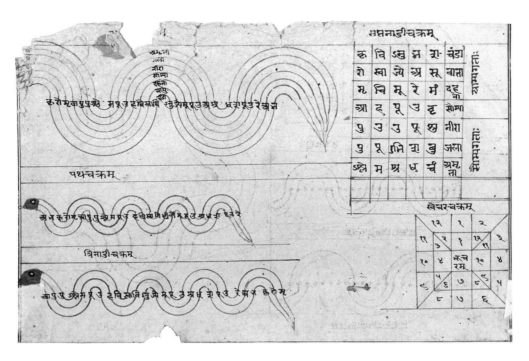

25a. (above) The flow of universal energy contained in the seed-syllables of the universe. Nepal, 18th century.

25b. (below) The universe as a cosmic web of letters. Each consonant of the Sanskrit alphabet is joined with each vowel, symbolizing the eternal evolution and involution of the world.

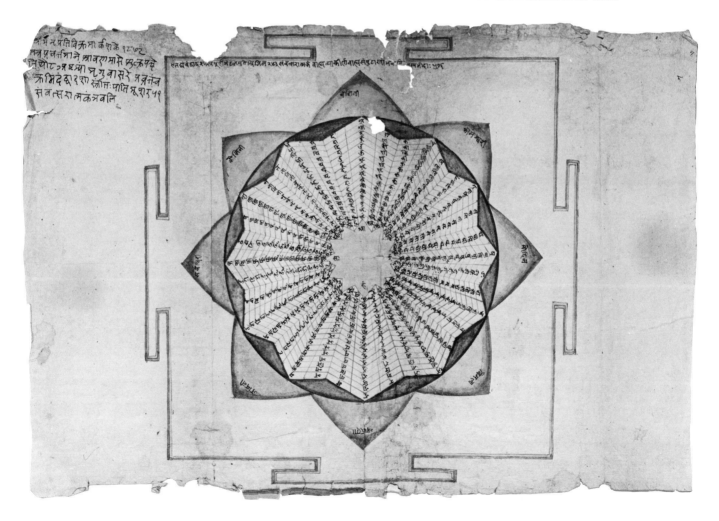

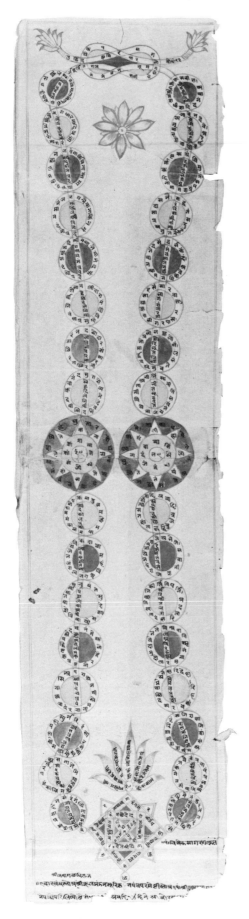

ble sound (*dhvani*) and visible form (*rūpa*). These sounds and forms are provisional, a reflection of the immutability of the varṇa. Varṇas are to ordinary sounds and letters as atoms are to matter.

The varṇas are identified with God's Primal Energy: "The gods are the seeds of the world. The letters developed from the seeds." The letters are *mātṛkās*, little pictures of the Divine Mother. To copy the alphabet is an act of worship; the letters themselves are objects of contemplation. Meditation on them should culminate in the grand vision of the "Garland of Letters," the embodiment of being (*sat*) in the sound and form of the alphabet.

In order to facilitate such a vision, many elaborate arrangements of the Sanskrit alphabet were made. The letters were shaped into a cosmic tree, divided into five classes symbolizing the five elements (earth, water, fire, air, ether), or equated with the signs of the zodiac. In a ritual known as *mātṛkā-nyāsa*, the vowels were assigned a position on the human body and the practitioner touched the appropriate area as he recited the alphabet. In another rite, certain letters are grouped together with each one of the *cakras*, the six psychophysical centers of the human body. The creative unity of Śiva (male principle) and Śakti (female principle) is also present in the alphabet; the vowels are the Śakti of the consonants, which are inert until activated by the creative Life Force.

The letters of the alphabet are mantras—sacred prayer syllables linking the practitioner to a particular divine principle. Each letter is charged with energy that creates vibrations in the inner consciousness of the devotee. Mantras then are tools for thinking—worshiping and meditating on mantras shapes the mind and makes it pure.

The most effective mantras are the seed syllables (*bījākṣara*)—combinations of letters containing the sum total of the divinity. The greatest of these is OM, mother of all sounds. Composed of the elements A, U, M—signifying the creation, preservation, and dissolution of the world—OM is the manifestation of *bindu*, the creative impulse of the cosmos. OM is the source of all mantras and seed syllables.

26. Another version of the Garland of Letters, in this case symbolized as lotuses.

27. Letters of the Sanskrit alphabet related to parts of the subtle body.

The composition of the seed syllables is not arbitrary. For example, KRĪM̐, seed character of Kālī, consists of K = Kālī, R = Brahmā, Ī = Māyā, M̐ = mother of the universe, and the bindu, dispeller of sorrow. That is, Kālī is master of creation and destruction, and should be worshiped for the cessation of sorrow. ŚRĪM̐, bīja of Lakṣmī, goddess of good fortune, is derived from Ś = abundance, R = wealth, Ī = satisfaction, and M̐ = unlimited. Even the word for the personal pronoun "I," AHAM̐, is a bīja-mantra: A = Śiva, HA = Śakti, and M̐ (nādabindu) = union.

Seed syllables and mantras are frequently substituted for anthropomorphic images on cosmic diagrams (yantra) because their concentrated nature makes them more potent than coarse images. Commonly the letters of the alphabet are placed on the outer rim or edge of the yantra, and the mantras and seed syllables within. Recitation of the mantras and seed syllables while visualizing those divine powers inherent in the letters is said to anchor the meditator in the world of the Supreme.

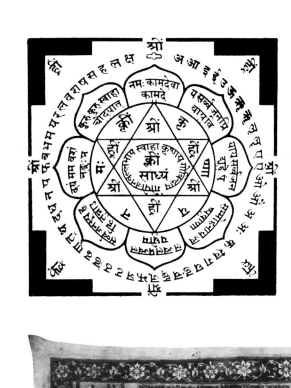

28. Yantra of Kṛṣṇa.

29. OM, seed syllable of the universe.

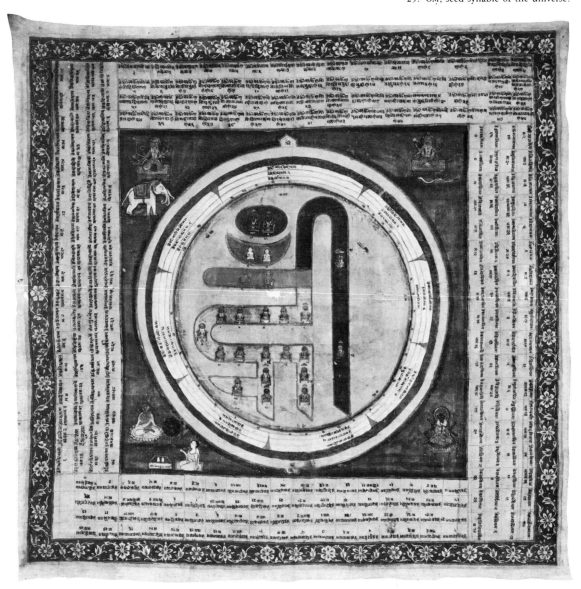

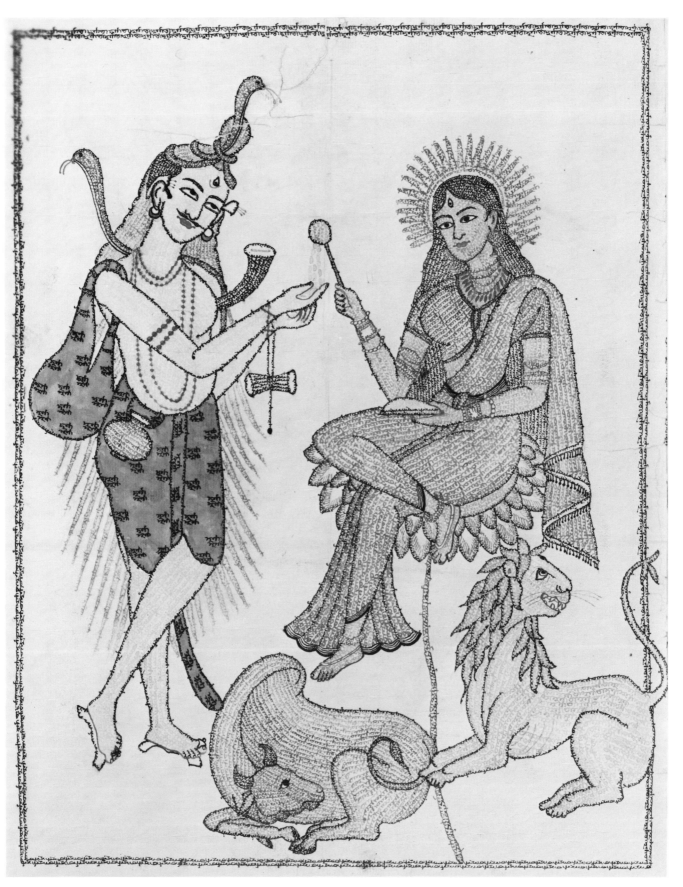

30. A masterpiece of Hindu Tantric calligraphy portraying the images of Śiva and Annapūrṇa. It is composed entirely of mantras written in Bengali script.

A	आ	Ṛ	ऋ
Ā	आ	Ṝ	ॠ
I	इ	Ḷ	ऌ
Ī	ई	AṂ	अं
U	उ	AḤ	अः
Ū	ऊ	KA	क
E	ए	KHA	ख
AI	ऐ	GA	ग
O	ओ	GHA	घ
AU	औ	ṄA	ङ

31. Calligraphic form of the Devanāgarī
 Sanskrit alphabet.

CA	तच	TA	त	YA	य
CHA	छ	THA	थ	RA	र
JA	ज	DA	द	LA	ल ल
JHA	झ झ	DHA	ध	VA	व
ÑA	ञ	NA	न	ŚA	श
ṬA	ट	PA	प	ṢA	ष
ṬHA	ठ	PHA	फ	SA	स
ḌA	ड	BA	ब	HA	ह
ḌHA	ढ	BHA	भ	KṢA	क्ष
ṆA	ण ण	MA	म		

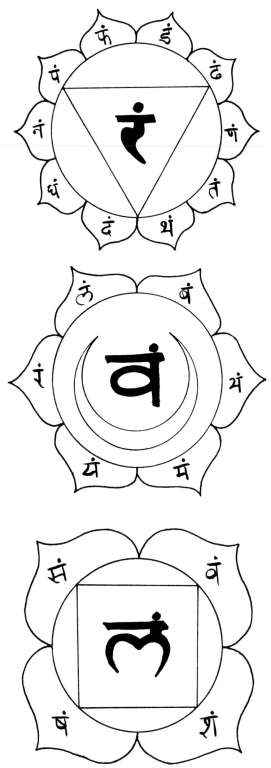
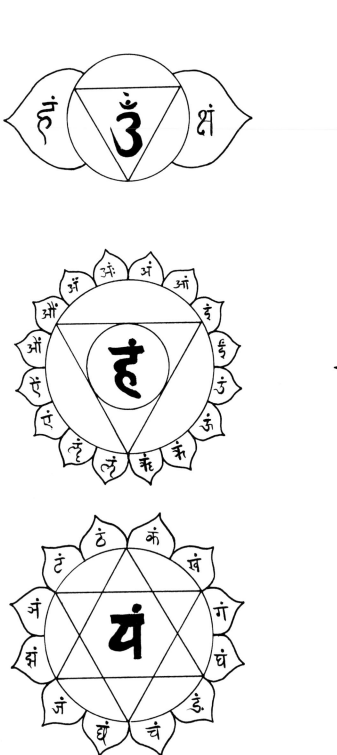

32. The six *cakra*, psychophysical energy centers. Each cakra is associated with certain letters of the alphabet. Beginning from the lower right: *mūlādhāra cakra*—VAM, ŚAM, ṢAM, SAM, with the seed syllable LAM; *svādiṣṭhāna cakra*—BAM, BHAM, MAM, YAM, RAM, LAM, with the seed syllable VAM; *maṇipūra cakra*—ḌAM, ḌHAM, ṆAM, TAM, THAM, DAM, DHAM, NAM, PAM, PHAM, with the seed syllable RAM; *anāhata cakra* (lower left)—KAM, KHAM, GAM, GHAM, ṄAM, CAM, CHAM, JAM, JHAM, ÑAM, ṬAM, ṬHAM, with the seed syllable YAM; *viśuddha cakra*—AM, ĀM, IM, ĪM, UM, ŪM, ṚM, ṜM, ḶM, ḸM, EM, AIM, OM, AUM, AMM, AMḤ, with the seed syllable HAM; and the *ājñā cakra*—HAM and KṢAM with the seed syllable short (half) AM. The seventh cakra (not shown here), *sahasrāra*, has one thousand petals inscribed with combinations of all the letters of the alphabet, with the seed syllable OM.

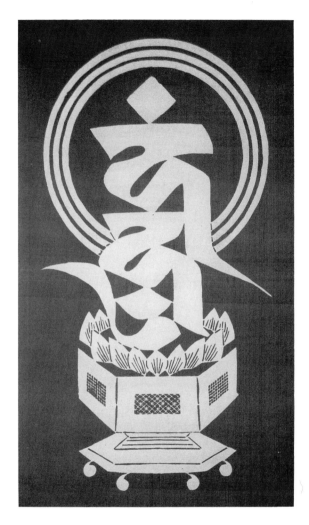

33. HŪṂ, seed-syllable of Aizen Myō-ō (Rāgarāja Vidyārāja), the deity that transmutes base passions into the purest gold. In Japan, Aizen was the patron saint of geisha, courtesans, and Tachikawa Sect Buddhists. The latter believed that genuine sexual intimacy was the best form of Buddha worship. *Kataezome* print by Serizawa Keisuke (1895–1983).

THE WORLD OF BUDDHA IN A SINGLE LETTER

The esoteric significance of the Sanskrit alphabet was incorporated into Tantric Buddhism with several changes. First, the letters were perceived as "exploding" from the emptiness (*śūnyatā*) rather than originating from Śabda Brahman. The precise difference is difficult to explain clearly, but simply stated, Buddhist philosophers rejected any kind of first cause and therefore thought the letters to be "uncreated," existing according to natural principles and learned through insight. The Siddhaṃ alphabet was said to have been taught by Śākyamuni (or Mahāvairocana) and kept secret until it was revealed to the famous Indian saint Nāgārjuna (c. 200) who passed it on to his disciples.

Second, the orthodox Hindu insistence on strict adherence to classical Sanskrit pronunciation of the mantras was disregarded as Buddhism spread

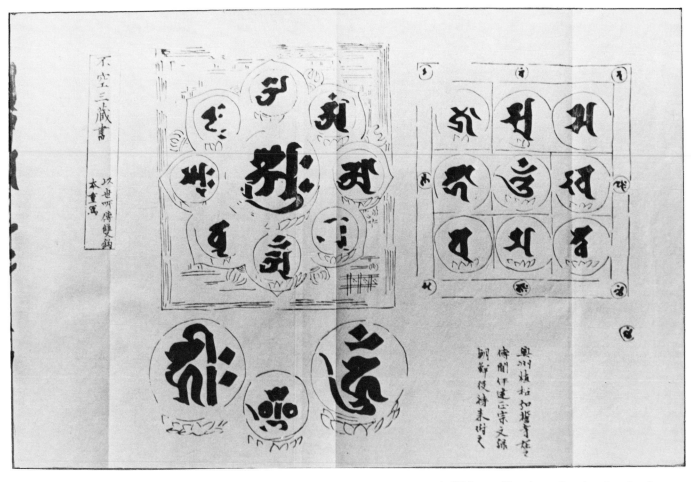

34. Siddhaṃ calligraphy attributed to Amoghavajra.

35.
The Siddhaṃ letter A with explanation of its esoteric significance in Chinese characters; attributed to Saichō.

outside India. Few non-native speakers could be expected to master the correct tones; moreover, in some places—China, for example—the sound of a text mattered less than its written form. In fact, among the Chinese nothing had real value unless put in writing.

Third, Buddhas and Bodhisattvas replaced the gods and goddesses of the Hindu pantheon (although a number were retained under one aspect or another). Seed syllables of the Buddhas were formed in patterns similar to that of the devas. HRĪḤ, bīja of Amitābha Buddha, consists of H = karma, R = passions, Ī = calamity, and Ḥ = removed, epitomizing this Buddha's vow to free his followers from all evils.

Fourth, the letter A displaced OM as the seed syllable supreme. In the *Mahāvairocana Sūtra*—brought to China by the patriarch Śubhākarasiṃha and translated into Chinese by Waxing in 725—it states: "What is the mantra dharma? It is the teaching of the letter A." A symbolizes many things: innate nonproduction; suchness (*tathātā*)

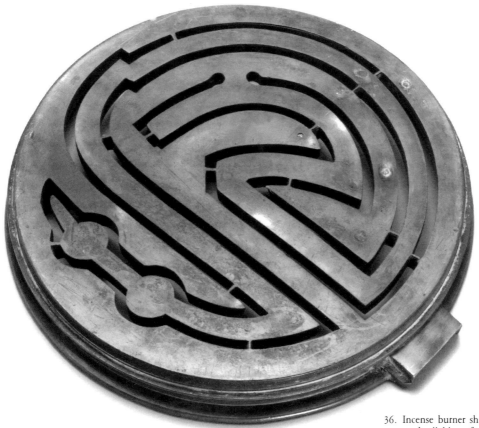

36. Incense burner shaped in the form of HRĪḤ, the seed-syllable of Amitabha Buddha. Incense burned in this device perfumed the air with "holy smoke."

beyond being and nonbeing; the unity of saṃsāra and nirvāṇa; the dharmakāya, ideal body of Buddha; the perfection of wisdom; the middle way. A is the seed syllable of Mahāvairocana, the Great Buddha of Light (Jap: Dainichi Nyorai). Meditation on this letter (ajikan) became an important esoteric practice.

Use of other esoteric practices related to sacred script, especially the writing and recitation of mantras—the distilled teachings of Buddha—remained widespread but in general there was a simplification of the incredibly complex Indian Tantric doctrines of China and Japan. Emphasis was placed on seed syllables, especially in conjunction with maṇḍalas.

"From emptiness comes the seed. From the seed, the conception of an icon develops, and from that conception, the external representation of the icon is derived" (Mahāsukhaprakāśa). Awareness of emptiness is transformed into a seed; the seed develops into a Buddha, which may then be portrayed as an image. Conversely, one may begin from the other direction—contemplation of the icon unites the devotee with the seed, eventually returning him to the emptiness. Written in the proper way with the proper spirit the concentrated power of the seed syllable is capable of manifesting the latent Buddhas within the practitioner. Without such proper knowledge the letters are nothing more than profane markings.

Of the four types of maṇḍalas—mahā maṇḍalas depicting the Buddhas and Bodhisattvas in human form, samaya maṇḍalas showing them as objects, dharma maṇḍalas with only bījas, and karma maṇḍalas, which are three dimensional sculptural maṇḍalas such as Borobudur—dharma maṇḍalas are regarded as the most sublime, the vision of one who is totally awake. Indeed, those who have mastered the seed syllables may dispense with all other texts, mantras, or images for they can see the world of Buddha in a single letter.

Itabi, stone slabs engraved with an image, name, or seed syllable of a Buddha or Bodhisattva, were erected as memorials. The practice was especially widespread in the eastern part of Japan from the thirteenth to the sixteenth centuries; more than twenty thousand such *itabi* remain.

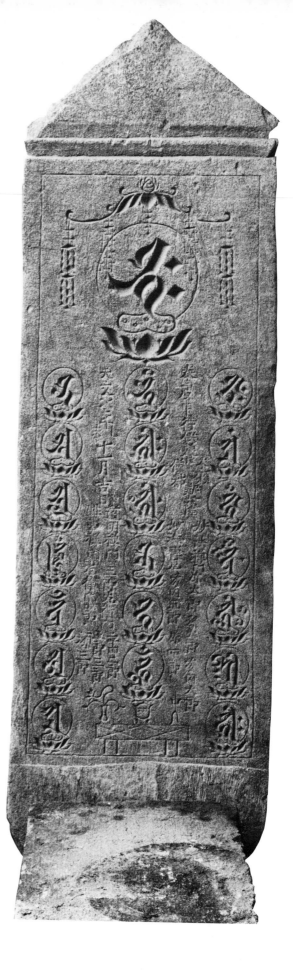

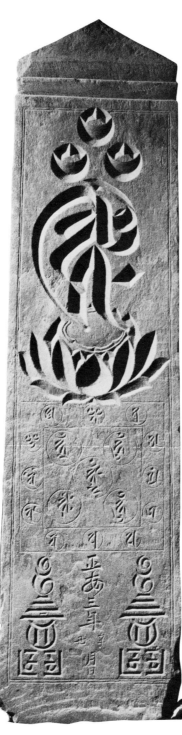

(*left*)

37. Fudō Myōō (Acala) maṇḍala with a large decorative seed syllable for Amida; 1301.

(*right*)

38. The twenty-one Buddhas with BHAḤ, the seed syllable for Śākyamuni Buddha, on the top; 1535.

(*facing page*)

39. HRĪH, seed syllable of Amida Buddha (Amitābha), erected 1324.

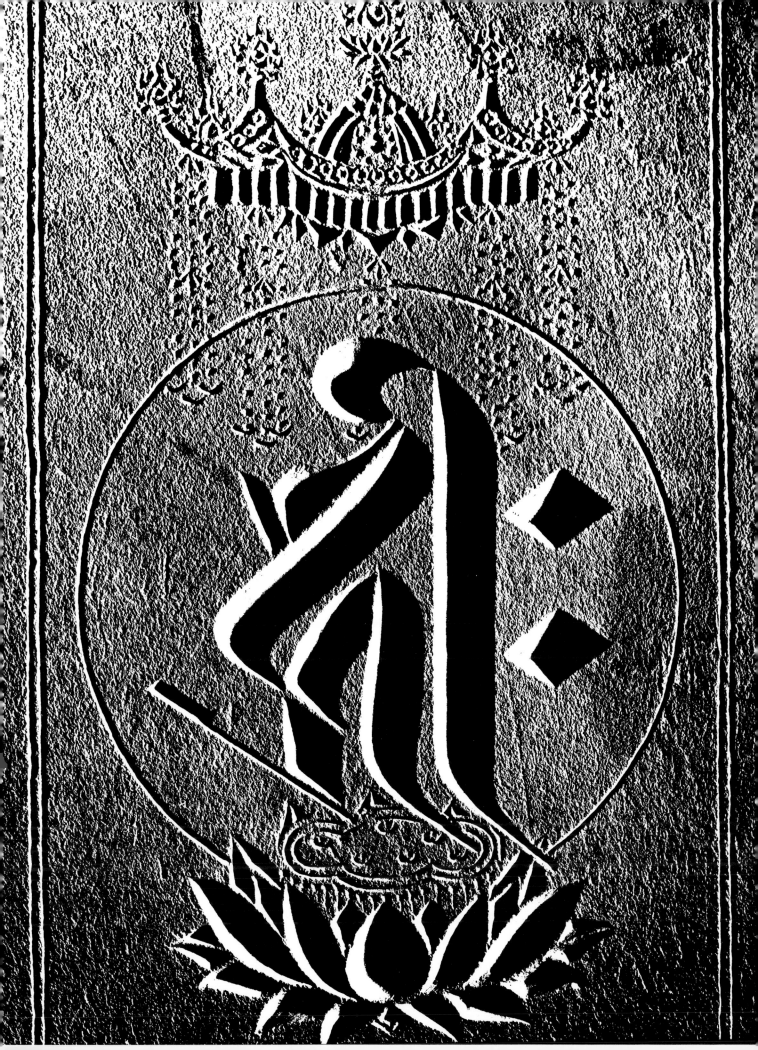

Temples and shrines prepare special seals and woodblock prints with Siddhaṃ seed syllables to distribute to parishioners, visitors, and pilgrims.

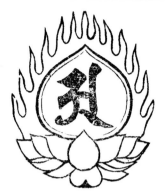

40. Seal of the seed syllable A.

41. Seal of the seed syllable VĀMH.

43. The seed syllable A and BHAH in the center with the temple seals in either corner.

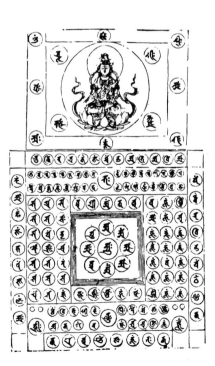

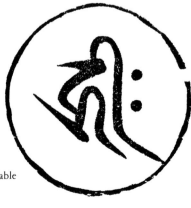

42. Seal of the seed syllable HRĪH.

44. A woodblock maṇḍala of the Garbhadhātu from Dewa Sanzan; Northern Japan.

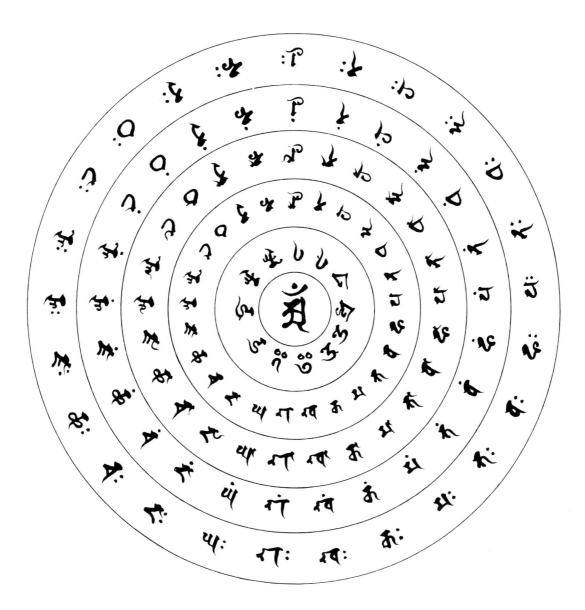

45. Siddhaṃ alphabet arranged as a cosmic web of letters pulsating forth from the seed-syllable AM.

SIDDHAṂ MANUAL

This manual contains the Siddhaṃ alphabet, seed characters for all the important Buddhas and Bodhisattvas plus their mantras, a section on maṇḍalas, and a brief explanation of Siddhaṃ on tombstones. The majority of illustrations are taken from the works of Professor Tokuyama.

Generally, both the Japanese and Sanskrit pro-

nunciations are given for each seed character, mantra, Buddha, Bodhisattva, and so on mentioned. Since the manual is arranged in order of difficulty, it is best to follow that order, working some time with the alphabet and basic strokes before proceeding.

HOW TO WRITE THE SIDDHAM CHARACTERS

The formal characters are written with a special stiff wooden brush (*hake-fude*) on hard, glazed paper. The soft characters can be written with a Japanese fude or any other soft-hair brush. Hold the brush as straight as possible in both styles. The angular shapes of the formal characters are fixed and should be written carefully, with good balance; much more freedom is allowed with the soft-brush characters, there being many different schools of Siddham calligraphy. Use black Japanese ink (*sumi*) at first; after the stroke order and structure of the characters are mastered, different materials and inks may be used.

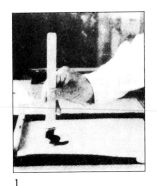

1

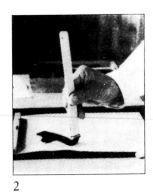

2

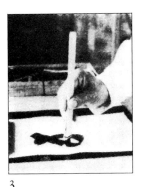

3

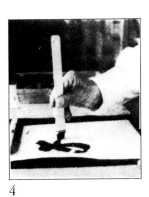

4

刷毛書き梵字・練習書法集

It is important to practice the basic strokes over and over; copying the strokes and letters on a blackboard with a flat piece of chalk is a good way to learn proper order and balance. When writing on paper keep the table clean, the mind intent on the letters, and do not eat, drink, or smoke. Remember the act of copying is an act of contemplation—one is worshiping and ultimately transforming oneself into the Buddha or Bodhisattva being formed. Written characters should never be thrown away; if it is necessary to dispose of practice sheets they should be burned or buried.

As mentioned previously, in ancient times before the teacher began the lesson he wrote out the word SIDDHĀM (perfection) or SIDDHĀMRASTU

(May there be perfection!) and made the students copy this first. Later on the formula NAMAḤ SAR-VAJÑĀYA SIDDHĀM (Homage to the all-knowing. Perfection!) was inscribed at the head of copybooks.

Note: SIDDHĀM, SIDDHĀMRASTU, and NAMAḤ SAR-VAJÑĀYA SIDDHĀM are not, strictly speaking, grammatically correct Sanskrit. However, they have been used for over a thousand years, and, rightly or wrongly, have become part of the tradi-tion. In this Siddham manual, all of the seed syllables and mantras are given in their customary form. When these are corrupt, the correct form is given in parentheses, when known.

THE SIDDHAM ALPHABET

The Siddham alphabet is traditionally arranged into four sections: twelve vowels, four additional vowels, thirty-three consonants, and two special combinations.

Explanation of the chart:
1. Formal: formal-style character written with a stiff brush.
2. Brush: soft-style character written with a Japanese fude or other soft brush.
3. Stroke order: stroke order of each character.
4. Variations: variants of the character.
5. In combination: shape and placement of the character when used in combinations or ligatures.
6. Devanāgarī: Devanāgarī script equivalent.
7. Roman letter: Roman letter equivalent.
8. Esoteric meaning: Each character is said to have an esoteric meaning; most also have special Sanskrit names.

There are several different versions of the fifty-one-letter Siddham alphabet with slight discrepancies between them. The chart given here, based on the work of Professor Tokuyama, is considered the most comprehensive and accurate. When practicing this alphabet always write in order from start to finish; do not stop halfway or omit any letters.

VOWELS (MĀTĀ)

	formal	brush	stroke order	variations	in combination	Devanāgarī	roman letter	esoteric meaning
1						अ	a	anutpāda unborn
2						आ	ā	ākāśa space
3						इ	i	indriya sense organ
4						ई	ī	īti calamity
5						उ	u	upamā simile
6						ऊ	ū	ūna incomplete
7						ए	e	eṣaṇā seeking
8						ऐ	a i	aiśvarya sovereignty
9						ओ	o	ogha flood
10						औ	a u	aupapāduka self-produced

	formal	brush	stroke order	variations	in combination	Devanāgarī	roman letter	esoteric meaning
11						अं	a ṃ	anta limit
12						अः	a ḥ	astaṃgama setting

EXTRA VOWELS

	formal	brush	stroke order	variations	in combination	Devanāgarī	roman letter	esoteric meaning
13						ऋ	ṛ	ṛddhi supernatural power
14						ॠ	r̄	analogy
15						ऌ	l̥	dye
16						ॡ	l̥̄	submerge

CONSONANTS (VYAÑJANA)

	formal	brush	stroke order	variations	in combination	Devanāgarī	roman letter	esoteric meaning
17						क	ka	karma action
18						ब	kha	kha sky

	formal	brush	stroke order	variations	in combination	Devanāgarī	roman letter	esoteric meaning
19	ग	ग			ग	ग	g a	gati going
20	घ	घ			घ	घ	gha	ghana dense
21	ङ	ङ			ङ	ङ	ṅa	aṅga part
22	च	च			च	च	c a	cyuti transition
23	छ	छ	छ	छ	छ	cha	chāyā shadow	
24	ज	ज		ज	ज	ज	j a	jāti birth
25	झ	झ			झ	झ	jha	jhaṣabala warring enemies
26	ञ	ञ		ञ	ञ	ञ	ña	jñāna knowledge
27	ट	ट		ट	ट	ट	ṭa	ṭaṅka pride
28	ठ	ठ			ठ	ठ	ṭha	viṭhapana flourish

	formal	brush	stroke order	variations	in combination	Devanāgarī	roman letter	esoteric meaning
29						ड	ḍa	ḍamara tumult
30						ढ	ḍha	mīḍha disappear
31						ण	ṇa	raṇa battle
32						त	ta	tathātā suchness
33						थ	tha	sthāna dwelling
34						द	da	dāna generosity
35						ध	dha	dharmadhātu dharma realm
36						न	na	nāman name
37						प	pa	paramārtha ultimate meaning
38						फ	pha	phena foam

	formal	brush	stroke order	variations	in combination	Devanāgarī	roman letter	esoteric meaning
39						ब	ba	bandhana binding
40						म	bha	bhava existence
41						म	ma	mama my
42						य	ya	yāna vehicle
43						र	ra	rajas passion
44						ल	la	lakṣaṇa mark
45						व	va	vāc speech
46						श	śa	śānti peace
47						ष	ṣa	ṣaḍāyatana six senses
48						म	sa	satya truth

	formal	brush	stroke order	variations	in combination	Devanāgarī	roman letter	esoteric meaning
49							ha	hetu cause

SPECIAL COMBINATIONS

	formal	brush	stroke order	variations	in combination	Devanāgarī	roman letter	esoteric meaning
50							llaṃ	
51							kṣa	kṣaya destruction

The slanted stroke that begins many of the letters is called the *a ten*; it stands for *hosshin*, the Buddha-seeking mind. It is written ∨∖ with a slight upward pressure at the end. The angular stroke *a* ∫∣ is the *shugyō ten*, the point signifying hard training. The round point placed over letters for the "m" sound is always written in two strokes '∫∙∫² ; this point is the *bodai ten*, the mark of enlightenment. The aspirate "ḥ," represented by two dots on the right-hand side of the letters, is the *nehan* (nirvāṇa) *ten*. One of the seed characters of Dainichi Nyorai, *āṃḥ*, has all four elements which symbolize the four stages of practice—resolve, practice, enlightenment, nirvāṇa.

The alphabet itself is fairly simple but the number of combinations is very large. The 6,364 possible combinations are divided into 18 separate grids; examples of how the grids are formed are given below.

Since the seventh or eighth century Siddhaṃ script has been used exclusively for seed syllables and mantras; nothing has been originally composed in the script in China and Japan and few sūtras or other works are extant. Therefore, most of the combinations in the remaining seventeen grids are rarely, if ever, seen. The combinations that do occur in the various mantras can be recognized by referring to the "in combination" section of the alphabet chart.

Punctuation marks are as follows:

is written at the beginning of a text

ditto mark

comma (formal)

comma (informal)

period (formal)

period (informal)

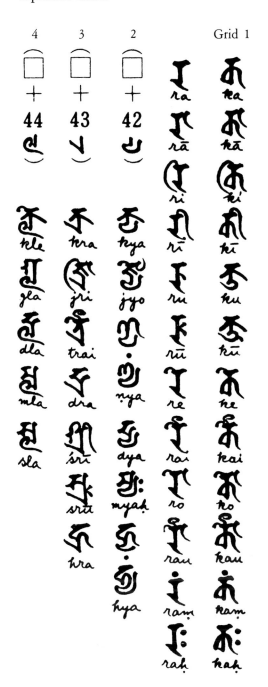

At the end of a text these marks are often used:

46. Siddhaṃ grid.

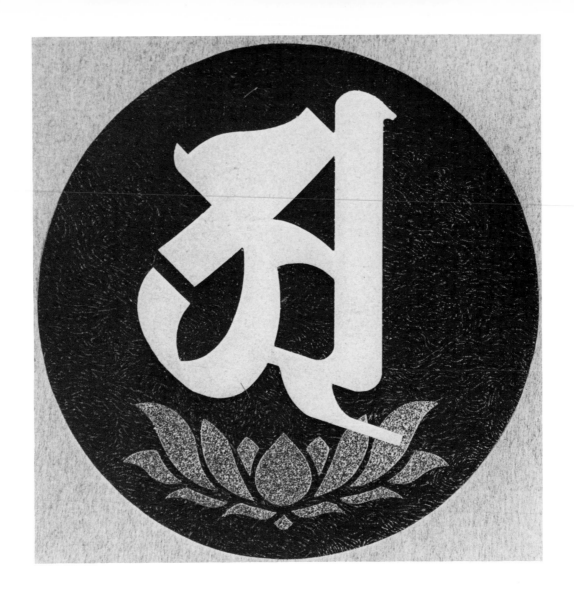

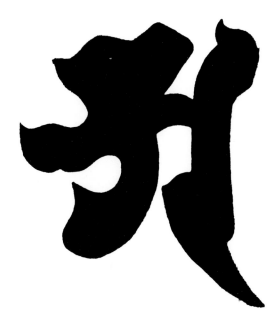

The Almighty Letter A

A is the first and most important of the Siddham characters. It is the source of all vowels and consonants; it includes and is included in every sound produced by human beings. Hence, in both a physical and spiritual sense it is the origin of all elements. It is the seed character of Mahāvairocana (Dainichi Nyorai), the supreme Buddha who manifests the unity of all phenomena. A is uncreated, the primordial form of existence.

Meditation on the letter A (*ajikan*) is an essential practice of esoteric Buddhism. Usually, the character is set on an eight-petaled lotus in the center of a round moon, and then mounted on a board or scroll. The mounted character is set against a wall in the meditation hall. After performing the prescribed ritual including prostrations, mantras, and mudrās, the meditator sits in the lotus posture about one meter from the character.

Pronouncing the A sound with each breath, he visualizes the moon, drawing it into his heart and expanding it gradually until its brilliance permeates the universe. Now from the center of the moon A is perceived as the essence of Mahāvairocana—the distinction between worshiper and worshiped is effaced. Near the end of the meditation the moon and the letter are returned to their original form.

The character used for meditation may be written in either formal or soft style.

> One look at the letter A
> Destroys evil passions;
> The efficacy of the mantra
> Transforms this body into Buddha.

THE LETTER A WRITTEN WITH A BRUSH

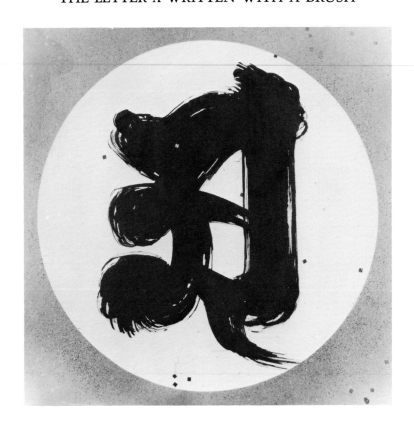

SOFT BRUSH STROKE ORDER

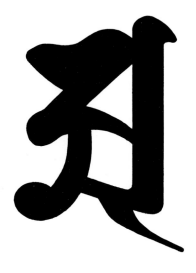
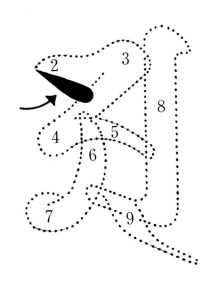

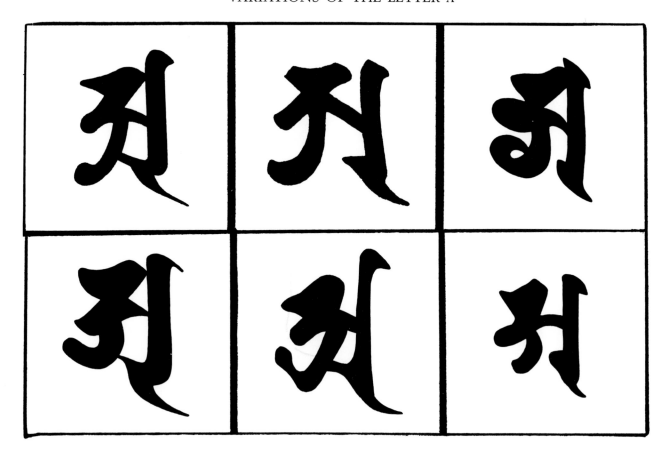

The seed-syllable ĀṂ visualized as a Buddhist practitioner; one becomes the object of meditation.

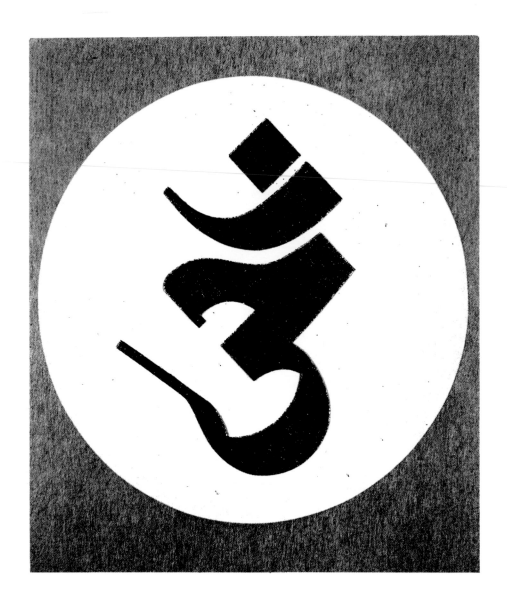

OM: *The Sacred Syllable*

OM is described in the *Māṇḍūkya Upaniṣad* as the best, the highest, and the most wonderful of all sounds. It stands for both change and change-lessness. Its components are A, U, M. A is the letter mentioned above; it represents the waking state. U is the middle sound made between the opening and closing of the mouth; it symbolizes the dream state. M is the third sound, made with the lips shut; it is the state of deep sleep. The silence (*turīya*) which follows is the consummation of the syllable's power—peaceful, unified, and unut-

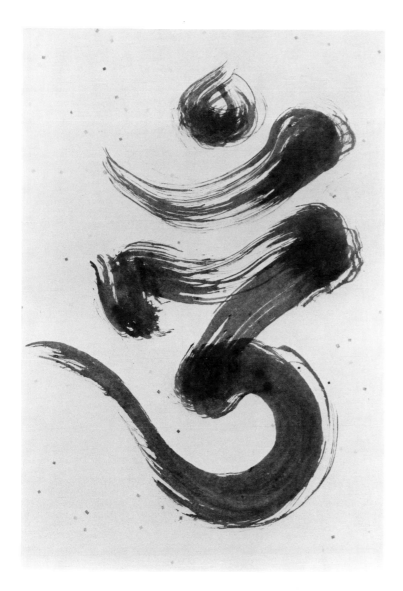

Note: The round stroke in the soft-brush style is written in the shape of a cintāmaṇi, a wish-granting jewel.

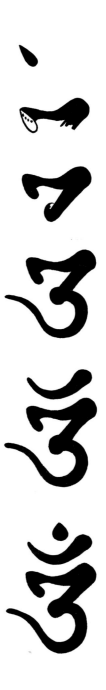

terable. When pronounced together they recreate the alpha and omega of existence. OṂ is the seed character of the universe.

Some realize the unity of Brahman-Ātman in OṂ while others find in it the nonduality of Buddha-nature; yet OṂ itself retains its position as a symbol of supreme liberation, beyond words and concepts. OṂ is the ultimate word of affirmation and should be spoken and written with confidence.

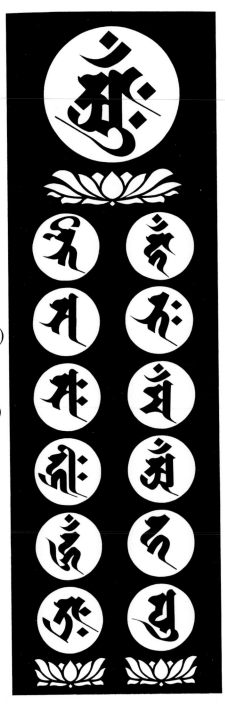

12. Dainichi Nyorai
(Mahāvairocana Tathāgata)

Taizōkai
(Garbhadhātu)

7. Yakushi Nyorai
(Bhaiṣajya Tathāgata)

1. Fudō Myōō
(Acala Vidyārāja)

8. Kanzeon Bosatsu
(Avalokiteśvara Bodhisattva)

2. Shaka Nyorai
(Śākyamuni Tathāgata)

9. Seishi Bosatsu
(Sthāmaprāpta Bodhisattva)

3. Monju Bosatsu
(Mañjuśrī Bodhisattva)

10. Amida Nyorai
(Amitābha Tathāgata)

4. Fugen Bosatsu
(Samantabhadra Bodhisattva)

11. Ashuku Nyorai
(Akṣobhya Tathāgata)

5. Jizō Bosatsu
(Kṣitigarbha Bodhisattva)

13. Kokuzō Bosatsu
(Ākāśagarbha Bodhisattva)

6. Miroku Bosatsu
(Maitreya Bodhisattva)

The Thirteen Buddhas

The thirteen Buddhas are often grouped together. The list is comprised of the thirteen principal Buddhas and Bodhisattvas who are venerated on the special days following a believer's death. A different Buddha or Bodhisattva is honored on the seventh, twenty-seventh, thirty-seventh, forty-seventh, fifty-seventh, sixty-seventh, seventy-seventh, and one-hundreth days and on the first year, third year, seventh year, thirteenth year, and thirty-third year anniversaries. Although they are linked in a sequence they also stand alone and can be written separately.

FUDŌ MYŌŌ

KĀN
hāṃ

STROKE ORDER
formal soft

MANTRA

na — no
ma — maku
sa
ma
nda
ba
zara
dan
kan
(period)

Fudō Myōō (Acala Vidyārāja). The Immovable One, incarnation and messenger of Dainichi Nyorai. Fudō's terrifying appearance represents the fierce aspect of Dainichi when combating wrongdoing. Surrounded by cosmic flames that consume evil and passions, Fudō will not allow the enemies of Buddhism to prevail. Though it appears frightening, Fudō's fury is actually sublime, and designed to protect his worshipers. He smites those who oppose him yet imparts knowledge to those who acknowledge his presence.

Fudō dwells deep in the mountains and ascetics attempt to transform themselves into Fudō by undergoing a thousand-day training period. The entire day is spent in pilgrimage around the mountain, visiting shrines, meditating in caves, and purifying the mind and body in waterfalls. From the seven-hundreth day there is a nine-day period of no eating, no drinking, no sleeping, and no lying down; the ascetic focuses entirely on Fudō.

The Siddhaṃ of Fudō is considered especially effective and is often found engraved on swords. It is the most dynamic of the seed letters and has many different forms.

Mantra: NAMAḤ SAMATTA-VAJRĀṆAM HĀM
(NAMAḤ SAMANTA-VAJRĀṆĀM HĀṂ)

47. HĀṂ, seed syllable of Fudō Myōō, written by Tokuyama on the final day of a thousand-day training period.

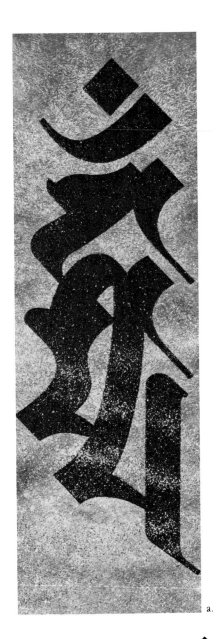

49. Calligraphic interpretation of HĀM.

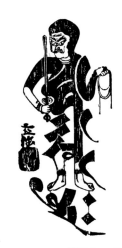

48. Variations of Fudō Myōō: a. HĀMMĀM (formal); b. HĀMMĀM (brush); c. HĀMMAM (brush).

50. HĀM inscribed on a short sword.

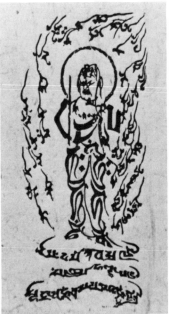

51. Two representations of Fudō Myōō written in mantras. The upper one is attributed to Kūkai.

SHAKA NYORAI

BAKU
bhaḥ

STROKE ORDER
formal soft

MANTRA

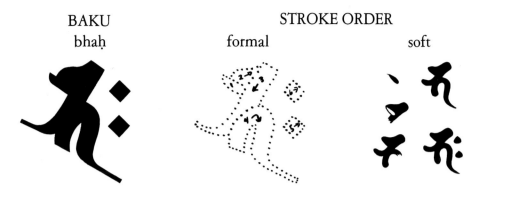

na — no
ma — maku
— sa
— ma
— nda
— bo
— da
— nan
— baku

Shaka Nyorai (Śākyamuni Tathāgata). The historical Buddha, born in northern India in c. 565 B.C. After renouncing the world and practicing the severest austerities for six years, he realized complete and perfect enlightenment at the age of thirty-five and devoted the remaining forty-five years of his life to teaching the dharma.

Śākyamuni's awakening was not limited to himself; it included all beings, animate and inanimate, throughout the universe. Śākyamuni is perceived as the manifestation of the eternal Buddha, his dharma-body being identical with Buddha-nature. However, his dharma-body is not formless as some maintain—it has shape, color, and the power of speech.

His seed character represents that ideal body—actually present yet free of restrictions.

Mantra: NAMAḤ SAMATTA-BUDDHĀNĀM BHAḤ
(NAMAḤ SAMANTA-BUDDHĀNĀM BHAḤ)

MONJU BOSATSU

MAN
maṃ

STROKE ORDER
formal soft

MANTRA

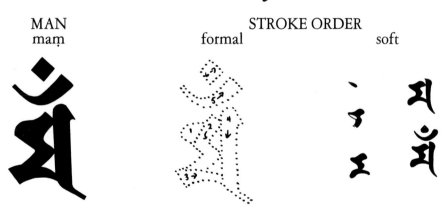

om
a
ra
ha
sha
no

Monju Bosatsu (Mañjuśrī Bodhisattva). Left-hand attendant of Śākyamuni and head of all the Bodhisattvas. Personification of wisdom (prajñā) and purified intellect. In the Garbhadhātu he is shown seated on a white lotus, teaching; in the Vajradhātu he is depicted riding on a golden lion, holding a sword to cut off intellectual entanglements and a book to awaken the mind. He is sometimes worshiped as the god of literature and learning.

He plays a prominent role in many sūtras, especially in the *Vimalakīrti Nirdeśa Sūtra* where he alone has sufficient knowledge to debate with the wise layman.

His seed character represents the deepest wisdom.

Mantra: OM ARAPACANA

FUGEN BOSATSU

AN aṃ	STROKE ORDER formal soft	MANTRA

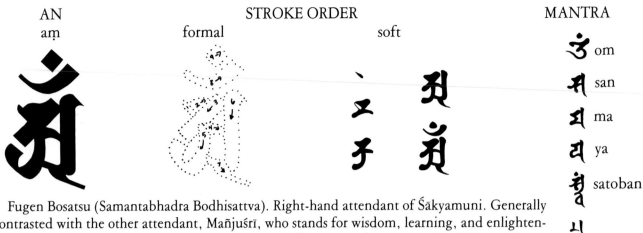

om
san
ma
ya
satoban

Fugen Bosatsu (Samantabhadra Bodhisattva). Right-hand attendant of Śākyamuni. Generally contrasted with the other attendant, Mañjuśrī, who stands for wisdom, learning, and enlightenment. Samantabhadra epitomizes the teaching, meditation, and practice of Buddhism. His actions are based on compassion rather than intellect. He lives among us, even manifesting himself as a courtesan to teach a higher form of love.

His ten great vows are the basis of Bodhisattva practice. They are: to venerate all the Buddhas, to praise the Tathāgata, to offer prayers, to repent, to rejoice in virtue, to turn the wheel of the dharma, to dwell with Buddha, to follow the Buddha's teaching, to be friends with all beings, and to devote oneself to the salvation of others.

Mantra: OṂ SAMAYAS TVAṂ

JIZŌ BOSATSU

KA ha	STROKE ORDER formal soft	MANTRA

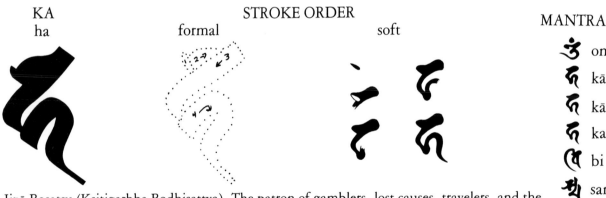

om
kā
kā
ka
bi
sanma
ei
sowa
ka

Jizō Bosatsu (Kṣitigarbha Bodhisattva). The patron of gamblers, lost causes, travelers, and the dead—especially children. He is the Bodhisattva of the underworld, determined to deliver all creatures from the pains of hell. He can appear in all six realms of existence and never turns anyone away. He is said to be the Bodhisattva who looks after all beings during the 5,670,000,000-year interval between Śākyamuni's parinirvāṇa and Maitreya's coming.

Images of Jizō are placed at crossroads, along country roads, and in other out-of-the-way places, often dressed in red hats and shawls made by parents of deceased children.

His appearance is somewhat feminine, with soft features and a benign smile. He is generally dressed as a monk, carrying a pilgrim's staff in his right hand and a wish-fulfilling jewel (cintāmaṇi) in the left.

Mantra: OṂ HAHAHA VISMAYE SVĀHĀ

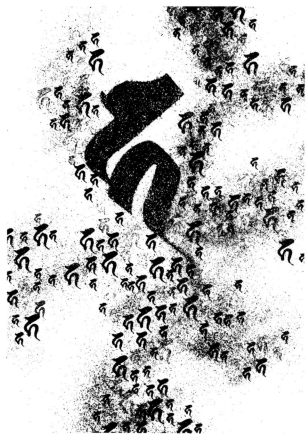

53. A section of a one thousand Jizō seed syllable maṇḍala. Creating stone or written images is said to carry great merit; each new image can save innumerable beings.

52. Brush style HA.

HA	Ī	I	HO	HĀ	I

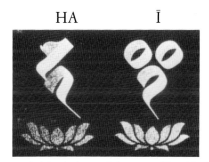
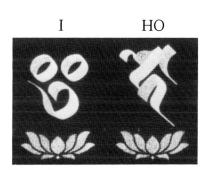
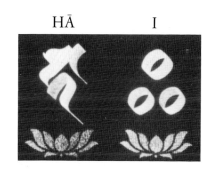

54. The six forms of Jizō as manifested in the worlds of gods, human beings, fighting demons, beasts, hungry ghosts, and hell.

MIROKU BOSATSU

YU	STROKE ORDER		MANTRA
yu	formal	soft	

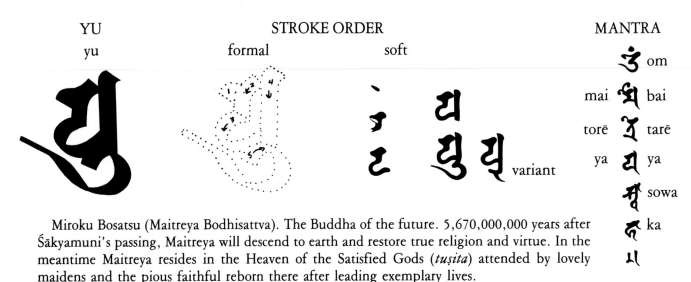

om
mai bai
torē tarē
ya ya
sowa
ka

Miroku Bosatsu (Maitreya Bodhisattva). The Buddha of the future. 5,670,000,000 years after Śākyamuni's passing, Maitreya will descend to earth and restore true religion and virtue. In the meantime Maitreya resides in the Heaven of the Satisfied Gods (*tuṣita*) attended by lovely maidens and the pious faithful reborn there after leading exemplary lives.

Maitreya sustains seekers of the Way and opens the doors of enlightenment to those who persevere to the end. In fact, Maitreya frequently appears on earth; the pot-bellied figure of Hotei, the laughing Buddha, now found everywhere in the world, is one of his incarnations. The delicate, half-seated figure contemplating the future is another.

Mantra: OṂ MAITREYA SVĀHĀ

YAKUSHI NYORAI

BAI	STROKE ORDER		MANTRA
bhai	formal	soft	

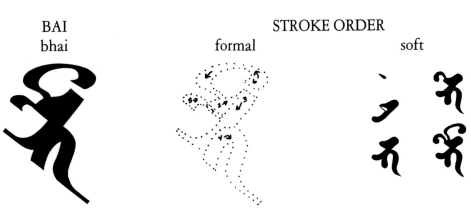

om
ko
ro
ko
ro
se
nda
ri
ma
to
gi
sowa
ka

Yakushi Nyorai (Bhaiṣajya Tathāgata). The Buddha of Healing. He can cure all manner of diseases, especially ignorance, the most fundamental illness and the source of all suffering. While Yakushi is concerned with real human problems of sickness, pain, famine, and longevity, ultimately his teaching of the dharma is the best medicine.

He is lord of the eastern paradise and holds a medicine jar in his hands, vowing to eradicate pain and distress. His seed character and mantra are also effective medicines.

Mantra: OṂ HURUHURU CAṆḌALI MĀTAṄGI SVĀHĀ
(OṂ HURUHURU CAṆḌĀLĪ MĀTAṄGĪ SVĀHĀ)

KANZEON BOSATSU

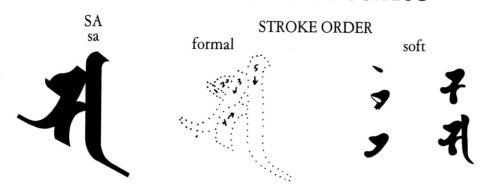

SA
sa

STROKE ORDER

formal

soft

MANTRA

om
a
ro
ri
kya
sowa
ka

Kanzeon Bosatsu (Avalokiteśvara Bodhisattva). The Fearless Bodhisattva of Great Compassion. As this Bodhisattva was about to enter nirvāṇa, there was a great cry of lament from all beings, so Avalokiteśvara thereupon renounced final release until all others entered. Avalokiteśvara will save anyone who asks for help and is the supreme master of skillful means who can assume any form—Buddha, king, monk, householder, woman, son, daughter—to bring people to salvation. Avalokiteśvara is perfect freedom and is thus portrayed in both male and female forms. He/she is not bound in any way.

Avalokiteśvara is represented in various ways and therefore has several kinds of seed characters which are shown below.

Mantra: OṂ ĀROLIK SVĀHĀ

55. Ornamental variations of the letter SA.

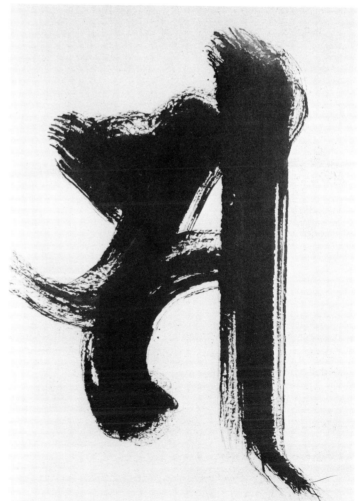

56.
Brush style SA.

SEISHI BOSATSU

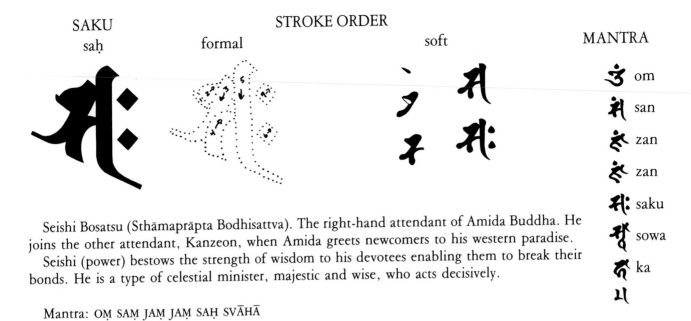

SAKU	STROKE ORDER		MANTRA
saḥ	formal	soft	

MANTRA (right column, top to bottom):
om
san
zan
zan
saku
sowa
ka

Seishi Bosatsu (Sthāmaprāpta Bodhisattva). The right-hand attendant of Amida Buddha. He joins the other attendant, Kanzeon, when Amida greets newcomers to his western paradise.

Seishi (power) bestows the strength of wisdom to his devotees enabling them to break their bonds. He is a type of celestial minister, majestic and wise, who acts decisively.

Mantra: OṂ SAṂ JAṂ JAṂ SAḤ SVĀHĀ

AMIDA NYORAI

KIRĪKU	STROKE ORDER		MANTRA
hrīḥ	formal	soft	

MANTRA (right column, top to bottom):
om
a
miri
ta
tei
zei
ka
ra
un

Amida Nyorai (Amitābha Tathāgata). Buddha of Infinite Light and Life, and lord of the western paradise. This Buddha vowed to bring anyone who invoked his name with a sincere heart to his Pure Land.

Amida's merit is so great he can transfer it freely to weak and foolish people who have no other hope of salvation. He is our great friend who will never abandon us.

The seed character of Amida is found everywhere; it is a single-letter *nembutsu*, ''Hail to Amida Buddha.'' It is the most propitious sign possible and ensures good luck.

Mantra: OṂ AMṚTA TEJEHARA HŪṂ

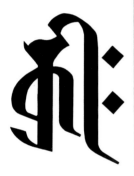

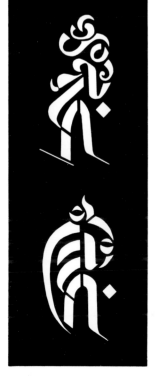

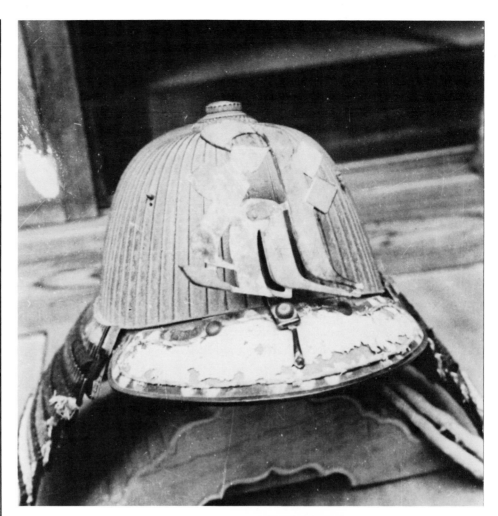

58. HRĪḤ on samurai's helmet.

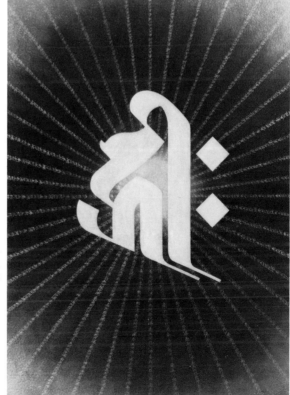

59. The beams radiating
from HRĪḤ are formed
of the Chinese characters
namu amida butsu.

57.
Ornamental variations
of the letter HRĪḤ.

ASHUKU NYORAI

UN
hūṃ

STROKE ORDER

formal soft

Note: The last stroke is often omitted in the soft character.

MANTRA

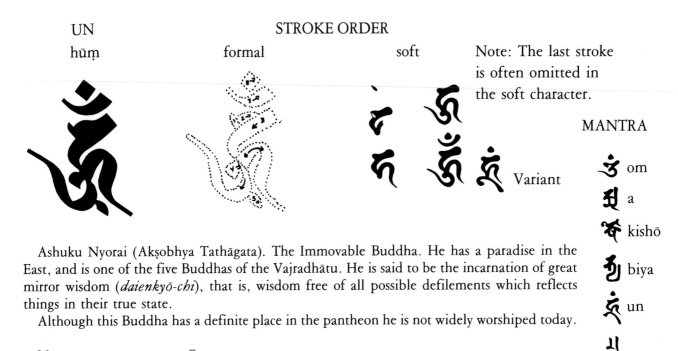

Variant

om
a
kishō
biya
un

Ashuku Nyorai (Akṣobhya Tathāgata). The Immovable Buddha. He has a paradise in the East, and is one of the five Buddhas of the Vajradhātu. He is said to be the incarnation of great mirror wisdom (*daienkyō-chi*), that is, wisdom free of all possible defilements which reflects things in their true state.

Although this Buddha has a definite place in the pantheon he is not widely worshiped today.

Mantra: OṂ AKṢOBHYA HŪṂ

DAINICHI NYORAI
(Vajradhātu)

BAN
vaṃ

STROKE ORDER

formal soft

MANTRA

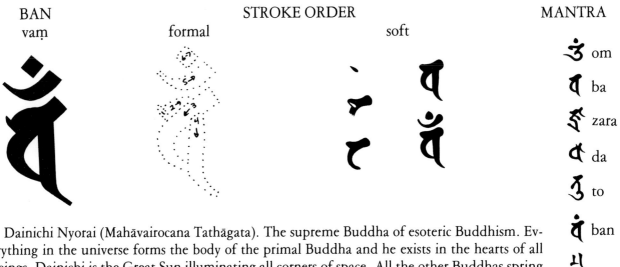

om
ba
zara
da
to
ban

Dainichi Nyorai (Mahāvairocana Tathāgata). The supreme Buddha of esoteric Buddhism. Everything in the universe forms the body of the primal Buddha and he exists in the hearts of all beings. Dainichi is the Great Sun illuminating all corners of space. All the other Buddhas spring from his immense energy.

Dainichi has two spheres of action: the Diamond Realm (Vajradhātu), indestructible, spiritual, unified, centered on prajñā; and the Womb Realm (Garbhadhātu), material, dynamic, fertile, all inclusive. The Diamond aspect is shown here.

Mantra: OṂ VAJRADHĀTU VAṂ

Formal

Brush

60. AṂḤ, seed syllable of Dainichi in the Womb Realm. Formal and brush styles.

61. The Dainichi mantra A VI RA HŪṂ KHAṂ (read from the bottom) in the shape of a stūpa.

DAINICHI NYORAI (Garbhadhātu)

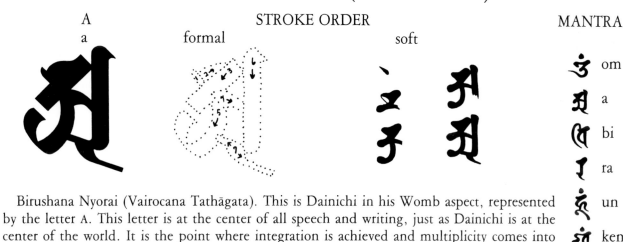

A a	STROKE ORDER		MANTRA
	formal	soft	

om
a
bi
ra
un
ken

Birushana Nyorai (Vairocana Tathāgata). This is Dainichi in his Womb aspect, represented by the letter A. This letter is at the center of all speech and writing, just as Dainichi is at the center of the world. It is the point where integration is achieved and multiplicity comes into form.

The Great Buddha in Nara is an image of Vairocana.

Mantra: OṂ AVIRA HŪṂ KHAṂ

62. Variation of VĀMḤ, Dainichi of the Diamond Realm.

63. Ornate display of the seed syllable VĀMḤ.

64. Seed syllables of the other Buddhas exploding from VĀMḤ.

KOKUZŌ BOSATSU

STROKE ORDER

formal soft

MANTRA

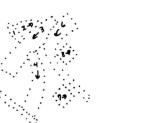

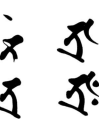

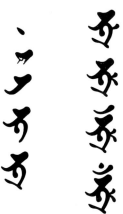
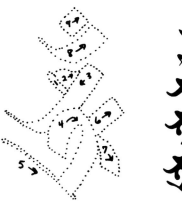

om
ba
zara
ara
tanno
om
taraku
sowa
ka

Kokuzō Bosatsu (Ākāśagarbha Bodhisattva). The Bodhisattva of Space, so called because his wisdom and benevolence is as vast as space itself. Worship of this Bodhisattva is not very widespread but he is a favorite of certain mystics since his mantras are considered very powerful and are transmitted secretly.

Kūkai, the founder of Shingon in Japan, regarded Kokuzō as his special protector.

Mantra: OM VAJRA-RATNA OM TRĀḤ SVĀHĀ

Boron (BHRŪM), the seed syllable of Ichiji-kinrin (Ekākṣara-uṣṇīṣa-cakra), combines elements of all the thirteen Buddhas and is sometimes used to represent them in one letter.

Ichiji-kinrin is the supreme Buddha that resides in the uṣṇīṣa, the distinguishing lump of flesh on the crown of an enlightened one.

Seed Syllables of the
Heart Sūtra

The *Heart Sūtra* can be condensed into a single syllable. The top letter is the seed syllable of prajñā and the bottom is DHIḤ + MMA, which stands for Monju, the Bodhisattva of prajñā. On the left is the famous mantra of the *Heart Sūtra*, which is in Sanskrit: GATE GATE PĀRAGATE PĀRASAMGATE BODHI SVĀHĀ!

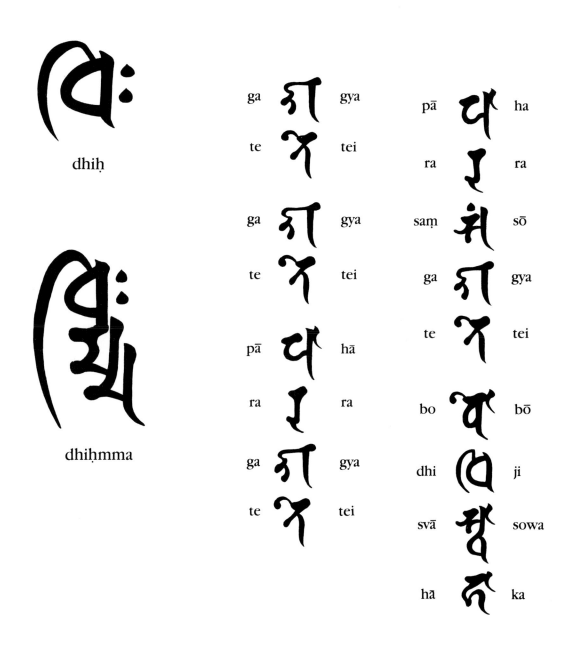

dhiḥ

dhiḥmma

ga		gya	pā		ha	
te		tei	ra		ra	
ga		gya	saṃ		sō	
te		tei	ga		gya	
pā		hā	te		tei	
ra		ra	bo		bō	
ga		gya	dhi		ji	
te		tei	svā		sowa	
			hā		ka	

Sanzon: The Three Honored Ones

DAINICHI SANZON

DAINICHI
vaṃ

AIZEN MYŌŌ	FUDŌ MYŌŌ
hūṃ	hāṃ

AMIDA SANZON

AMIDA
hrīḥ

SEISHI	KANNON
saḥ	sa

NYORAI SANZON

DAINICHI
āṃḥ

AMIDA	ASHUKU
hrīḥ	hūṃ

SHAKA SANZON

SHAKA
bhaḥ

FUGEN	MONJU
aṃ	maṃ

SHAKA SANZON

YAKUSHI SANZON

YAKUSHI
bhai

AMIDA	SHAKA
hrīḥ	bhaḥ

KANNON SANZON

KANNON
sa

JIZŌ	FUDŌ MYŌŌ
ha	hāṃ

FUDŌ SANZON

FUDŌ
hāṃmāṃ

SEITAKA	KONGARA
ṭū	tra

A Buddha or Bodhisattva is often shown together with two attendants. The attendants complement the principle symbolized in the central figure. For example, Amida's attendants Seishi (strength) and Kannon (skillful means) are the two vehicles that bring their master's unlimited compassion to sentient beings.

Siddhaṃ Maṇḍalas

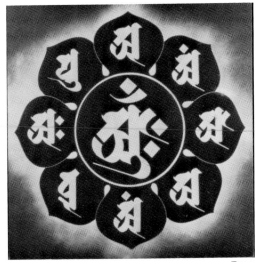

THE EIGHT DEITIES OF THE GARBHADHĀTU

HŌDŌ NYORAI

MIROKU BOSATSU a FUGEN BOSATSU
yu aṃ

TENKURAION NYORAI DAINICHI NYORAI KAIFUKE NYORAI
aḥ āṃḥ ā

KANNON BOSATSU MONJU BOSATSU
bu MURYŌJŪ NYORAI a
aṃ

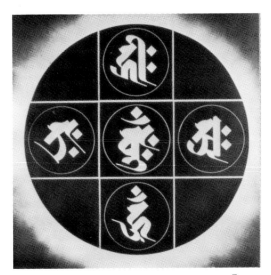

AMIDA MAṆḌALA

je
6

te ha
5 7

ta oṃ ra
4 1 8

mṛ hūṃ
3 a 9
2

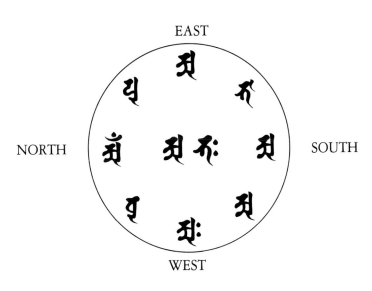

EAST

NORTH SOUTH

WEST

HOKKE (Lotus Sūtra) MAṆḌALA

MONJU

MIROKU a YAKUO
yu bhā

FUGEN TAHŌ NYORAI SHAKA NYORAI MYŌŌN
aṃ a bhaḥ a

KANNON JŌFUKYO
bu a
MUJINNI
aḥ

THE FIVE BUDDHAS OF THE VAJRADHĀTU

AMIDA
hrīḥ

HŌSHŌ DAINICHI FUKŪJŌJU
trāḥ vāṃḥ aḥ

ASHUKU
hūṃ

Amida (Amitābha) Maṇḍala

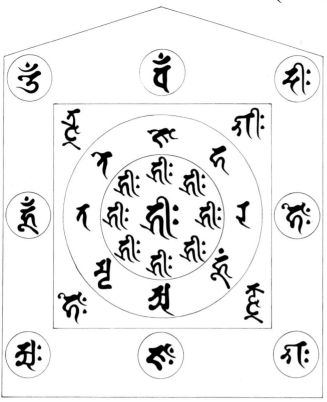

The twelve Bodhisattvas surrounding the center seed syllables and mantra of Amida are all from the Diamond World (Vajradhātu): four female pūjā Bodhisattvas of the interior, four of the exterior, and four *saṃgraha* (virtue-embracing) Bodhisattvas. The last two groups are the eight pillar Bodhisattvas who support the maṇḍala. The nine seed syllables of Amida fill the universe as the mantra revolves ceaselessly. The center image may be replaced by a different seed character or image to form a new maṇḍala.

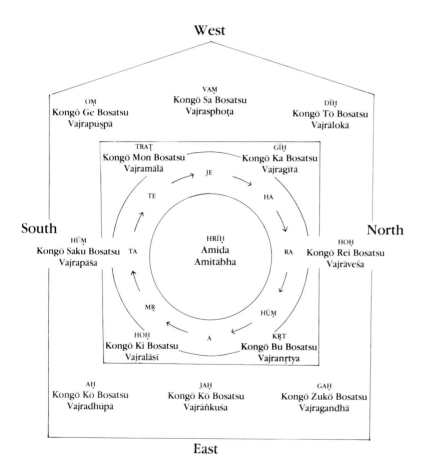

Fudō Myōō Maṇḍala

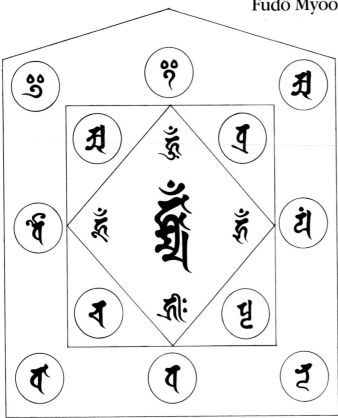

The Five Great Vajra Kings are in the center; the twelve guardians from India protect, respectively, the eight directions, the zenith and nadir, and the sun and the moon.

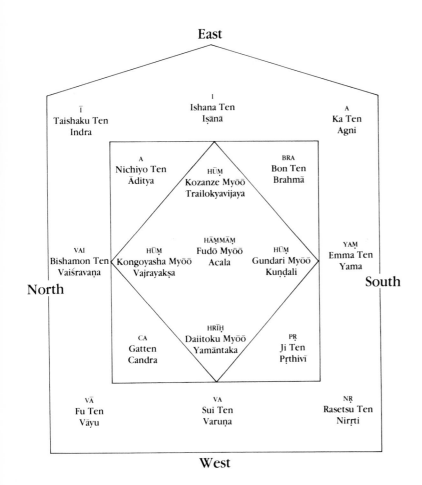

East

Ī	I	A
Taishaku Ten	Ishana Ten	Ka Ten
Indra	Iṣānā	Agni

	A	BRA
	Nichiyo Ten	Bon Ten
	Āditya	Brahmā
	HŪṂ	
	Kozanze Myōō	
	Trailokyavijaya	

North

VAI	HŪṂ	HĀṂMĀṂ	HŪṂ	YAM
Bishamon Ten	Kongoyasha Myōō	Fudō Myōō	Gundari Myōō	Emma Ten
Vaiśravaṇa	Vajrayakṣa	Acala	Kuṇḍali	Yama

South

	CA	HRĪḤ	PṚ	
	Gatten	Daiitoku Myōō	Ji Ten	
	Candra	Yamāntaka	Pṛthivī	

VĀ	VA	NṚ
Fu Ten	Sui Ten	Rasetsu Ten
Vāyu	Varuṇa	Nirṛti

West

The Mantra of Light (Kōmyō Darani)

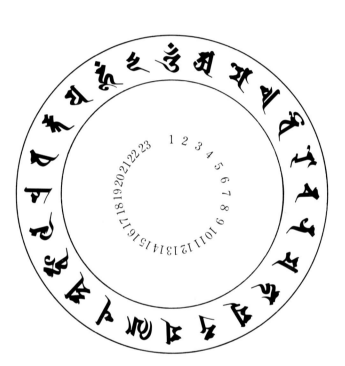

pra 19	ma 13	ca 7	oṃ 1				
va 20	ṇi 14	na 8	a 2				
rtta 21	pa 15	ma 9	mo 3				
ya 22	dma 16	hā 10	gha 4				
hūṃ 23	jva 17	mu 11	vai 5				
·	la 18	dra 12	ro 6				

OṂ AMOGHA VAIROCANA MAHĀMUDRA MAṆI PADMA JVALA PRAVARTTAYA HŪṂ. Transmitted to Japan by Kōbō Daishi, this mantra is said to be most effective if chanted daily, three, seven, or twenty-one times. Immediately after a person dies it is chanted one hundred times to insure rebirth in the western paradise. Its meaning is something like:

Infallible brilliance of the Great Mudrā!
Creating the radiance of the Jewel and the Lotus.

66. Siddhaṃ Maṇḍala of the Garbhadhātu.

65. Siddhaṃ Maṇḍala of the Vajradhātu.

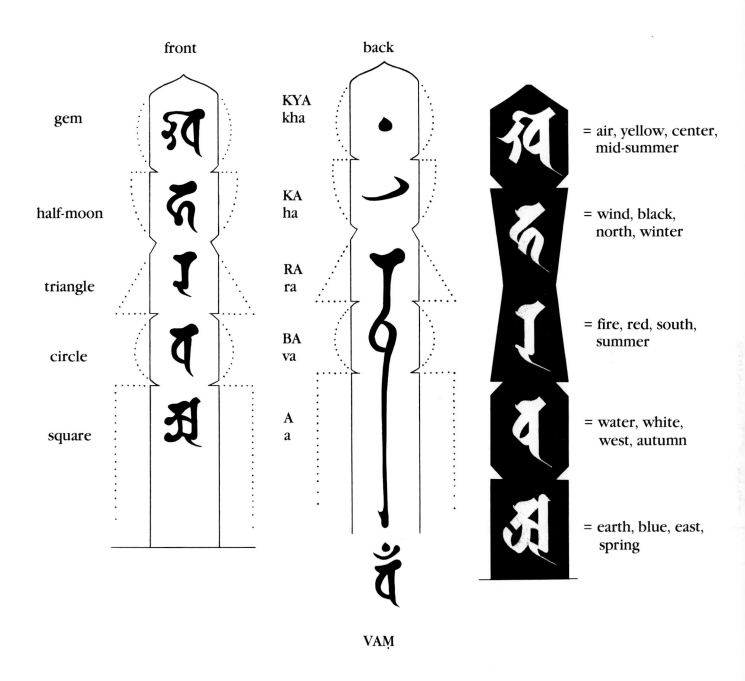

	front	back	
gem		KYA kha	= air, yellow, center, mid-summer
half-moon		KA ha	= wind, black, north, winter
triangle		RA ra	= fire, red, south, summer
circle		BA va	= water, white, west, autumn
square		A a	= earth, blue, east, spring

VAṂ

KYA-KA-RA-BA-A
Siddhaṃ on Tombstones

Tombstones made with five parts are called *Gorin-tō*. Each shape inscribed with a Siddhaṃ character symbolizes one of the five great elements; taken together they represent the phenomenal world in constant flux.

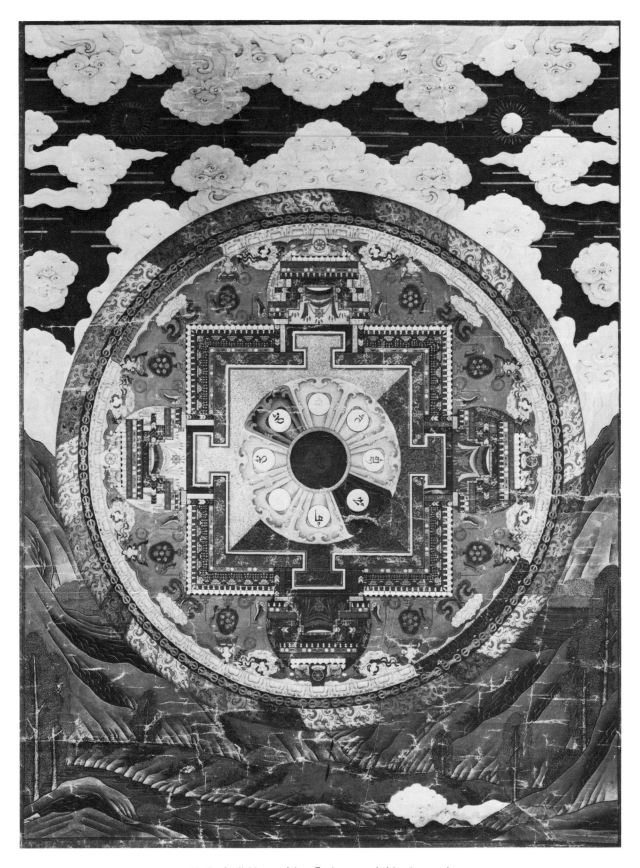

67. Seed syllable maṇḍala. HŪM is surrounded by the sacred
syllables BAM TAM GHAM SAM GAM ŚAM CAM CAM.

THE SACRED TIBETAN LETTERS

"Hail to the sacred vowels! Supreme salutations to the holy consonants!"

—PRAYER TO THE ALPHABET RECITED BY
STUDENT MONKS.

HISTORY

Although there is evidence of a lost Shang-Shung Pönpo (zhang-zhung; bon-po) script, it is generally believed that Tibet had no written language until King Songtsen Gampo (srong-btsan-sgam-po; 617–699) had an alphabet introduced in order to propagate Buddhism among his subjects. After being converted to the Buddhist teachings by his two wives, the king dispatched his chief minister, Thönmi Sambhoṭa (thon-mi-sambhoṭa), and sixteen other students to Kashmir in northwest India to study Sanskrit and Buddhist literature. Thönmi learned the Lentsa

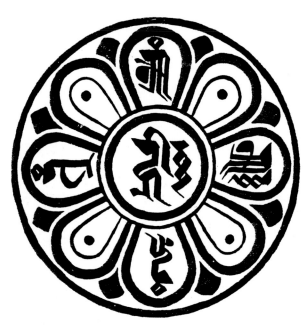

68. The seed syllable HRĪḤ surrounded by the syllables OM ĀḤ HŪM TRAM.

(lan-tsha; probably a corrupt term from an Indian language) and Wartula Gupta scripts from the master Devavidyāsiṃha. When he returned to his homeland, Thönmi devised a Tibetan alphabet consisting of thirty consonants, four vowels, and six extra letters for writing Sanskrit, in addition to composing the first grammar of the Tibetan language.

Translations from Sanskrit, Chinese, Khotanese, and other languages were soon made using the new alphabet, but they were done rather haphazardly. King Sena Legjing (sad-na-legs-'jing) set up a special commission comprised of both Indian and Tibetan scholar-monks to oversee all translations and standardize the terminology based on only the Sanskrit originals. Among the more noted members were the Indians Vimalamitra, Jinamitra, Dānaśīla, Śīlendrabodhi, Śāntigarbha, and Bodhimitra, and the Tibetans Vairocana, Kawa Paltsek (ska-ba-dpal-brtsegs), Yeshe De (ye-shes-sde), and Chökyi Gyaltsen (chos-kyis-rgyal-mtshan). Sena Legjing's successor, King Ralpachen (ral-pa-can; r. 817–836), actively supported the commission, hoping that their work would result in a uniform, grammatically sound Tibetan language.

Unfortunately, followers of the native Pön religion and their patrons among the nobles did not share Ralpachen's enthusiasm for the new teaching; they overthrew and executed him and attempted to suppress Buddhism. The Buddhists had the final word, however, when a hermit archer-monk (who explained his deed as an act of compassion to prevent the king from committing

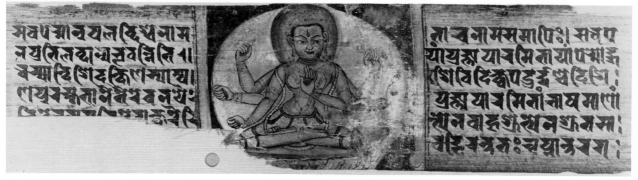

69. Tāla leaf manuscript of the *Aṣṭasāhasrikā-prajñāpāramitā-sūtra* in a variant of Siddhaṃ script. India/Nepal c. 1140.

even more sins and thus burning longer in hell) expertly shot an arrow through the heart of the tyrant Langdarma (glang-dar-ma) in 842. Thereafter Tibetan Buddhism was never seriously challenged again until the twentieth century.

Education in the monastic schools often followed the pattern established in India. Young novices were taught the letters of the alphabet in the form of a chant to be recited and meditated on at the beginning of each lesson. The letters were visualized in a scheme similar to that of the Garland of Letters, with the vowels and consonants being repeated orally three times. Calligraphy was an important part of the curriculum; an Indian reed pen was used and each monk was expected to make his own. At first the students outline the letters without ink on a wooden board covered with chalk dust; later they use ink, and after about eight months or so they are permitted to use paper. Especially talented monks were assigned to the copying of various texts, and it was common for them to write abstracts from the sūtras and tantras in silver or gold ink on ornate cardboard varnished with black lacquer for display in the temple.

The earliest manuscripts were written on special fibrous paper or birch bark in long narrow sheets. The paper was often primed with a dark color and the text written in gold or silver ink with red ink for display. The gold and silver inks were made by pulverizing lumps of metal and mixing them with glue. Unlike Indian texts, which were strung together, the pages of completed manuscripts were placed loosely on top of each other and then bound with red ribbon and engraved wooden covers, wrapped in silk, and kept in spacious libraries.

Gradually, variants of the original script developed into the following styles:

Uchen (dbu-can), book script for Buddhist texts, often carved in wood for printing

Ume (dbu-med), cursive hand script for texts and general use

Bamyik ('bam-yig), decorative script for official documents

Drutsa ('bru-tsha), decorative script for official documents and title pages of books—especially those written in Ume.

Lentsa, special type of script based on the ancient Gupta writing, used for seed syllables and titles of texts

Chuyik ('khyug-yig, "quick writing"), fast hand script for notes, letters, and general use

70. This manuscript page from the *Trashi tsekpe do* (*bkra-shis-brtsegs-pa'i-mdo*) is written in gold, silver, and black ink on a blue background. Uchen script.

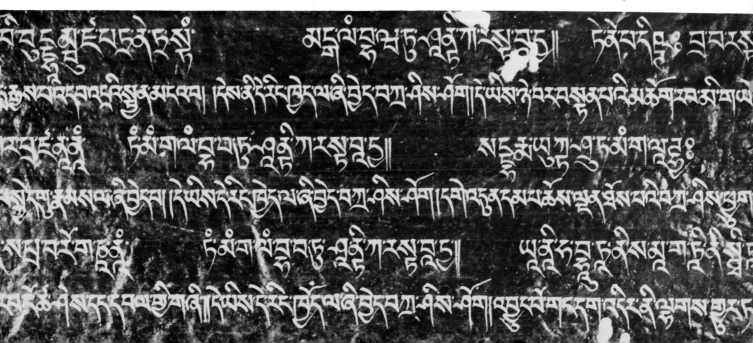

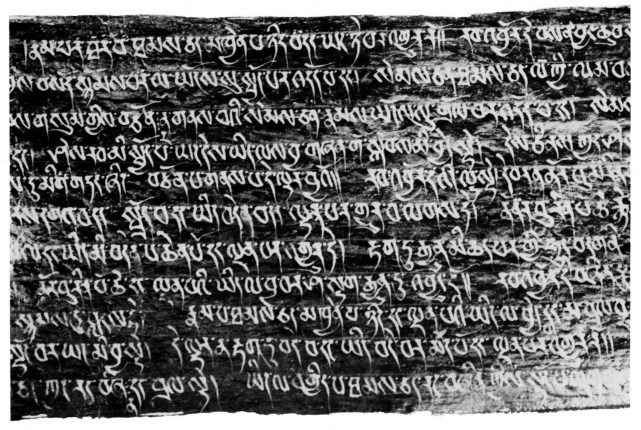

71. Silver ink on black lacquered paper. A combination of Uchen and Ume scripts.

Tibetan calligraphy was used to its best advantage on wooden printing blocks. Early on, the arts of writing, carving, and printing merged so that Tibetan script is perhaps the only one of the East that is as beautiful printed as it is written. Each page of a manuscript was carefully carved in negative on heavy wooden blocks about 75 cm long and 25 cm wide. The blocks were inked and paper was pressed against them with a large roller. Calligraphy, written or printed, transformed Tibetan culture. It helped shape the language by allowing it to be written down and analyzed; it promoted the translation of Buddhist texts and the creation of Tibetan literature; and in the form of sacred inscriptions it decorated the country.

72. Printed Prajñāpāramitā text in Uchen script.

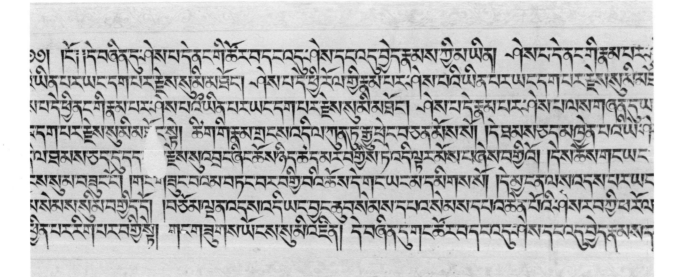

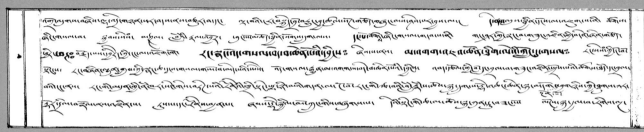

73. Sample manuscript pages from a text of feast songs with commentary. The title page (top) is written in Drutsa script, the text in Ume.

74a. Manuscript page from a text on chö (chod) practice with commentary. The root text (larger script) is written in Ume, the commentary in Tsukmachuk script.

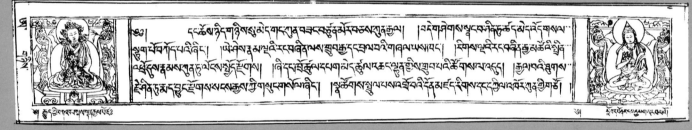

74b. A typical example of a modern woodblock print, excerpted from a commentary on the *Guhyagarbhatantra*, printed in Uchen script.

75a. Manuscript page from a *Supplication to the Khyentse Rinpoche Lineage*, written in a style of Ume originated by Vairocana the Translator.

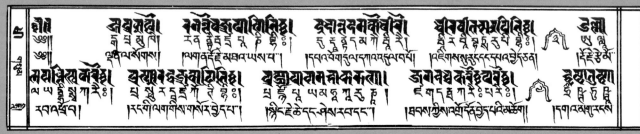

75b. Page from a woodblock print of the *Mañjuśrīnāmasaṅgīti*. The entire text is printed in Lentsa and Uchen (in Sanskrit) with the Tibetan translation in Uchen below.

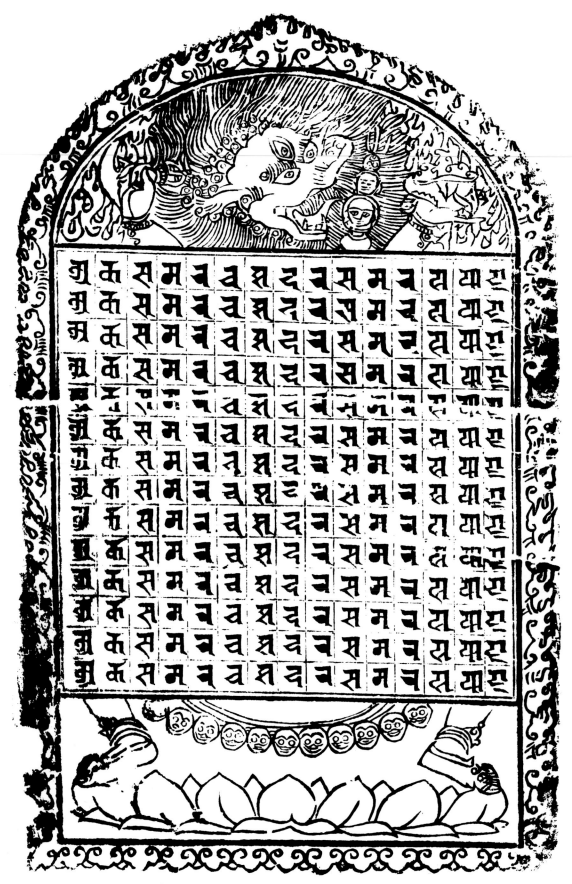

76. The mantra and depiction of Siṃhamukhā—a type of yantra used to protect against demons.

THE SACRED TIBETAN LETTERS

The Tibetans imported many practical matters—government organization, social standards, ink and paper—from China but looked toward India for spiritual guidance and adopted that nation's holy script. They learned that every letter is a sacred symbol, yet understood that each people must recreate the symbols and sounds in their own idiom.

Thus the pronunciation of mantras by Tibetans differed radically from the sound of brāhmaṇic Sanskrit. Mantras were not translated into Tibetan; they were left in their original Sanskrit. However, owing to the Tibetan system of orthographic transliteration of Sanskrit, the peculiarities of Tibetan pronunciation, and the enormous fundamental differences between the two languages the pronunciation of mantras assumed a unique form. The Tibetans themselves acknowledge this by referring to their pronunciation of Sanskrit as *sur chak ki dra* (zur-chag-gi-sgra)—having a corrupt sound.

A written mantra or seed character is as potent as a spoken one. The most potent of all is the mantra OM MAṆI PADME HŪM, composed of the six syllables OM MA ṆI PAD ME HŪM. The explanation of this mantra could require a book in itself (a fine one is *Foundations of Tibetan Mysticism* by Lama Anagarika Govinda), but in essence it represents the breakthrough (OM) of seeing the absolute (MAṆI, jewel) in the relative (PADME, lotus) beyond time, space, and individuality (HŪM). Each of the six syllables is said to have the ability of cutting the gate for birth into each of the six realms of existence: gods, human beings, fighting demons, beasts, hungry ghosts, and hell. This mantra is regarded as the epitome of Buddhist teachings and should be practiced especially by those who do not have the ability to study Buddhism in great depth.

This mantra of liberation was written, carried, or printed everywhere—on rocks and on prayer flags. It was printed thousands, sometimes millions, of times on coils of paper and placed inside prayer wheels. Besides this mantra, other mantras and seed syllables were used in an incredible

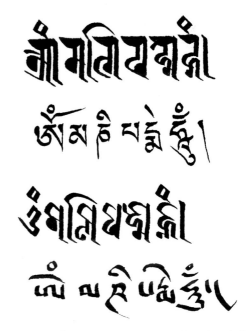

77. The sacred mantra OM MAṆI PADME HŪM written in Lentsa, Uchen, Drutsa, and Ume.

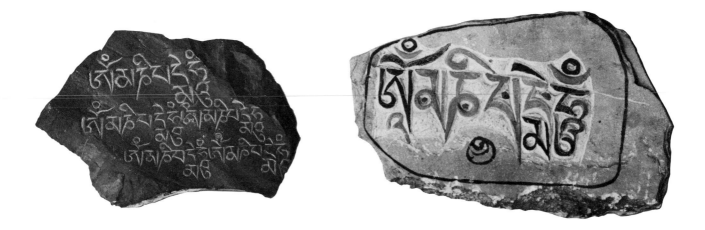

78. "Maṇi stones," inscribed with the mantra OM MAṆI PADME HŪM were placed so that one would always pass them on the right.

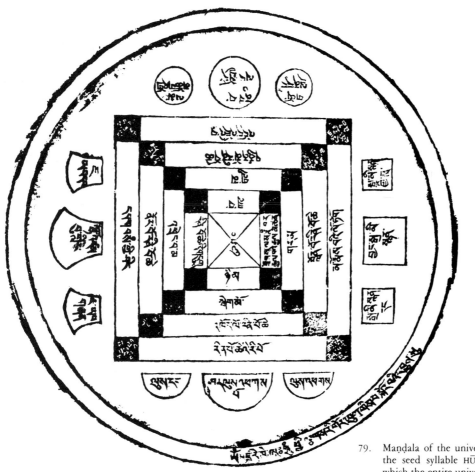

79. Maṇḍala of the universe. Within the central square is the seed syllable HŪM, symbolizing emptiness, from which the entire universe arises. The rest of the diagram depicts the four continents and their subcontinents as well as various other components of the world. This is a simplified representation of some of the major elements of Indian and Tibetan cosmology. N. E. Nepal.

80.

A woodblock print. The name LAKṢMI, the goddess of prosperity is written on the top in Lentsa script. Below this on the right is the Chinese character *fu*, prosperity, and on the left the Chinese character *shou*, longevity. The inscription at the bottom explains that these three words are the auspicious letters of India and China. On the top left and right are the eight auspicious substances; between the Chinese characters are the eight auspicious symbols; and below are the three combination animals—fish head with otter body, crocodile head with conch body, and garuḍa head with lion body—which bring victory over disharmony and discord.

number of ways. Most paintings were inscribed on the reverse side with the seed syllables of the deity portrayed on the front; the painting was not considered consecrated until this was done. Charms for success and amulets for protection against every possible calamity—illness, stillbirth, fire, thieves, wild animals, demons, insanity—contained the appropriate mantra and seed syllables. Mystical monograms were prominently displayed in towns, monasteries, and mountain passes.

Reverence for the written or printed Buddhist teachings, sometimes even words in general, was so great that no Tibetan would ever wantonly destroy a piece of paper with letters on it. Unneeded documents were carefully placed in caves and left to their natural dissolution while special reliquaries were provided for worn texts, fragments of sacred books and manuscripts, or other important pieces of paper. The letters were as divine as the Buddhas and Bodhisattvas themselves.

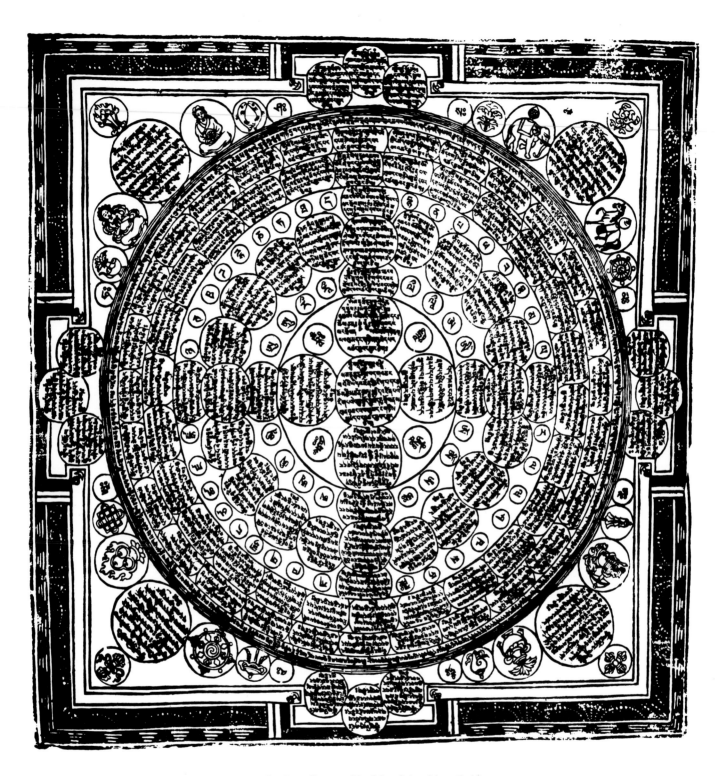

81. The Great Treasury Maṇḍala of Auspicious Emblems
and Syllables, printed in red. Sikkim, India.

82. Iron pen case, wooden pens, copper ink pot, iron seals and wax. The heavy iron pen cases were suspended from the monks' belts; the cases became convenient and effective weapons during disturbances.

TIBETAN CALLIGRAPHY MANUAL

Traditionally Tibetan calligraphers used a handmade reed pen that slid over the rough Tibetan paper more easily than a brush or steel pen. These days, however, Tibetan calligraphy is done with all three instruments. The proper way to hold the pen is with the thumb and index fingers. The middle and ring fingers are drawn up into a fist and the little finger is extended, forming a surface for the hand to rest on as well as providing greater stability. The thick and thin parts of the letters are made by twisting the pen with the thumb and index fingers. When using a steel italic pen, please note that Uchen script utilizes a left-handed pen while Ume requires a right-handed one.

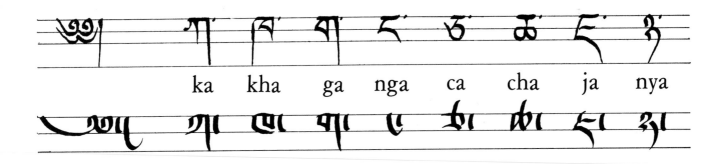

ka kha ga nga ca cha ja nya

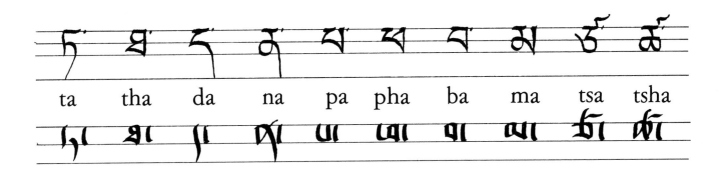

ta tha da na pa pha ba ma tsa tsha

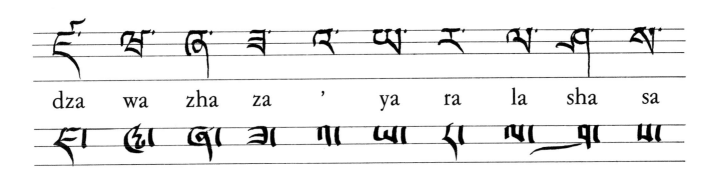

dza wa zha za ' ya ra la sha sa

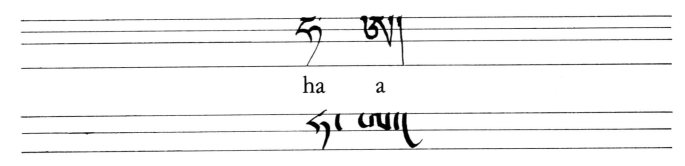

ha a

83. The proper proportions for Uchen script (above) and Ume script (below).

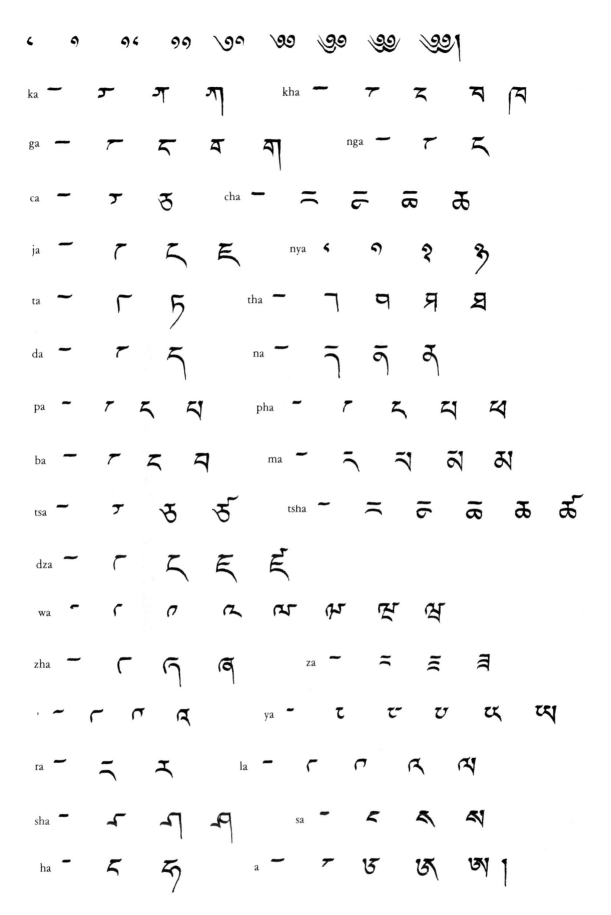

84a. Stroke order of Uchen.

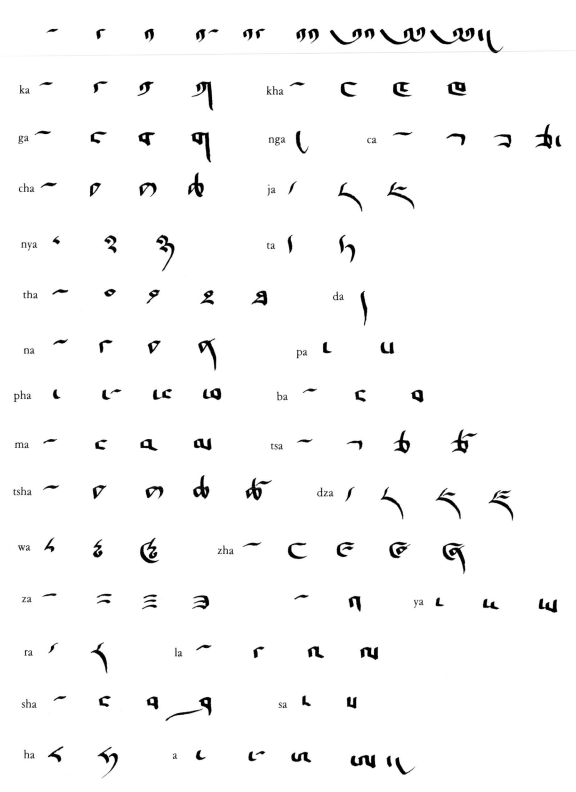

84b. Stroke order of Ume.

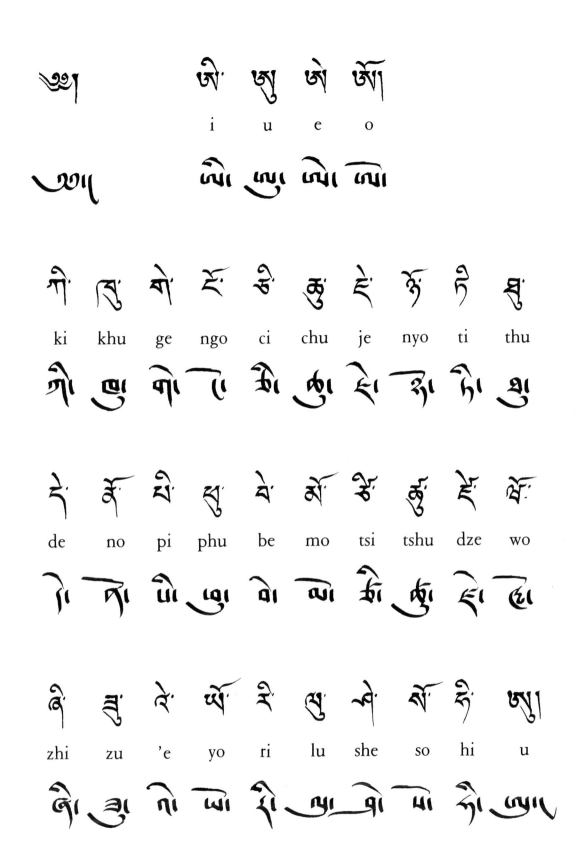

i u e o

ki khu ge ngo ci chu je nyo ti thu

de no pi phu be mo tsi tshu dze wo

zhi zu 'e yo ri lu she so hi u

85a. The Uchen and Ume consonants with vowels.

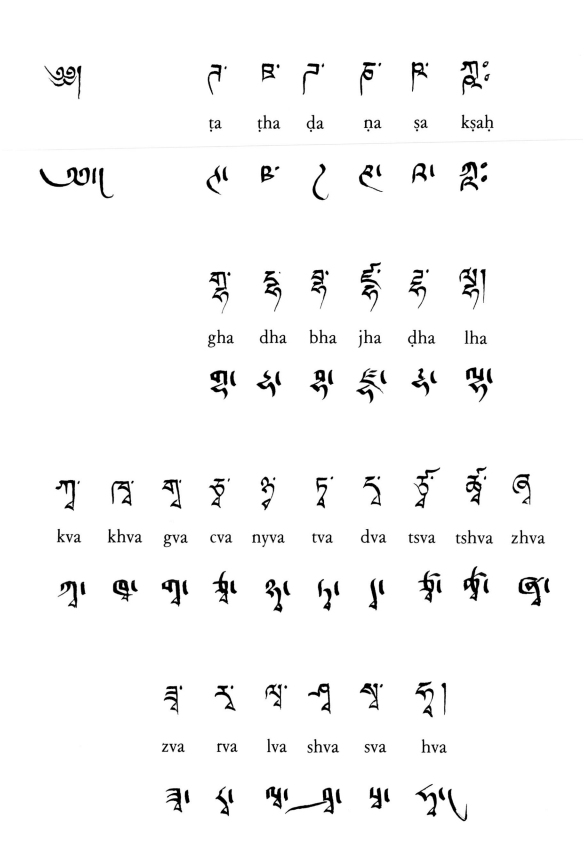

	ṭa	ṭha	ḍa	ṇa	ṣa	kṣaḥ

gha	dha	bha	jha	ḍha	lha

kva	khva	gva	cva	nyva	tva	dva	tsva	tshva	zhva

zva	rva	lva	shva	sva	hva

85b. Uchen and Ume letters used in transliterating Sanskrit (top four lines) and consonants with wazur conjunct.

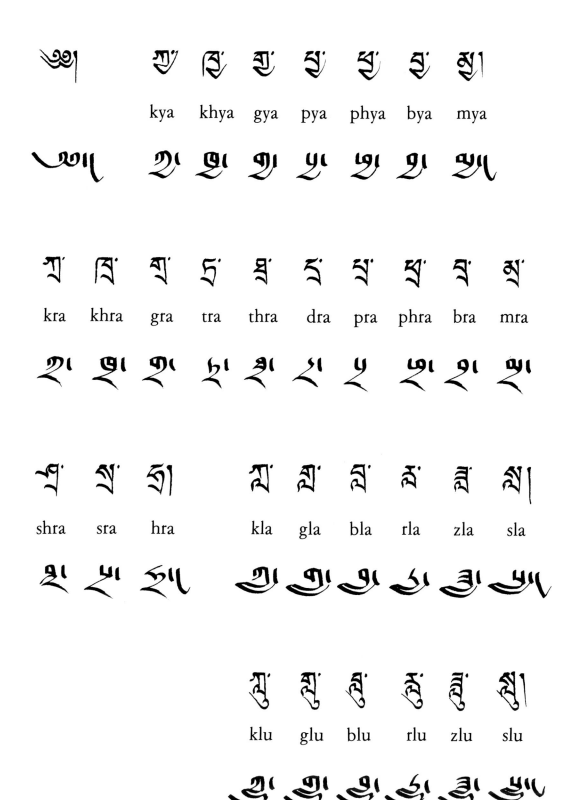

kya khya gya pya phya bya mya

kra khra gra tra thra dra pra phra bra mra

shra sra hra kla gla bla rla zla sla

klu glu blu rlu zlu slu

85c. Uchen and Ume subjoined letters: *yata* (*ya-btags*; "ya
subjoined"), *rata* (*ra-btags*), *lata* (*la-btags*), and *lata*
with vowel "u".

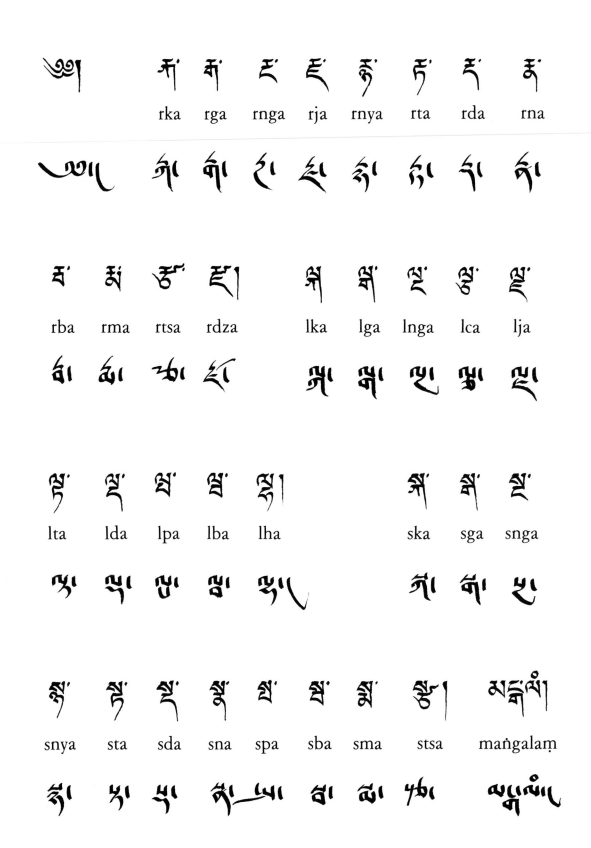

	rka	rga	rnga	rja	rnya	rta	rda	rna

	rba	rma	rtsa	rdza		lka	lga	lnga	lca	lja

	lta	lda	lpa	lba	lha		ska	sga	snga

snya	sta	sda	sna	spa	sba	sma	stsa	maṅgalaṃ

85d. Uchen and Ume with head letters: *rago* (*ra-mgo*; ''ra on the head''), *lago* (*la-mgo*), and *sago* (*sa-mgo*). The concluding word ''maṅgalaṃ'' means ''May this be auspicious.''

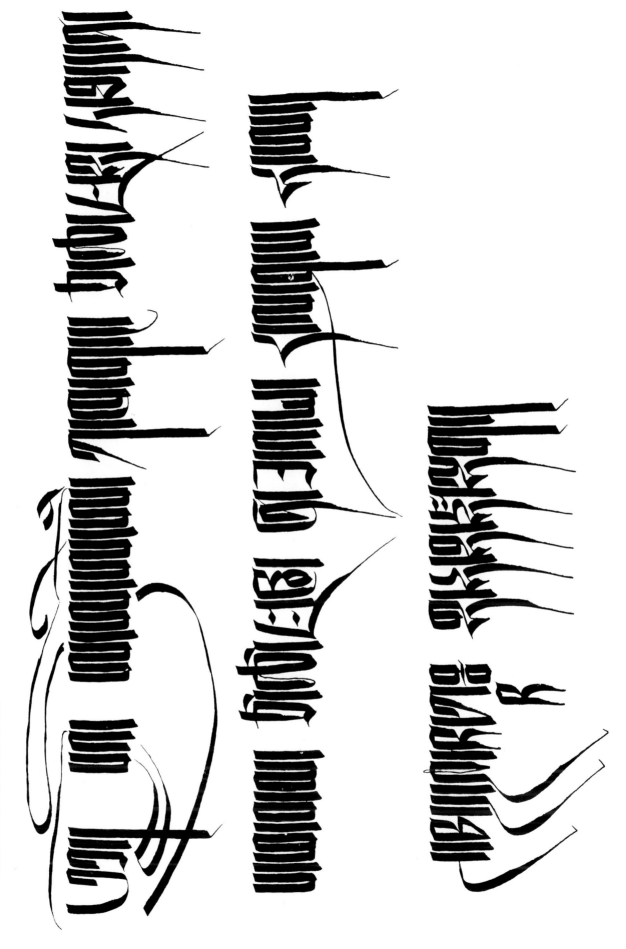

86a. The following three illustrations provide an excellent example of Bamyik script, also known as *Tsukchen* (*tsugs-chen*), a well-known variant of Ume. This script is primarily used for teaching those who are beginning to learn the art of writing in Tibetan. It is also used decoratively. This page includes the four vowels, the consonants, and the special consonants used to transliterate Sanskrit.

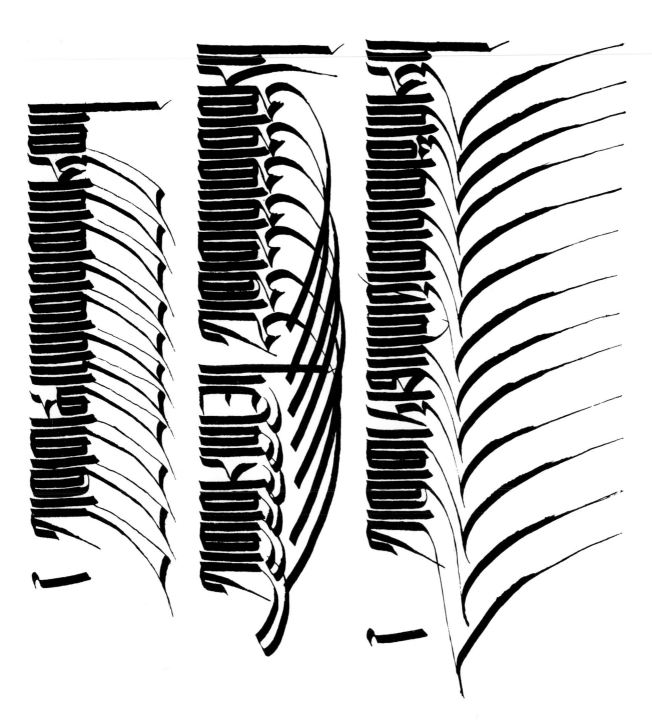

86b. Bamyik subjoined letters: yata, lata, yata with vowel "u," and rata.

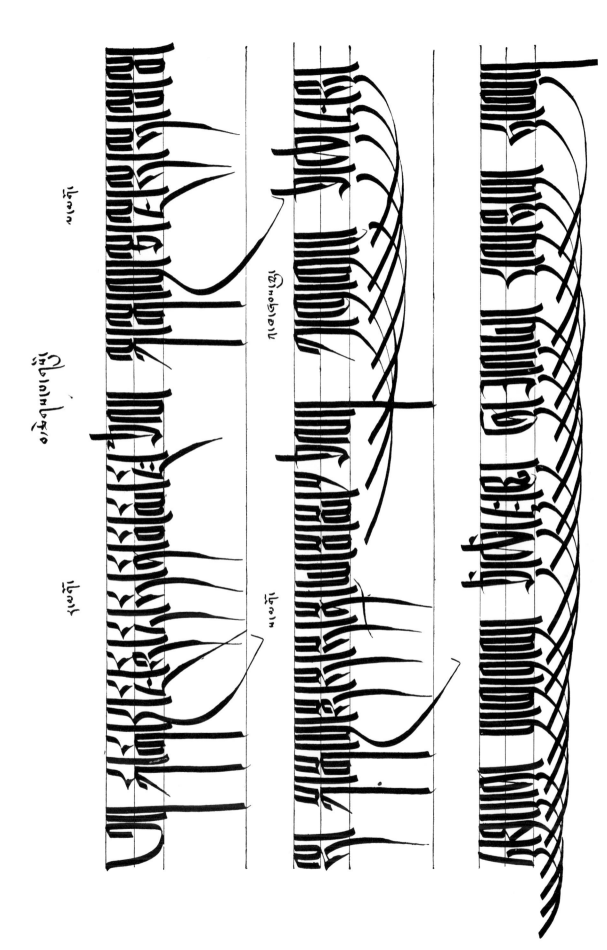

86c. Bamyik head letters: rago, lago, sago; and then the consonants with the vowel "u".

87. These four examples of scripts are a progressive shorten-
 ing and abbreviating of Ume:

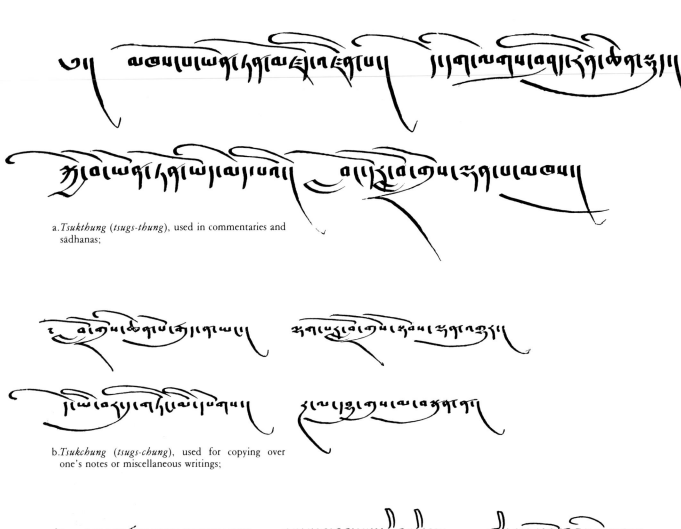

a. *Tsukthung* (*tsugs-thung*), used in commentaries and
 sādhanas;

b. *Tsukchung* (*tsugs-chung*), used for copying over
 one's notes or miscellaneous writings;

c. *Tsukmachuk* (*tsugs-ma-'khyug*), a combination of
 examples b. and d., not used much these days but in
 the past this script was used for writing to one's
 teachers or nobility. Also Tsukmachuk was used for
 quickly copying a text.

d. *Chuyik* (*'khyug-yig*), the most commonly used hand-
 writing script, utilized in personal letters and any
 type of notes.

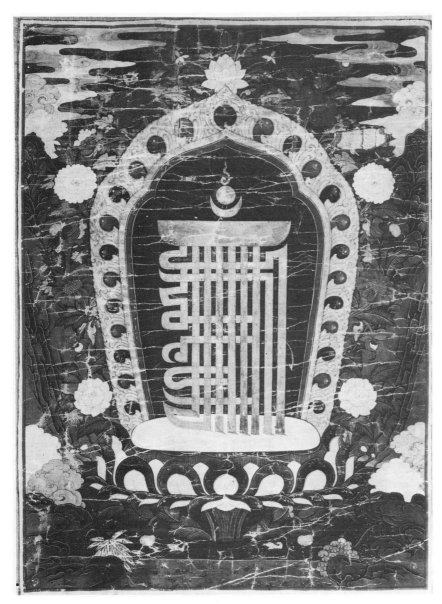

88. A thangka of the All-Powerful Ten.

89. A woodblock print of the Seven Letter monogram, N.E. Nepal.

Mystic Monograms

There are two kinds of well known monograms composed in Lentsa script: The Seven Letters, consisting of the consonants YA, RA, VA, LA, MA, KṢA, HA; and the All-Powerful Ten, the mantra of Kālacakra, consisting of the syllables OṂ, HA K-ṢA MA LA VA RA YA-Ṃ.

śata-kula-maṇḍala-abhimukhatā tattva-jñāna-māyā-nṛtyam saṃkrānti-vipariṇāma-niṣprapañca-dharmakāya vajradhṛg-vajra-ādi-prabhāsvara bhavataiveyaṃ mūrtiḥ sadā avasthiyatām sahaja ~ siddhayo diyatām

rigs brgya'i dkyil-'khor mngon du gyur-pa nyid de-kho-na yi ye-shes sgyu-mdi gar 'pho 'gyur spros-pa bral-ba'i chos-kyi-sku rdo-rje 'dzin-pa rdo-rje gdod-nas gsal khyod gcig rten 'dir rtag tu bzhugs-pa dang lhan-cig-skyes-pa'i dngos-grub stsol-bar mdzod

The hundred family mandala actualization Is the illusory dance of the wisdom of That, The dharmakāya which is free from the complexities of departing & changing, The vajra holder, vajra primordial brilliance, May you alone always remain in this representation; Please grant the coemergent siddhis.

oṃ āḥ hūṃ vajradhara samaya-tiṣṭha siddhi-vajra yathā sukham

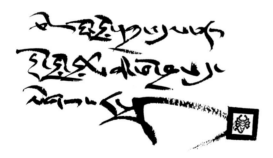

90. (Opposite page) An unusually elaborate thangka blessing, appearing on the back of a large thangka of Vajradhara. The three large syllables—OM, ĀH, HŪM—in Uchen script, bless the principles of body, speech, and mind respectively. Most thangkas are blessed with these three syllables alone, calligraphed by a lama. In this example, a verse of blessing is also calligraphed, composed by Chögyam Trungpa, Rinpoche (who calligraphed the OM, ĀH, HŪM). It appears in the following scripts and languages: Lentsa (Sanskrit), Uchen (Sanskrit), Uchen (Tibetan), Roman (Sanskrit), Roman (Tibetan), and Roman (English).

It is even more rare to bless a thangka with the hand and / or foot prints of an important incarnate lama. This thangka also received this blessing, performed by His Holiness the XVI Gyalwa Karmapa, head of the Kagyü sect of Tibetan Buddhism, who also placed his signature on the thangka.

91. An example of contemporary Tibetan calligraphy done by Chögyam Trungpa, Rinpoche. The large word in Uchen script is *drala* (*dgra-bla*), signifying the principle of transcending aggression. Beside this is a poem and brief colophon in Chuyik script. Trungpa Rinpoche's calligraphy is unique in its use of brush rather than the more traditional Tibetan usage of a pen.

92.
Shakyō of the *Lotus Sūtra*
(Saddharma-puṇḍarīka sūtra).
Śākyamuni and Prabhutaratna,
in the center of a large lotus,
are surrounded by various
Bodhisattvas, Arhats, and
patriarchs. The large characters at
the top read *"Hail to the Lotus
Sūtra of the Wonderful Law!"*
The text itself is written in small
Chinese characters. The complete
work has over 70,000 characters
and is 2.5 x 1.5 meters. This
splendid example of shakyō was
done in Vietnam during the years
1963–1964.

SHAKYŌ: SŪTRA COPYING

"After the passing away of the World-honored One we will go to all corners of the universe, unceasingly encouraging all beings to copy, read, and recite his sūtra."

—Lotus Sūtra

HISTORY

Transmission of the teaching of Buddha was primarily oral for the first five hundred years of Buddhist history. Even after the canon was committed to writing around 50 B.C. under the patronage of the Ceylonese king Viṭṭagāmiṇi, recitation from memory remained the preferred method of instruction in India and Southeast Asia. Not until Buddhism reached China, Japan, and Tibet did the written word assume equal authority to the spoken.

As noted previously, Indians were obsessed by the sound and structure of language while the Chinese were captivated by writing. The earliest Chinese characters, short oracular inscriptions on bones and shells, date from at least 1500 B.C. (compared to 300 B.C. for the Brāhmī script).

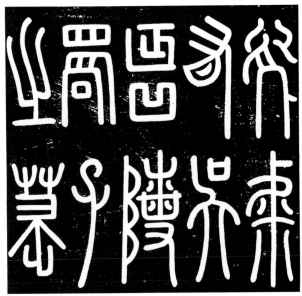

94. Ancient-style calligraphy attributed to Confucius (551–479) B.C.

Even in this ancient period, the writing system appears highly developed; about half of the three thousand characters discovered so far have been deciphered with many of them surviving more or less intact to the present day. From the beginning of Chinese civilization any event or idea that was thought to be of importance was recorded in writing. Thus, an impressive literature was quickly created.

During the reign of Shihuangdi (222–210 B.C.) the writing system was standardized. Within fifty years civil servants were chosen by means of a written examination based on their knowledge of the classics. Colleges were established to obtain, copy,

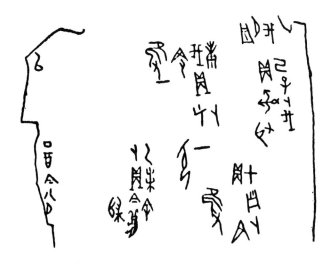

93. Oracle-bone characters; 14th century B.C.

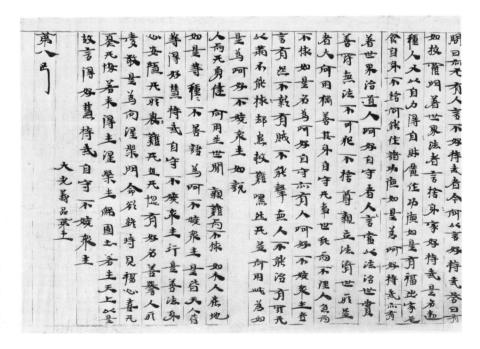

95. Tāla-leaf manuscript of the *Butchō Sonshō Darani* (*Uṣṇīṣa-vijaya-dhāraṇī*) and the *Heart Sūtra* in Siddhaṃ script; on the bottom of the upper leaf the Siddhaṃ alphabet is written; 6th century.

and interpret texts containing the teachings of Confucius, Mencius, and other eminent sages. Before long a national bibliography listing 677 works was made and civilization's first "objective" history was produced by Sima Qian. All this occurred well before the first century of the Christian era.

Improvement in the manufacture of brushes and ink, together with the invention of paper in the second century A.D. facilitated the development of writing into the art of calligraphy. Shihuangdi's minister, Li Si, is credited with codifying the ancient seal script and the other major styles—scribe's script (*li shu*), block script (*kai shu*), semi-cursive script (*xing shu*), and cursive script (*cao shu*)—were all established by A.D. 400.

Considering their devotion to written literature, it is not surprising that the Chinese eagerly obtained and translated Buddhist texts. An informal translation center was founded by An Shigao, a former prince of Parthia, upon his arrival in Loyang in A.D. 148. He concerned himself mostly with meditation manuals. In 167 he was joined by the Sythian Zhichan, whose specialty was the *Perfection of Wisdom* (*Prajñāpāramitā*) *Sūtras*.

96. A page of the Chinese translation of Nāgārjuna's *Mahāprajñā-paramitopadeśa*. The calligraphy is unusual in that it shows the transition from the stiffer older form to more fluid brushwork; 3rd–4th centuries.

The work done by this group is marred by many defects due to lack of knowledge of the languages involved. Translations by Dharmarakṣa and Zhi Qian made in the third century are better, but in their case literary style prevailed over substance. The inadequate number of translated works prompted a few intrepid Chinese monks to attempt the perilous journey to India to locate the missing texts. Faxian was the first to actually complete his quest and return to China. He was gone from 399–414 collecting sacred writings, but noted in his travel diary that the majority of Indian masters recited the sūtras from memory rather than relying on written texts.

The arrival of the illustrious missionary Kumārajīva in the capital city of Changan in 401 ushered in a new era of translation and sūtra copying. Translation bureaus staffed with as many as a thousand employees received support from the imperial court. Chinese monks continued to travel to India in order to improve their Sanskrit and gather more texts. Xuanzang and Yijing, who lived in India from 629–645 and 671–695 respectively, were the greatest of these pilgrim-translator monks.

Along the "Silk Road" of Northern China many sūtras were being copied in a variety of languages and scripts; texts in Khotonese, Uighur, Sogdian, and Tibetan, among others, were written in variations of Brāhmī, Kharoṣṭhī, and Aramaic scripts. In all, there were said to be Buddhist sūtras, Nestorian bibles, and Manichean scriptures in seventeen languages and twenty-four scripts. Sūtras were written on paper, birch bark, silk, and leather with wood, reed, quill, or bone pens (bamboo did not grow there).

The translation bureaus operated in the following manner. Senior scholar monks would verify the accuracy of the Sanskrit text, comparing different versions if necessary. Then the chief translator would supervise the recitation of the original text and the translation into Chinese, which was recorded by a scribe. The written Chinese translation was checked against the original by another specialist and then the polisher of style and proofreader made their corrections before a final copy was made by a calligrapher.

Clearly, the Chinese were conscientious about this work, but nonetheless there was disagreement

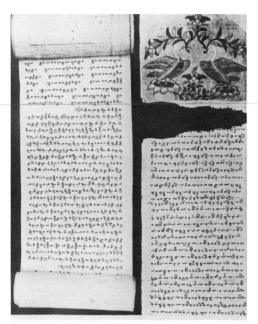

97a.

97b.

97c.

97. Shakyō from along the Silk Road, 4th–8th centuries: a. Khotanese; b. Uighur; c. Sogdian.

98. Eulogy and birthday congratulations in Chinese, Tibetan, Manchu, and Mongolian, sent by the Chinese emperor to the Panchen Lama; China, A.D. 1780.

over the style of translation. Those who favored strict adherence to the original complained that most translators were too loose with their interpretation, freely arranging the text and omitting what offended their taste. Others defended this approach saying that it was best to translate the gist of a sūtra in graceful literary language that would appeal to refined Chinese. Kumārajīva took the middle ground stating that a translation can never capture the flavor of the original nor is it desirable to do so; as long as the general meaning of a sūtra is faithfully preserved in an acceptable form the seed of the Buddhist teaching will be planted. Kumārajīva's views prevailed and thus, in contrast to the Tibetan translations which are almost word for word, the Chinese versions were "creative," allowing full development within the context of Chinese culture.

As soon as translations appeared the virtue of sūtra copying as a devotional practice was recognized—sūtra copying combined worship, literature, and calligraphy. Beginning with Emperor Daowu in 386 a long line of rulers issued imperial commands for special copying of all available sūtras, and several copied portions themselves. All of the eminent monks of the period encouraged their followers to write out the sūtras on which their teaching was based. For example, Zhikai (538–597), founder of the Tiantai school, instructed his disciples to copy the *Lotus Sūtra* while Shandao (613–681), first patriarch of the Pure Land sect, made more than ten thousand copies of the *Sukhāvatīvyūha Sūtra* (Amidakyō).

Sūtras were engraved on the sides of mountains, inside cave temples, and on large sūtra pillars that were erected at crossroads. Copies were made in gold and silver ink on the finest paper, enclosed in lacquer boxes, and stored in special buildings. (During this same period in Europe, Christian kings supported the establishment of scriptoriums in monasteries for copying the Bible. Many of the illuminated manuscripts were written in gold on stained purple vellum.)

99a. Sūtras in stone: The opening lines of the *Diamond Cutter Sūtra* engraved on Mt. Tai in China; each character is nearly two feet square. China, 6th century.

99b. Sūtras in stone: Rubbing of the *Diamond Cutter Sūtra*
engraved in a cave temple. This is part of an entire canon
engraved in stone over a thousand-year period. China,
6th–16th centuries. The Confucian and Taoist Classics
were also extensively carved in stone.

Sūtra copying was brought to the Korean penin-
sula perhaps as early as the third century but un-
fortunately no examples have survived. The oldest
extant copy dates from a comparatively late A.D.
754. However, the copies done in the eleventh to
thirteenth centuries are exceptionally fine, written
in gold and silver with exquisite illustrations.

In 552 the Paikche king, Syŏng Myŏng, dis-
patched a mission to meet with Emperor Kimmei
of Japan and request help in a campaign against
the government of Silla. Syŏng Myŏng did not get
any support but the Buddha images and sūtras he
presented as a gift were accepted with great in-
terest. Within fifty years the new religion was em-
braced by the ruling family.

Prince Regent Shōtoku (574–622), father of
Japanese Buddhism, knew the sūtras so well he
wrote commentaries on three of them. He sent
one of his ministers to China to import recently
translated texts. By 673 the entire canon was being
systematically copied by Japanese scribes. In 728 a
sūtra copying office (*shakyōsho*) was created in
Nara by imperial order. Following the establish-
ment of Kokubunji—prayer temples for the
welfare of the nation—in every province in 741,
the office was charged with providing each temple
with copies of the *Kankōmyō-Saishōō-kyō* and the
Hokke-kyō written in gold ink. Separate offices
were set up to copy other sūtras and commentaries
and many large temples also maintained their own
facilities for shakyō.

Scribes seeking employment at the Nara office
were required to pass a demanding test for ac-
curacy, style, and clarity. They were paid five *mon*
for one sheet; each sheet contained thirty seven-
teen-character lines; six to eight sheets a day was
average. Every sheet was checked by three dif-
ferent proofreaders. The scribes were fined one
mon for every mistaken or omitted character and if
they skipped a line the penalty was twenty mon.
The office also employed outliners, correctors, il-
lustrators, and mounters. Over a fifty-year period
the office produced sixteen complete sets of what
was then the entire canon—one set consisting of
1,716 volumes. Although the office was closed
down by the beginning of the Heian period (794),
shakyō continued to be commissioned by a succes-
sion of emperors, ministers, and feudal lords as
well as being done by individuals.

100. Frontispiece from Korean shakyō of the *Avataṃsaka Sūtra*. The text is in silver ink; wherever the characters for Buddha, Dharma, or Saṅgha occur they are written in gold. Dated 1291.

101. Shakyō of the *Kengu-kyō*, ordered by Emperor Shōmu (701–756), famous for establishing the shakyō bureau and supervising construction of the Great Buddha in Nara, c. A.D. 740.

姓居士種者令若貢之无錢肘
計便告吏臣卿往推覓本是豪
大任當嫁廖時王愁憂无餘方
惡當密遣人而護養之女年轉
人然是未利夫人所生此雖醜
之也所以者何此女雖醜承不似
內宮勤意守護勿令外人得見
如馬尾王觀此女无一喜心便勅
體麁麁澀猶如駏皮頭髮麁彊猶
晉言金剛其女面狼極為醜惡肌
人名曰摩利時生一女字波闍羅
給孤獨園尒時波斯匿王罕大夫
如是我聞一時佛在舍衛國祇樹
波斯匿王女金剛品第八

The purpose of the Nara office was to provide accurate copies of the sutras for study and religious services. However, as in China, the devotional aspects of shakyō soon were emphasized. Regardless of whether the meaning was understood or not, the act of writing (or having someone write) the sutras was in itself a meritorious deed. Sūtras were carved in wood, engraved on roof tiles, bronze utensils and bells, written on leaves and fans, and embroidered on silk. Small stones were sometimes gathered, each stone being inscribed with one character, and when an entire sūtra was completed the stones were buried. Sūtras were placed in special containers and installed in stone houses to await the coming of Maitreya Buddha, as a kind of "time capsule." Groups were formed to do shakyō—one person would do one chapter or one volume, or two people would alternate lines. On memorial days each member of a family would do a chapter or verse of a sūtra as an offering. Wives of the emperor busied themselves copying the *Lotus Sūtra* in red ink. A few sūtras were written in blood drawn from a pricked finger.

Nobles spent fortunes to acquire the finest Chinese and Japanese paper, gold and silver inks, and the best calligraphers and illustrators for their shakyō. Emperor Shirakawa commissioned a complete set of the sūtras in gold ink in 1103; seven more were done in the next hundred years.

102. Test calligraphy of a scribe seeking employment at the Nara shakyō bureau. He flunked.

103. Sūtras engraved on a tile (a.) and written on a stone (b.)

103b.

103a.

104. *Chūsonji-kyō.* The lines are written alternately in gold and silver.

Perhaps the finest of these are the Chūsonji-kyō commissioned by Fujiwara Kiyohira and finished in 1125 and the Ikutsujima Jinja Heike Nōkyō dedicated in 1164. In 1211 Emperor Toba summoned 13,215 monks to copy the entire canon in one day.

More impressive than such extravagances were the efforts of the two men who copied the entire canon by themselves. Starting at the age of forty-two it took Fujiwara Sadanobu (1088–1156) twenty-three years to finish a complete set. He presented it to Kusaka Shrine in Nara, but it was lost in a disastrous fire shortly thereafter. The priest Shikijō Hōshi (1159–1242) was twenty-eight when he decided to follow Sadanobu's example. For the next forty-two years he wandered about the country as a beggar-monk. Whenever he received paper and ink he would continue his work, depositing completed sections at local temples. Several others attempted a similar feat but Sadanobu and Shikijō were the only two to succeed.

105. A page of the *Issai-kyō* by Shikijō.

106. *Heike-nōkyō*. No expense was spared to obtain the finest materials for this shakyō. It is most likely the costliest shakyō ever produced.

107. Shakyō of the *Rishu-kyō* (*Adhyarthasatika-prajñā-pāramitā-sūtra*) by one of the members of the powerful Fujiwara clan, 1142.

The period from 1050 to 1250 was the golden age of shakyō with more than forty complete sets of the canon produced. Gradually, as printed sūtras were introduced from China and Korea, shakyō of the entire canon died out. In 1354 the shogun Ashikaga commissioned a complete set, and in 1412 a large group of monks assembled to copy a set to commemorate the deaths of their patron and his army. This is the last set copied by hand in Japan. The last set in China was done in the eleventh century. A complete set of the Tibetan canon (*Kanjur*), written in gold ink on black paper, was prepared in the fifteenth century and there were perhaps some later copies.

108. "Eyeless" shakyō. Due to turmoil in the imperial court, work on the pictures was interrupted before the features of many of the figures could be filled in. Later the paper was used as is and the Rishu-kyō was written over it. On this page are two large Siddhaṃ characters, AH and TRAM. 1193.

109. Apparently, this scene depicting plum-blossom viewing in the spring snow was originally intended as an illustration for a waka poem, but was dedicated to shakyō instead.

110. Illustrated shakyō of the Kamakura period. A page from the *Kako-genzai-inga-kyō* which relates the life of Śākyamuni Buddha. 1254.

111. Shakyō of the *Sūtra of Entering the Substance of the Realm of the Law* by Liu Yang (1719–1804), Grand Tutor of the Qing court.

Shakyō of shorter sūtras, however, has continued unabated to the present day, and in fact has undergone a remarkable revival in this century. Modern calligraphers, recognizing that shakyō of the Nara period set the standard for proper composition of the block characters, advise their students to study the ancient texts carefully. In addition to commissioning professional calligraphers to copy certain sūtras for special occasions, temples of all schools actively promote shakyō by sponsoring regular workshops. (Some also raise money by encouraging their parishioners to copy the one-page *Heart Sūtra* and dedicate it to the temple

together with a small contribution. One temple financed its four-million-dollar renovation this way.)

A number of lay people began shakyō after World War II as an offering for the repose of the soul of a lost relative or friend. One such person has copied one thousand *Heart Sūtras*, the *Lotus Sūtra*, and the six-hundred-volume *Mahaprajñā-pāramitā Sūtra* in a thirty-year period. And upon his election a recent prime minister copied the *Heart Sūtra*, dedicating it to the peace and prosperity of the nation.

112. The *Heart Sūtra* in ancient seal script (*tensho*) by the modern calligrapher Satō Yūgō.

113. Shakyō of the *Heart Sūtra* by Satō Eisaku (1901–1975), former Prime Minister of Japan and recipient of the Nobel Peace Prize.

譬喻經第卅 出地獄品　　　　廿嘉元年三月十七日寫訖

太上玄元道德經卷參終　　建漸二年燉煌郡索紞

諸佛要集經　　　　元康六年三月十八日寫已

摩訶般若波羅蜜守空品第十七　　一晛想故師

佛說菩薩藏經第一　　甘平十五年歲在丁酉

大般涅槃經卍第十六　　此丘法敬所養經

大般涅槃經卷第十二　　奉為三父於荊州竹林寺

誠實論卷第十四　　過昌元年歲次壬辰

律藏初分卷第十四　　大代普泰二年歲次壬子

菩薩處胎經卷第三　　仏弟子陶仵康

114a.

大智度經釋論卷第八十五　　開皇十三年

大般涅槃經卷第十一　　故名佛菩薩為聖人也

威隨劫三昧晉日賢劫定意經　　問三昧品第一

僧伽吒經卷第二　　沙門智首敬寫一切經

金剛般若波羅蜜經卷　　姚大唐貞觀十五年四月八日

佛性海藏經卷第一　　清信佛弟子宋懷道

妙法蓮華經卷第二　　顯慶五年三月十四日

大樓炭經卷第三　　咸亨四年京兆郡公蘇慶節為父

金剛般若波羅蜜經　　秘書省楷書賈敬本寫

妙法蓮華經卷第二　　大周長安二年歲次壬寅

114b.

114. The historical evolution and development of different
styles of shakyō in China and Japan: a. Chinese shakyō,
A.D. 256–500; b. Chinese shakyō, A.D. 592–675; c.
Japanese shakyō of the Tempyō era, A.D. 615–768; d.
Japanese shakyō, A.D. 948–1254. Calligraphy by Kishi-
moto Isoichi.

天平写経

復平説无相寘同偕或吩中道而衰眼猶吩　　六一五　法華義疏

金剛場陀羅尼経　　三蔵法師闍那崛多訳　　六八六　和銅経

大般若波羅蜜多経巻第二百七十九　　和銅五年　　七一三

大般若波羅蜜多経巻第四百六十五　　神龜五年　神龜経　　七二八

過去現在因果経　　尓時太子年至十歳　　七三五　大聖武

賢愚経梵志施佛納衣得受記品第五十八　　巻五　　七四〇

千手千眼陀羅尼経　　僧正玄昉発願敬写　　七四一

金光明最勝王経序品第一　　三蔵法師義浄奉制訳　　七四一　国分寺経

有念者此何因説手長者観内身如身観内　　七四九　中宮寺経

大般若波羅蜜多経巻第一　　大唐三蔵聖教序太宗文皇帝製　　七六八　南倉経

114c.

和風写経

佛説摩訶般若波羅蜜多心経　　隅寺心経

具壽鄔波離請世尊曰大德於其眾苦有長

山中與大比丘眾俱皆是阿羅漢諸漏已盡

菩薩名曰文殊師利法王子大威德藏法王

授菩薩戒儀　　先南無　　三反了　九九八

佛説此已舍利弗及諸比丘一切世間天人阿

般若理趣所謂諸法空與無自性相應故諸

諸佛世尊時説是経是故行者於佛滅後

念彼如来若即於念時従彼發素文選生八

太子徐前而語車匿及以捷陟一切恩愛會

114d.

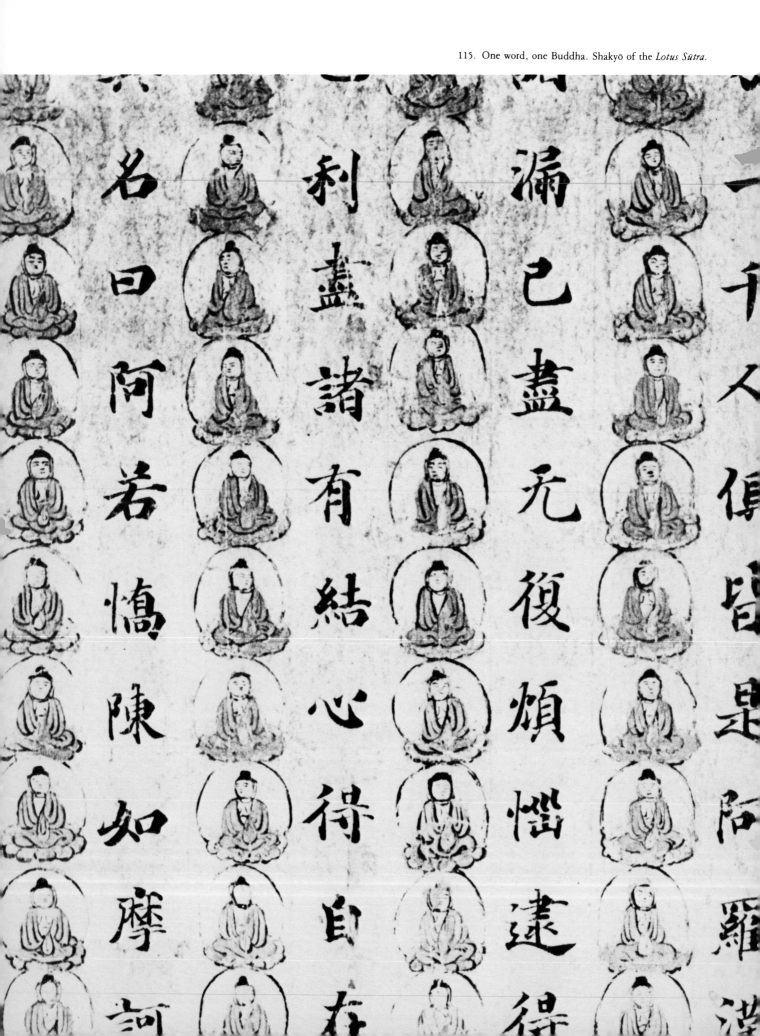

116. Each letter of the *Lotus Sūtra* enshrined in a stūpa. Japan, Heian era.

ONE WORD, ONE BUDDHA

The five virtues of shakyō are:

Venerating the letters with your eyes
Keeping the letters in your heart
Chanting the letters with your mouth
Writing the letters with your hands
Becoming one with Buddha

The physical relics of Buddha are his ashes; the relics of his teaching are the copied sūtras. Those sūtras proclaim the great virtue of "receiving, preserving, reading, copying, and chanting" the holy texts. Shakyō is thus a type of skillful means (*upāya*) enabling others to approach the Buddhist teaching.

On another level shakyō is an act of worship, an offering for the repose of the deceased to help them avoid evil and suffering in their search for final release.

Shakyō is also a prayer. Many rulers in China, Tibet, and Japan wrote sūtras adding the postscript "For the protection of the country and the welfare of all my subjects." There are numerous cases of people recovering from illnesses, being saved from calamity, or receiving some wonderful benefit after doing shakyō. Perhaps it is true that

"if one copies the sūtras all petitions will be answered"; but individual requests should not be the exclusive purpose of shakyō.

Finally, shakyō is a form of meditation. It is written Zen, for it requires the same determination and concentration as sitting Zen. One cannot write properly if one is upset, angry, or distracted in any way. Writing intensely in silence with a composed mind purifies the heart. Each word is a new Buddha.

117.
The chant "Namu Dai Bosa," (Hail to the Great Bodhisattva) formed by a chapter of the *Lotus Sūtra*.

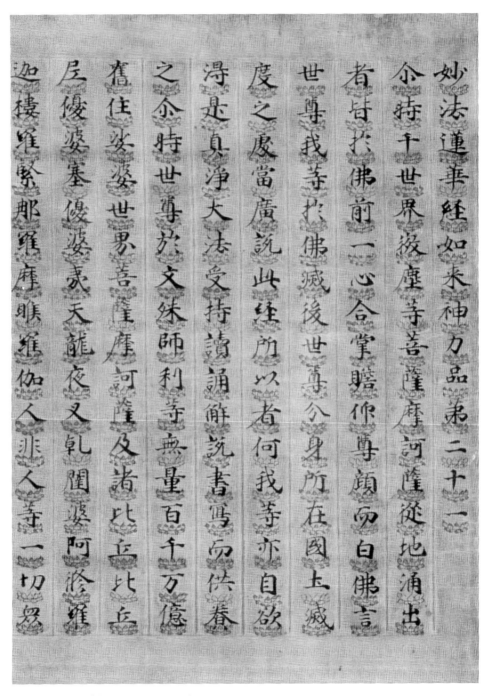

118. Each letter of the *Lotus Sūtra* on a lotus.

119. a. A stūpa formed of the characters of the *Saishōō-kyō*;
 b. Detail.

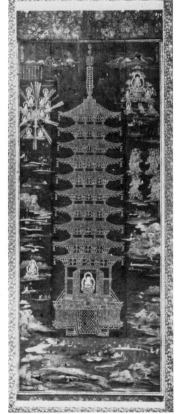

119a.

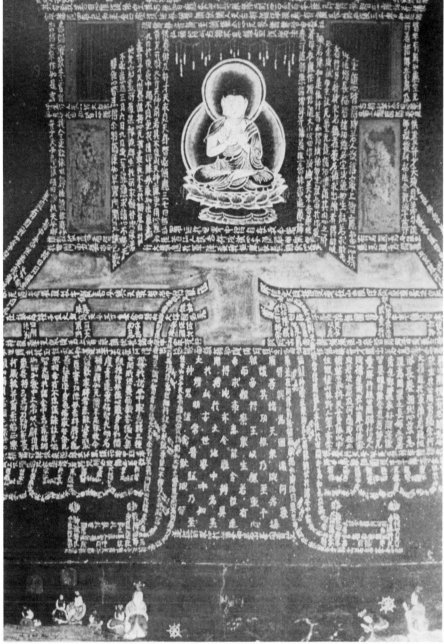

119b.

SHAKYŌ MANUAL

There are many different methods of shakyō, varying from temple to temple and from individual to individual. Some are quite elaborate. Every July at Enryakuji, head temple of the Tendai sect on Mt. Hiei, a Nyohō Shakyō Kai (session) is held. Based on the practice of Jikaku Daishi (Ennin; 794–864), for three days the *Lotus Sutra* is copied according to a complicated ritual. Others are simple. At Tōdaiji in Nara, a ball-point pen or even a pencil may be used. The finished sūtras are stored inside the Great Buddha there. In the Nichiren school one must wear a mask that covers the nose and mouth and not touch the paper with the hands during shakyō, and when tired or distracted one must chant the *daimoku: namu myōhō rengekyō*.

Individuals try to do some shakyō every day and in the past groups tended to do shakyō on one of the six fast days of the month: the 8th, 14th, 15th, 23rd, 25th, and 30th. Actually, any time or place is suitable.

The most popular sūtra is the one-page *Mahā-prajñāpāramitā-hṛdaya Sūtra*, the *Heart Sūtra*. Versions in Sanskrit, Chinese, Tibetan, Korean, and English are given in this manual. Once one decides on the language and script the following procedure is recommended.

Completely clean and scrub the room and table that will be used for copying. Since one's spirit should flow through the body and into the ink, it is better to use a fountain or script pen (or a brush if writing in Chinese) rather than a ball-point pen or pencil, although, as noted above, even these are permissible. Prepare fresh paper and make sure the writing instruments are clean and arranged neatly on the desk. Do not eat or drink anything for some time before starting, and do not eat, drink, or smoke while copying. If possible purify oneself with a thorough washing. Put on clean clothes, light incense, and sit quietly in meditation for a few minutes.

In classical shakyō practice one puts the palms of the hands together in gassho, and makes three great prostrations (touching the forehead to the ground), but a simple bow is sufficient. Read or chant the sūtra through one time. In Japan a stylized invocation is then read, often the Four Great Vows:

> *shujō muhen seigan do*
> *bonnō mujin seigan dan*
> *hōmon muryō seigan gaku*
> *butsudō mujō seigan jō*

Sentient beings are numberless, I vow to
 save them all
The passions are inexhaustible, I vow to
 cut them off
The dharma is unfathomable, I vow to
 master it
Buddha's way is supreme, I vow to
 attain it

Any such resolution will do.

Keep the back straight, whether in a chair or sitting Japanese style (*seiza*), relax the shoulders, breathe from the *tanden* (the physical and spiritual center of the body just below the navel), and hold the brush firmly but not too tightly. Write each stroke with full concentration of body and mind, as if swinging a heavy wooden sword. The strokes should be thick, strong, and clear, the bigger and more powerful the better. Copy the sūtra with the entire body, not just the hands. Each letter should be written with a feeling of gratitude for the teaching. Do not hurry or copy absentmindedly.

Work straight through without stopping. If a mistake is made (in shakyō a mistake is a sign of a lack of concentration) draw a single line through it (if writing in Chinese make a circle through the character); omitted characters should be written in the margin. Depending on the language and the script, it should take from forty minutes to 1½ hours to make a copy of the *Heart Sūtra*. Upon completion, one may record the date and one's name at the bottom of the page along with any special petition. A concluding invocation may be recited:

May the virtue of this sūtra enable all to have correct thoughts, hear the dharma, see Buddha, dwell in the Pure Land, and realize enlightenment.

Complete the session with a bow of gratitude. The copied sūtra should be kept in a proper place, for example, within an altar or stūpa if available. It should never be thrown away or used for any other purpose.

The simple method described above is appropriate for groups or individuals. Variations include using gold or silver ink on blue paper, using different styles of calligraphy or inks, making three prostrations for each character or word, combining scripts—there are many possibilities.

It is best to use the *Heart Sūtra* exclusively at first, especially if the script is unfamiliar. Other popular Buddhist texts are the *Diamond Cutter Sūtra*, the *Kannon Sūtra*, (the twenty-fifth chapter of the *Lotus Sūtra*), and the *Amida Sūtra*. Shakyō of the entire *Lotus Sūtra* is done fairly often.

Shakyō is not limited to Buddhist sūtras. Many of the *Upaniṣads* and the *Bhagavad Gītā* make ex-

120. The author doing shakyō in formal Japanese style (*seiza*).

cellent texts for shakyō and, of course, Christian copying of the Bible has a rich tradition. Nor is shakyō necessarily limited to "holy" texts; poetry or other forms of literature may also be copied with great spiritual benefit.

121. Each character of this shakyō was accompanied by three great prostrations. Muromachi period.

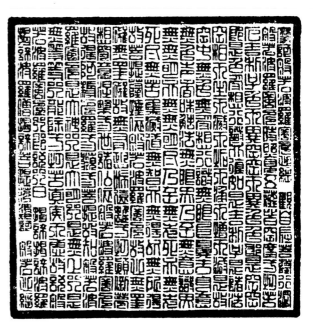

122. *Heart Sūtra* seal in ancient script (tensho). Actual size. Japan.

123. Sanskrit *Heart Sūtra* in Devanāgarī script. Compiled in 1882 by Oxford professors M. Muller and B. Nanjyō.

124. Sanskrit *Heart Sūtra* in Siddhaṃ script brushed by Jiun Sonja in 1792, with Chinese translation printed beneath.

歸命一切智　　聖　觀　自在菩薩　深
般若波羅蜜多　行行時　等　觀
五蘊　等自性　空　見　此身子
色　空　空如是色　色不異　空　空
不異色　色　空　空　色
如是如是　受　想　行　識　此身子
一切法　空　相　不生不滅　不垢
不淨　不增不滅　身子空中　無色
無受無想　無行　無識　無眼耳鼻
舌身意　無色聲香味觸　法
無眼界　乃至無意　識　界　無明無明
無明　盡無明　盡　乃至無老死　無老死
盡　無苦　集　滅　道無智無得　無
得故　菩薩　般若波羅蜜多　依　住　心
罣礙　心障礙　無故無　恐怖　顛倒　超越　究竟
涅槃　三世等　住　一切佛　般若波羅蜜多　依無
上　正等正覺　現證正覺　故　知當　般若波
羅蜜多　大章句　大明章句　無上章句無等　等
章句　一切苦　除　諸不虛故說　般若波羅蜜
多　解脫兄　即說咒曰　揭諦揭諦　波羅揭諦　波羅僧揭諦
菩提薩婆訶　般若波羅蜜多心　已竟

THE *HEART SŪTRA* IN SIDDHAṂ SCRIPT

brushed by Tokuyama Kijun. This is a revised Sanskrit version based on evaluation of various manuscripts and classical Sanskrit grammar. The romanization is:

Namas-sarvajñāya // āryāvalokiteśvara bodhisattvo gambhīra prajñāpāramitāyāṃ caryāṃ caramāṇo vyavalokayati sma // paṃca skandhāstāśca svabhā-vāḥ śūnyaṃ paśyati sma // iha śāriputra rūpaṃ śūnyatā // śūnyataiva rūpaṃ // rūpān-na pṛthak śūnyatā // śūnyatāyā na pṛthagrūpam // yad-rūpaṃ sā śūnyatā // yā śūnyatā tadrūpaṃ // evameva vedanā saṃjñā saṃskāravijñānāni // iha śāriputra // sarvadharmāḥ śūnyatā 'lakṣaṇā anutpannā aniruddhā amalā 'vimalā nōnā na paripūrṇāḥ // tasmāc-chāriputra śūnyatāyāṃ na rūpaṃ // na vedanā // na saṃjñā // na saṃskāro // na vijñānaṃ // na cakṣuh śrotra ghrāṇa jihvā kāya manāṅsi // na rūpa

śabda gandha rasa spraṣṭavya dharmāḥ // na cakṣurdhāturyāvan-na manovijñā na dhātur-na vidyā // nā vidyā // na vidyākṣayo // nā vidyākṣayo // yāvan-na jarāmaraṇaṃ // na jarāmaraṇakṣayo // na duḥkha samudaya nirodha mārgo // na jñānaṃ // na prāptiraprāptitvād-bodhisattvānāṃ prajñāpāra-mitāmāśṛtya viharatya cittāvaraṇaḥ // cittāvaraṇa nā 'stitvādatrasto // viparyāsā 'tikrānto // niṣṭha nir-vāṇaḥ // tryadhvavya vasthitāḥ sarva-buddhāḥ prajñāpāramitāmāśṛtyā 'nuttarāṃ samyaksaṃ bodhimabhisaṃ buddhāḥ // tasmājjñātavyaṃ // prajñāpāramitā mahāmaṃtro mahāvidyāmaṃtro // 'nuttaramaṃtro 'samasamaṃtras-sarva duḥkha praśamanaḥ // satyamamithya tvāccaprajñāpāra-mitāyā-mukto maṃtraḥ // tadyathā // gate gate pāragate pārasaṃgate bodhi svāhā // iti prajñāpāra-mitā hṛdaya sūtraṃ // samāptaṃ

CHINESE AND JAPANESE SHAKYŌ

Unless one has had some training in classical Chinese or Japanese calligraphy, it is best to use a pen (good ball-point, fountain, or felt-tip) to learn the proper stroke order, form, and balance of the characters. Students hoping to become scribes at shakyō bureaus wrote each of the commonly used characters 70–80 times as practice; it is advisable to follow a similar pattern with each individual character of the *Heart Sūtra* before actually beginning.

When writing with a brush (fude) use a clean inkstone; wet the stone with a small amount of water and grind the sumi (ink) stick with a circular motion, making an adequate supply of ink for one session. The paper should be absorbent and may be either ruled or unruled. Hold the brush perpendicular to the paper. Block characters (kaisho) are customary but accomplished calligraphers compose in semicursive (gyōsho), cursive (sosho), scribes' script (reisho), and seal script (tensho). Seventeen characters to a line is standard.

125. Stroke order of the Chinese characters in the *Heart Sūtra*.

摩訶般若波羅蜜多心經
観自在菩薩行深般若波羅蜜多時照見五
蘊皆空度一切苦厄舍利子色不異空空不
異色色即是空空即是色受想行識亦復如
是舍利子是諸法空相不生不滅不垢不淨
不增不減是故空中無色無受想行識無
耳鼻舌身意無色聲香味觸法無眼界乃至
無意識界無無明亦無無明盡乃至無老死
亦無老死盡無苦集滅道無智亦無得以無
所得故菩提薩埵依般若波羅蜜多故心無
罣礙無罣礙故無有恐怖遠離一切顛倒夢
想究竟涅槃三世諸佛依般若波羅蜜多故
得阿耨多羅三藐三菩提故知般若波羅蜜
多是大神咒是大明咒是無上咒是無等等
咒能除一切苦真實不虛故說般若波羅蜜
多咒即說咒曰揭諦揭諦波羅揭諦波羅僧
揭諦菩提薩婆訶
般若心經

126. The *Heart Sūtra* written with a pen.

摩訶般若波羅蜜多心経
観自在菩薩行深般若波羅蜜多時照見五
蘊皆空度一切苦厄舎利子色不異空空不
異色色即是空空即是色受想行識亦復如
是舎利子是諸法空相不生不滅不垢不浄
不増不減是故空中無色無受想行識無眼
耳鼻舌身意無色声香味触法無眼界乃至
無意識界無無明亦無無明尽乃至無老死
亦無老死尽無苦集滅道無智亦無得以無
所得故菩提薩埵依般若波羅蜜多故心無
罣礙無罣礙故無有恐怖遠離一切顛倒夢
想究竟涅槃三世諸仏依般若波羅蜜多故
得阿耨多羅三藐三菩提故知般若波羅蜜
多是大神呪是大明呪是無上呪是無等等
呪能除一切苦真実不虚故説般若波羅蜜
多呪即説呪曰
羯諦羯諦 波羅羯諦 波羅僧羯諦 菩提薩婆呵
般若心経

127. The *Heart Sūtra* in block characters (*kaisho*).

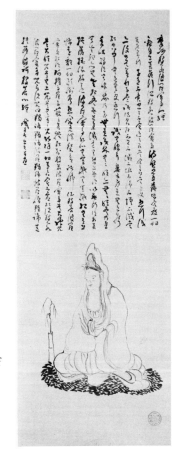

128. The *Heart Sūtra* in cursive calligraphy with a portrait of Kannon by Yamaoka Tesshū.

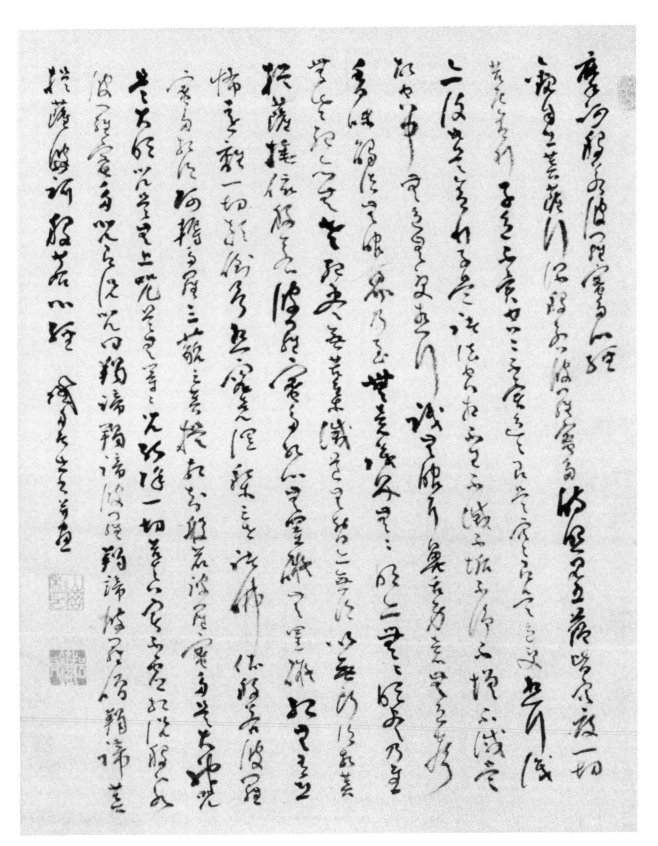

129. Close-up of Tesshū's *Heart Sūtra* in dynamic cursive script.

摩訶般若波羅蜜多心經

觀自在菩薩行深般若波羅蜜多時照見五蘊皆空度一切苦厄舍利子色不異空空不異色色即是空空即是色受想行識亦復如是舍利子是諸法空相不生不滅不垢不淨不增不減是故空中無色無受想行識無眼耳鼻舌身意無色聲香味觸法無眼界乃至無意識界無無明亦無無明盡乃至無老死亦無老死盡無苦集滅道無智亦無得以無所得故菩提薩埵依般若波羅蜜多故心無罣礙無罣礙故無有恐怖遠離一切顛倒夢想究竟涅槃三世諸佛依般若波羅蜜多故得阿耨多羅三藐三菩提故知般若波羅蜜多是大神咒是大明咒是無上咒是無等等咒能除一切苦真實不虛故說般若波羅蜜多咒即說咒曰揭諦揭諦波羅揭諦波羅僧揭諦菩提薩婆訶

般若心經

130. Top, the *Heart Sūtra* in scribes' script (*reisho*); below, seal script (*tensho*) both by Kishimoto Isoichi.

延命十句觀音經

觀世音　南無佛　與佛有因　與佛有緣

佛法僧緣　常樂我淨　朝念觀世音

暮念觀世音　念念從心起　念念不離心

昭和庚申歳正月齋戒沐浴　岸本磯一敬寫

131. The *Emmei Jūku Kannon-gyō* is a brief combination prayer-sūtra to Kannon (Kanzeon; Avalokiteśvara). Top, the sūtra written in red ink by Kishimoto Isoichi; below, a version combining the Siddhaṃ character SA, the Chinese text, and English translation by the author.

Ten Verse Life Prolonging Kannon Sutra

Kanzeon! Hail to Buddha!

We are one with Buddha,

Bound to the Awakened One,

And to the Buddha, Dharma, & Sangha.

We are always joyful & pure

In the morning thinking of Kanzeon,

In the evening thinking of Kanzeon,

Continous thoughts rise from the heart,

Those thoughts never leave our hearts.

延命十句觀音経
觀世音南無佛與佛有因與佛有緣
佛法僧緣常樂我淨朝念觀世音暮
念觀世音念念從心起念念不離心

132. *Heart Sūtra* in Tibetan—Uchen script.

TIBETAN SHAKYŌ

Although shakyō of the *Heart Sūtra* was not widespread in Tibet, one of the four virtuous acts of assembly was people gathering to copy texts (the others: assembly of monks for meditation and study, assembly of lay believers for worship, and gathering money to distribute to the poor). The copying of sacred texts contributes greatly to the religious merit of a lama. Gold ink is best, then silver and vermilion or black. The *Aṣṭasāhasrikā-prajñāpāramitā-sūtra* (*The Eight Thousand Line Sūtra of Transcendent Knowledge*) extolls the virtue of transcribing sūtras and was thus one of the texts most commonly used for shakyō in Tibet.

마하반야바라밀다심경

관자재보살 행심반야바라밀다시 조견오온개공 도일체고액 사리자 색불이공 공불이색 색즉시공 공즉시색 수상행식 역부여시 사리자 시제법공상 불생불멸 불구부정 부증불감 시고공중무색 무수상행식 무안이비설신의 무색성향미촉법 무안계 내지 무의식계 무무명 역무무명진 내지 무노사 역무노사진 무고집멸도 무지역무득 이무소득고 보리살타 의반야바라밀다고 심무가애 무가애고 무유공포 원리전도몽상 구경열반 삼세제불 의반야바라밀다고 득아뇩다라삼먁삼보리 고지반야바라밀다 시대신주 시대명주 시무상주 시무등등주 능제일체고 진실불허 고설반야바라밀다주 즉설주왈 아제아제 바라아제 바라승아제 모지 사바하

133. *Heart Sūtra* in Korean—Hangul script.

KOREAN SHAKYŌ

For centuries Korean Buddhists used Chinese characters but recently more emphasis is being placed on the native Hangul script. First promulgated in the middle of the fifteenth century, it is thought to be influenced by Siddham calligraphy.

ment. He should produce a thought which is unsupported by forms, sounds, smells, tastes, touchables, or mind-objects, unsupported by dharma, unsupported by no-dharma, unsupported by anything. And why? All supports have actually no support. It is for this reason that the Tathagata teaches: By

ENGLISH SHAKYŌ

People were doing shakyō in English (and other European languages) before they knew what it was called; the practice naturally occurred to those with an interest in calligraphy. The author has held successful shakyō workshops at most of the largest Zen centers in the United States resulting in a growing number of steady practitioners. After the preferred translation is selected, any traditional or modern calligraphic style may be used. Above is one page of a shakyō of the *Diamond Cutter Sūtra* by Priest Tensho of the San Francisco Zen Center. On the opposite page is an English version of the *Heart Sūtra*, written by Richard Levine.

Avalokitesvara Bodhisattva when coursing in the deep Prajna Paramita perceived that all five skandhas are empty and was saved from all suffering and distress. Shariputra, form is not different from emptiness, emptiness is not different from form. Form is exactly emptiness, emptiness exactly form. The same is true of feelings, perceptions, impulses, and consciousness. Shariputra, all dharmas are marked by emptiness. They do not appear nor disappear, are not tainted nor pure, do not increase nor decrease. Therefore in emptiness no form, no feelings, no perceptions, no impulses, no consciousness. No eyes, no ears, no nose, no tongue, no body, no mind. No sight, no sound, no smell, no taste, no touch, no object of mind. No realm of eyes until no realm of consciousness. No ignorance and no end to it. No old age and death and no end to them. No suffering, no origination, no stopping, no path, no attainment. With nothing to attain the Bodhisattva depends on Prajna Paramita. With no hindrance, no fear. Beyond perverted views he attains Nirvana. All Buddhas depend on Prajna Paramita and attain supreme enlightenment. Therefore know: Prajna Paramita is the great mantra, the brightest, highest, utmost mantra, allayer of all suffering, true not false. Proclaim this mantra which says: Gate, Gate, Paragate, Parasamgate, Bodhi Svaha! *Heart Sutra written out by hand, March 1995 - R. Levine*

134. *Kokoro*, ''heart / mind,'' by Munan (1603–1676).

ZENSHO:
ZEN CALLIGRAPHY

"Calligraphy is a picture of the mind."
—CHINESE SAYING

135. Part of Huaisu's autobiography written in cursive calligraphy.

HISTORY

It is difficult to speak of the history of Zen (Chinese: Chan) calligraphy; it is related, of course, to the history of Zen Buddhism but not exclusively so. It may be argued that there was Zen calligraphy in China before there was a Zen school —for example, the cursive Zen characters of the calligrapher-saint Wang Xizhi who lived some two hundred years before Bodhidharma came from the West. Even after Zen Buddhism was established in China, Korea, and Japan not all Zen calligraphers were adherents of the Zen sect.

No examples remain from the brushes of the first patriarchs of Chinese Zen (one of them,

Huineng, was illiterate). Two eighth century Chinese eccentrics are often represented as the prototypes of Zen calligraphers—"Drunken Zhang" and "Mad Monk Huai." After imbibing huge amounts of rice wine, Zhang would slap "delirious-cursive" characters on anything at hand—walls, trees, pots, clothes. Sometimes he would soak his hair in ink and write with it. His equally crazed disciple, the monk Huai, was famous for substituting banana leaves for paper which he could not afford. He found money for wine, however, and wrote while in a drunken frenzy.

Actually such amusing behavior was frowned upon by the majority of Zen priests. Undisciplined displays were not appreciated; most of the pieces done by Chinese monks of the tenth to the thirteenth centuries are characterized by a certain solemn profundity, forceful, yet refined and reserved. Influential Chinese calligraphers of this era include the Confucian scholars Su Dongpo (So Tōba; 1036–1101) and Huang Tingjian (Kō Teiken; 1045–1105), and priests Yuanwu Keqin (Engo Kokugon; 1063–1135); Wujun Shifan (Bushan Shiban; 1177–1249), Xutang Zhiyu (Kidō Chigu; 1185–1269), Zhang Jizhi (Chō Sokushi; 1186–1266), Lanqi Daolong (Rankei Dōryu; 1203–1268), Wuxue Ziyuan (Mugaku Sogen; 1226–1286), Yishan Yining (Issan Ichinei; 1247–1317), Gulin Qingmao (Kurin Seimu;

1261–1323), and Liaoan Qingyu (Ryōan Seiyoku; 1288–1363).

The calligraphy of Eisai (1141–1215) and Dōgen (1200–1253), the two Japanese monks who established the Rinzai and Sōtō schools, respectively, in their native land, resembles that of their Chinese masters—well-ordered, controlled, and powerful. Daitō Kokushi, founder of Daitokuji in Kyoto, was perhaps the first to blend Chinese and Japanese styles of calligraphy. Daitokuji produced a succession of renowned calligraphers, and insofar as we can speak of a "school" of Zen calligraphy, the Daitokuji school is the oldest and largest. Other noted Japanese calligraphers of the time were Mūso (1276–1351), Kokan (1278–1346), Sesson (1290–1346), and Ikkyū (1394–1487).

136. The introductory section of Dōgen's *Fukanzazengi*.

In the first half of the Edo period the following Zen calligraphers are especially well-known: Kōgetsu (1571–1643), Takuan (1573–1645), and Seigan (1588–1661), all from Daitokuji; Fūgai (1568–1650), Shinetsu (1642–1696) and Manzan (1636–1715) from Sōtō Zen; and Bankei (1622–1693) and Munan (d. 1676) from Rinzai.

137. Calligraphy by Issan Ichinei. *Ō mu sho jū ni shō go shin*, "Arouse the mind without letting it settle anywhere," the verse from the *Diamond Cutter Sūtra* that awakened Huineng, the sixth Chinese Patriarch.

138. *Tsushingen*, "the piercing eye of insight," by Bankei.

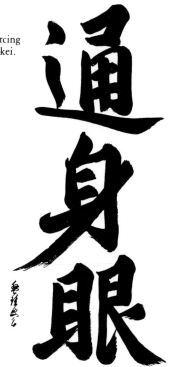

139. Calligraphy by Daitō Kokushi. The large character *Mu* with verse.

140a.

140b.

140. Zen places itself firmly between the poles of existence: a. *Mu*, "Nothing," by Munan; b. *Yu*, "Something," by Nyoten (n.d.). Together with the accompanying verse, the entire piece can be translated as: "Existence—it's like the floating clouds."

141. *Ten jin*, "Heavenly God," the honorary title of Michizane, patron saint of learning. Brushed by Fūgai, such a piece likely graced the study of a young scholar.

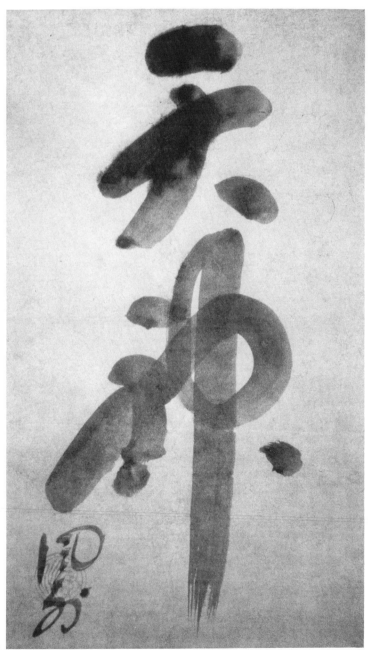

141.

142a.

142. Ōbaku calligraphy: a. *Shū chū zō jitsugetsu*, "Within one's sleeves the sun and moon are hidden," by Mokuan. Although often we do not realize it, we in fact hold all of the secrets of the universe right in our hands. b. *Ittai un*, "A girdle of clouds," by Kōsen. The character for girdle actually binds the "one" and "clouds" symbols. c. *Mu* (*yume*)-*Kaku* (*satori*) "Dream Awakening," also by Kōsen. Illusion and enlightenment always exist in conjunction; sometimes we are deep asleep, sometimes wide awake, but both states are encompassed by the seamless unity of Zen.

142b.

142c.

Following the establishment of the Ōbaku (Huang-po) school of Zen at Mampukuji in 1694, a new type of Chinese-style calligraphy was brought to Japan. Ōbaku calligraphy was thicker, stronger, more cursive than that of previous centuries. Unlike the Rinzai and Sōtō sects, which were quickly assimilated into Japanese culture, Ōbaku retained its distinctive Chinese orientation in temple architecture, religious practices, food, and calligraphy. Among illustrious Ōbaku calligraphers are the founder of Mampukuji, Ingen (1592–1673), Mokuan (1611–1684), Sokuhi (1616–1671), Tetsugyū (1628–1700), Tetsugan (1630–1682), Jigaku (1632–1689), and Kōsen (1633–1695).

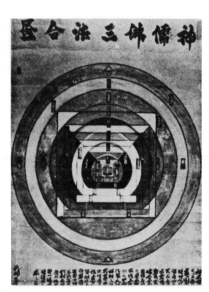

143. Two works by Tōrei: a. An unusual Zen maṇḍala showing the harmony of the teachings of Buddha, Confucius, and Shintō; b. *Shū iu mu*, "Jōshū said *mu*."

143a.

143b.

144. One-Word Barrier by Nantembō, age 83. "Arrive! Free-flowing water attains the ultimate." *Itaru*, the "one-word barrier" presented here, means both "proceed" and "arrive." Flow like water around all obstacles and you will ultimately arrive at the ocean of enlightenment. Do not stagnate or get bogged down with petty concerns. Progress ever onward!

The eighteenth and nineteenth centuries mark the golden age of Japanese Zen calligraphy. Hakuin (1685–1768), Jiun (1717–1804), Tōrei (1721–1792), Sengai (1750–1837), Ryōkan (1758–1831), Nanzan (1756–1839), and Yamaoka Tesshū (1836–1880) were active in this era, producing a large number of splendid works.

In this century such monks as Nantembō (1839–1925) and Gempō (1865–1961) have done calligraphy that is not inferior to that of past masters. Calligraphy by present day Rōshis is eagerly sought and head abbots of large temples of all sects are obligated to spend some time each week writing appropriate pieces of calligraphy to meet the demands of their parishioners, present as gifts to their friends and students, or for display on special occasions. Surely some of the calligraphy being done will be valued as highly by later generations as we value that of the great Zen calligraphers of centuries ago.

145a.

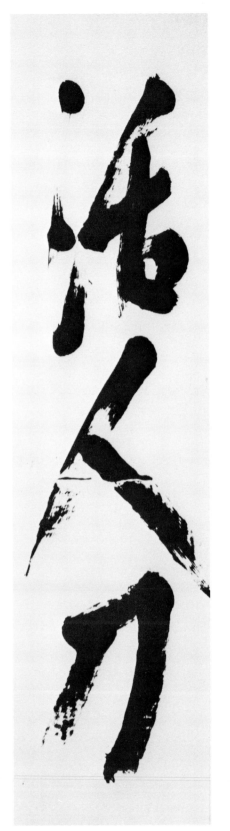

145b.

145. Two one-line calligraphies: a. *San shoku shōjō shin*, "The mountain colors are (Buddha's) pure body" by Nanzan; b. *Katsu jin ken*, "The Life-Giving Sword," by Gempō. He was called the "20th-century Hakuin," composing right up to his death at age 96.

146. *Jōzai ryōjusen*, "[Śākyamuni] is eternally preaching on Vulture Peak," a *nigyō mono* by Jiun.

CALLIGRAPHY IS THE PERSON

The word *zensho*, Zen calligraphy, is of recent origin; the classical term is *bokuseki*, traces of ink. It is usually associated with the calligraphy of medieval Chinese and Japanese Zen priests. Such Zen calligraphy can be classified into nine groups:

inkajō, certificate of enlightenment
jigo, name given to a monk by his master
hōgo, dharma talks
geju, gāthā (a type of Buddhist verse)
yuige, death verse
shidōgo, exhortory sermon
shi, poetry (one's own or that of a poet/master)
gakuji, two or three large characters written horizontally for display on a wall or over a doorway
shokan, letters

To this should be added

san, inscriptions on Zen paintings
ichi (ni) gyō mono, one- or two-line Zen sayings mounted on a scroll
ensō, Zen circles

However it is done, such classification merely describes the various kinds of writing a Zen master was required to do in the course of giving religious instruction. In themselves these pieces cannot qualify as Zen calligraphy; they must be written in the Zen spirit. This is the criterion for zensho.

Calligraphy is indeed a painting of the mind; the degree of enlightenment is expressed in the flow of the ink. Once someone mistakenly tried to ef-face some characters written by Wang Xizhi. He discovered that the characters had actually penetrated the wood. Regardless of how deeply he cut, it was impossible to erase them. Recently, studies by Terayama Katsujō have shown Zen calligraphy is truly "alive." He collected authentic Zen calligraphy, forgeries of those works, and copies made by modern calligraphers and examined them with an electron microscope, magnifying certain sections from fifty to one hundred thousand times. The magnified ink particles of the authentic pieces were vibrant, full of *ki*, numinous; by contrast, the ink particles of the forgeries and copies were dispersed, weak, dead. Even the lithographic copies of authentic pieces retained a three-dimensional quality, albeit somewhat reduced. Scientific "proof" of the vitality of Zen calligraphy reaffirms what those who have seen real examples already know—calligraphy that may be hundreds of years old looks as fresh as if it was just written and it seems to embrace the viewer.

Since the Zen calligrapher abandons him- or herself in the calligraphy the content comes from within rather than without. Hence, each piece is unique, reflecting the ever-changing response of the calligrapher to the environment, to the instruments of writing, and to the image in his or her

147. *Kyozan,* "Mountain Dweller," a *jigo* by Rankei, founder of Kenninji in Kamakura.

148. Death verse (*yuige*) of Priest Nishiyama Zentei: "Going on a journey without fear, like the Lion King [Śākyamuni]. The light of prajñā is brilliant, shining like the sun." 20th century, Japan.

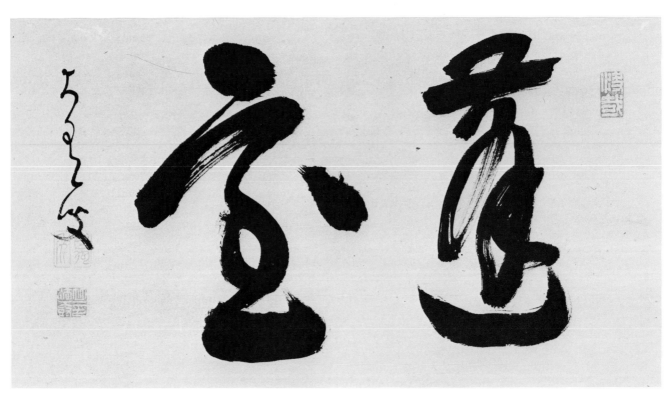

149. *Dōshitsu,* "Room of Dao," hung in a room for meditation. A *gakuji* by Hōju (1776–1864), a disciple of Jiun.

150. Inscription on painting of Mount Fuji by Mugai (1881–1943). The characters resemble billowing clouds and seem to float up and down the paper. The poem celebrates the coming of the new year in the sacred land of Japan, a time of renewal and fresh resolve.

151. *Ichigyō mono* of two Zen sayings: a. *Heijō* [or *byōjō*] *shin kore dō*, "Everyday mind is the Way," by Chū-hō (1760–1838), abbot of Daitokuji; b. *Jikishin kore dōjō*, "Single-mindedness is the place to practice the Way," by the Rinzai priest Kyodō (1808–1895).

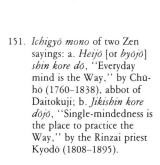

151a. 151b.

mind. On the highest levels the calligrapher moves in a world of pure form; the unity of calligrapher, brush, ink, and paper destroys all relative dimensions. There is freedom—detachment from rules, standards, and conventions. Nonetheless, calligraphic enlightenment is not realized easily or without many years of basic preparation through physical and spiritual forging.

Zen calligraphy is perfect simplicity. Whereas most of the other calligraphy presented in this book is based on complicated systems of imagery and have precise and well-defined forms, Zen calligraphy conveys the same profound truths in clear, everyday terms unimpaired by theoretical reasoning or mysticism. It is informal, irregular, and plain, nothing more than black ink on white paper. Even when dealing with esoteric themes, the Zen calligrapher cuts through elaborate symbolism, reducing magical doctrines to their original purity.

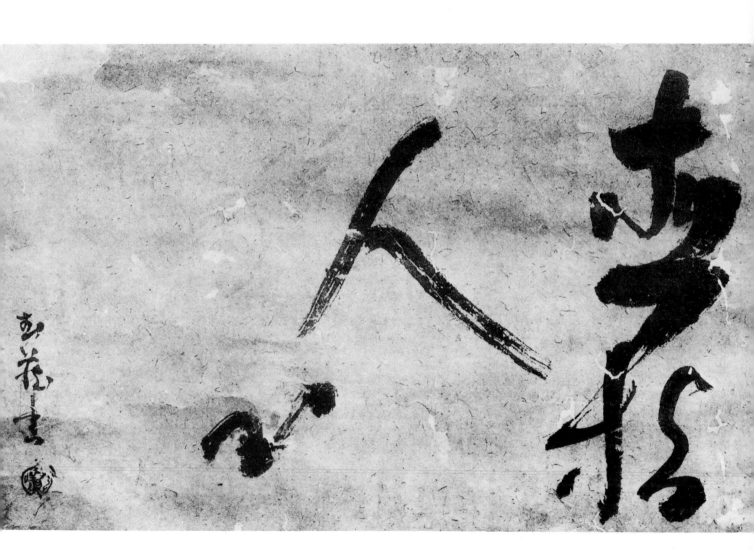

152. *Jikishi ninshin*, "[Zen] points directly to the human heart." Calligraphy of the famous swordsman Miyamoto Musashi (1584–1645).

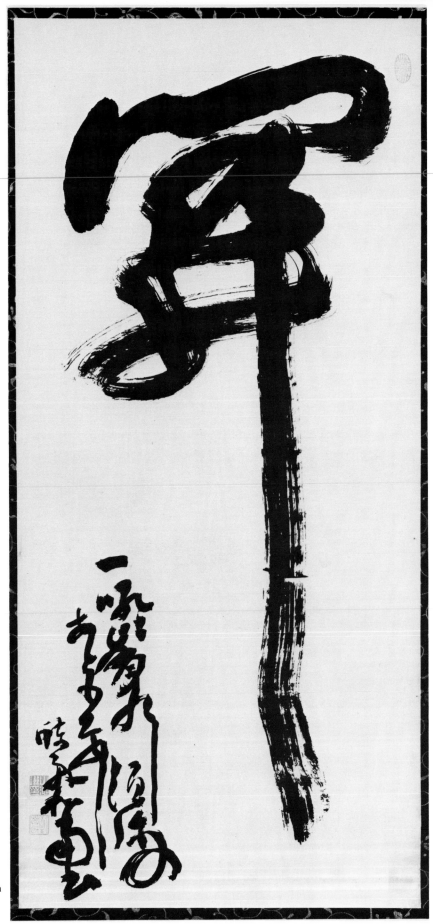

153. *Kan*, the barrier through which all Zen students must pass. Calligrapher unknown.

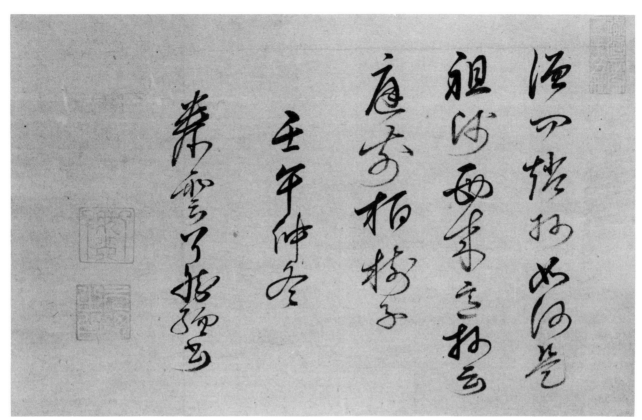

154a.

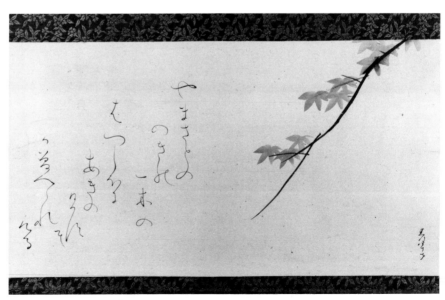

154b.

154. Calligraphy by two Buddhist nuns: a. Ryōnen's (1646–1711) calligraphy of the kōan: "A monk asked Jōshū, 'What is the meaning of the first Patriarch coming to the west?' Jōshū replied, 'The oak tree is in the garden.' " b. Painting and poem by Rengetsu (1791–1895). The poem says: "Deep in the mountains, a single branch of crimson maple leaves before my hut signals the coming of autumn."

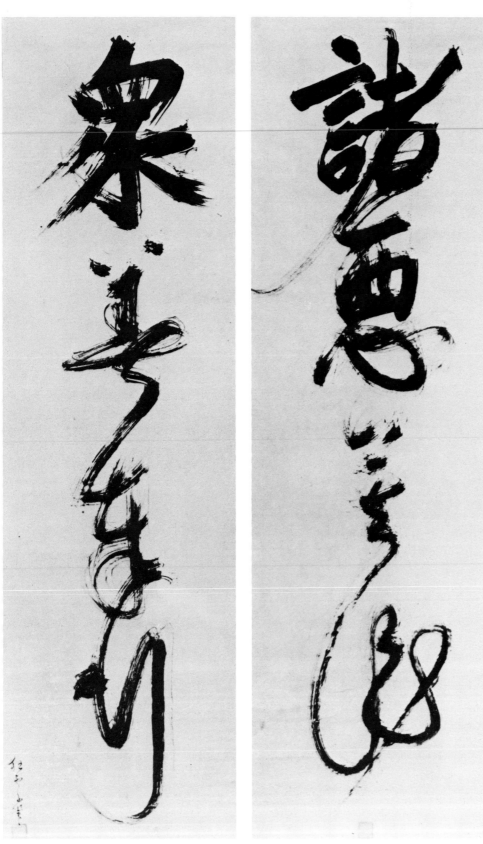

155. *Sho aku maku sa shu zen bu gyō,*
 "Refrain from all evil, do all that
 is good."

156. *Bukkai hairiyasuku makai hairigatashi,* "It's easy to enter the world of Buddha, but difficult to enter the world of the devil." From the standpoint of the Mahāyāna, it is not hard to become a saint if one lives alone in a peaceful environment free from strife and temptations. On the other hand, to attain enlightenment in the midst of *saṃsāra* is a much greater challenge.

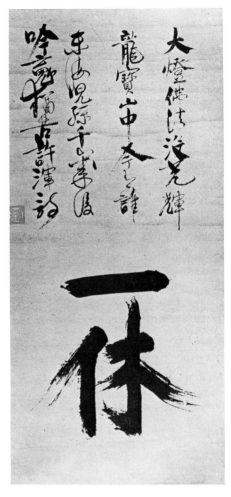

157. *Ikkyū,* "One rest." Ikkyū explained that his name stood for the brevity of human life and the foolishness of trying to avoid whatever comes. The poem above the two large characters laments the fact that the light of Daitō Kokushi's transmission is virtually extinguished among his descendants.

ZEN CALLIGRAPHERS

IKKYŪ

Ikkyū (1394–1481), said to have been an illegitimate son of Emperor Gokomatsu, was raised in a Zen temple. Following the death of his master, Kasō, in 1428, Ikkyū led a wandering life, refusing to take a temple or disciples of his own. He denounced the hypocrisy of his fellow monks while making no secrecy of his own preference for fish, saké, and sex. Even for a Zen monk, his behavior was outlandish. Nonetheless, he had many supporters and was appointed the forty-seventh abbot of Daitokuji when he was in his eighties. He was charged with supervising reconstruction of the entire complex, which had been burned to the ground during the Onin Wars. Ikkyū influenced the development of most of the Zen arts—calligraphy, painting, tea ceremony, noh drama, and gardening. His legendary wit and eccentricity has continued to keep him a popular figure in the public imagination.

Ikkyū's calligraphy reflects his personality—wild and unconventional with an intense, almost fierce quality.

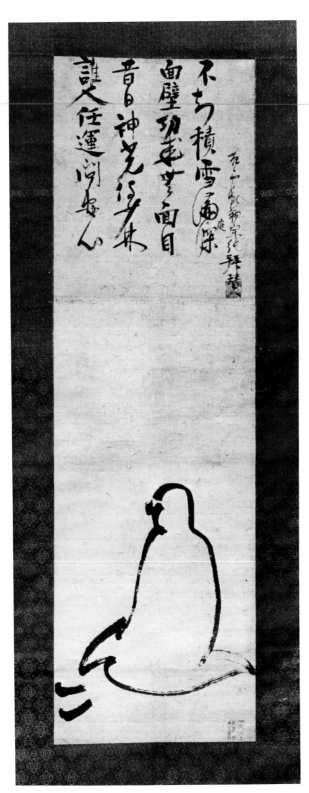

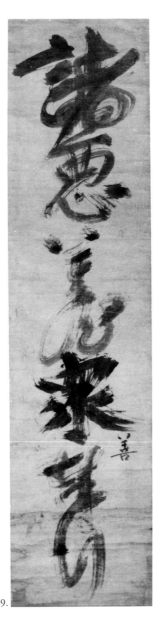

159.

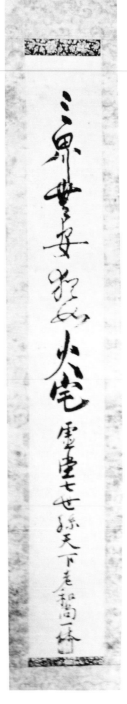

159. Single-line version of the saying in illustration 155. Ikkyū skipped the character *zen* in his enthusiasm, then added it later.

158. Painting of Bodhidharma by Bokkei with *san* by Ikkyū. Freely translated, the inscription reads, "Who will set the second Patriarch's mind at rest? Long ago, spiritual light radiated from Shōrinji. Bodhidharma faces the wall, hiding his face, while the second Patriarch stands waiting, unaware of the snow piling up."

160. *Sangai muan nao hataku no gotoshi*, "The three worlds are unsafe, like a burning house." Signed: "The seventh descendant of Kidō, the old priest Ikkyū."

TAKUAN

Like Ikkyū, Takuan (1573–1645) entered the priesthood at an early age, traveled widely, and became abbot of Daitokuji. He was in trouble with the military authorities at one stage of his life, but eventually enjoyed the favor of the shogun Iemitsu and had many samurai disciples.

He is noted, among other things, for inventing the distinctive radish pickles named after him, and his *Fudōshishimmyōroku*, a treatise on Zen and swordsmanship.

His calligraphy is less extreme than Ikkyū's; it is more diffuse, slightly softer but no less bold.

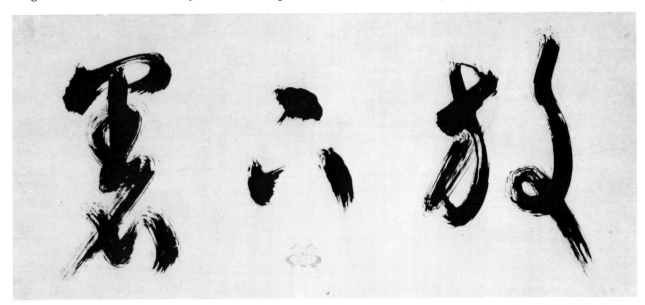

161. *Hōgejaku*, "Throw down completely!" That is, cast off all discrimination.

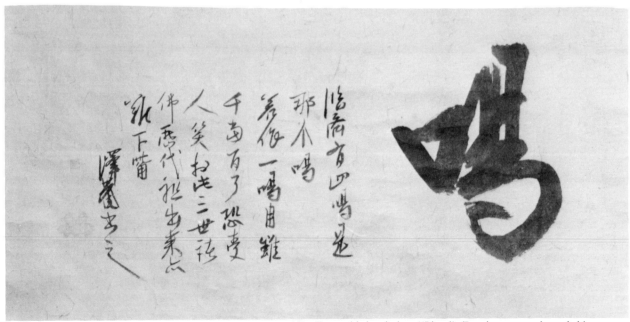

162. *Katsu* with inscription: "Rinzai's Zen shouts were the real thing, not a fake. A single yell of his terrified everyone around for miles and miles. All of the buddhas of the three worlds, all of history's great patriarchs, cannot match the ferocity of this shattering Zen shout!"

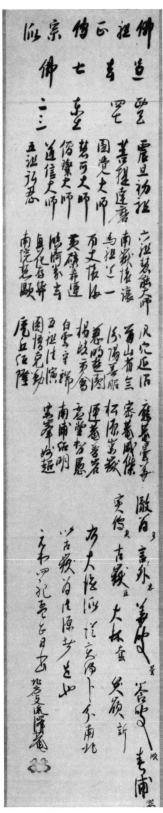

163. Dharma lineage of Daitokuji.

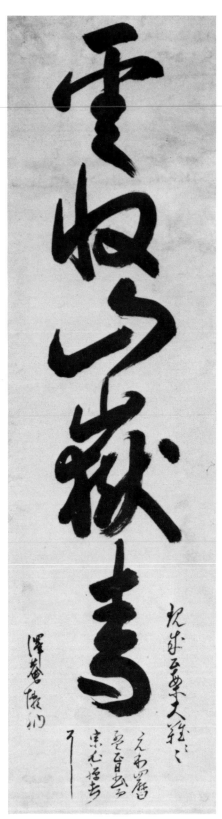

164. *Kumo osamatte sangaku aoshi*, "Clouds gathered up, green mountains." When the veil is lifted we can see the Pure Land.

HAKUIN

Born in Suruga Province, Hakuin (1685–1768) entered a Zen temple at fifteen. He trained at various temples before becoming abbot of Shōin-ji near Hara. Later, he rebuilt Ryūtaku-ji in Izu. He is perhaps the greatest of all Zen painter/calligrapher monks and certainly the central figure in Japanese Rinzai Zen, revitalizing its practice and establishing the modern kōan system.

Besides painting and calligraphy, he wrote many books and composed popular songs.

He used a variety of calligraphic styles when he was young, but in his later years he specialized in monumental *ichijikan* (one word barriers), large single characters together with a poem or saying in smaller calligraphy. His distinctive mastery of such calligraphy is unrivaled.

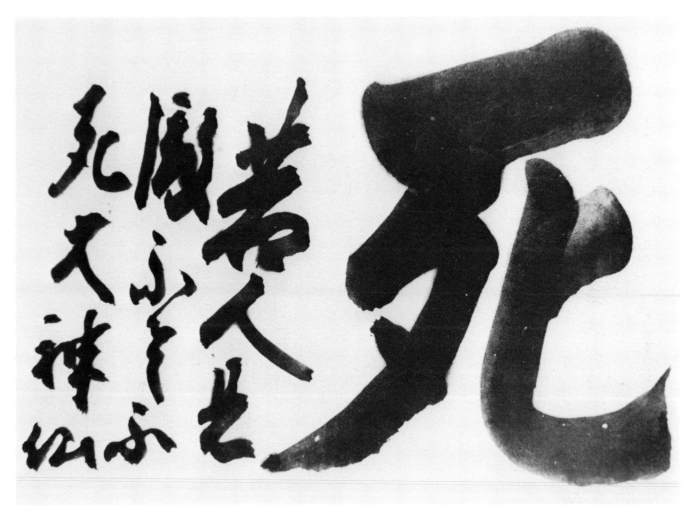

165. *Shi*, "Death." *Moshi hito mitōseba furofushi no dai-shinsen nari*, "Anyone who sees through death becomes ageless, deathless, immortal."

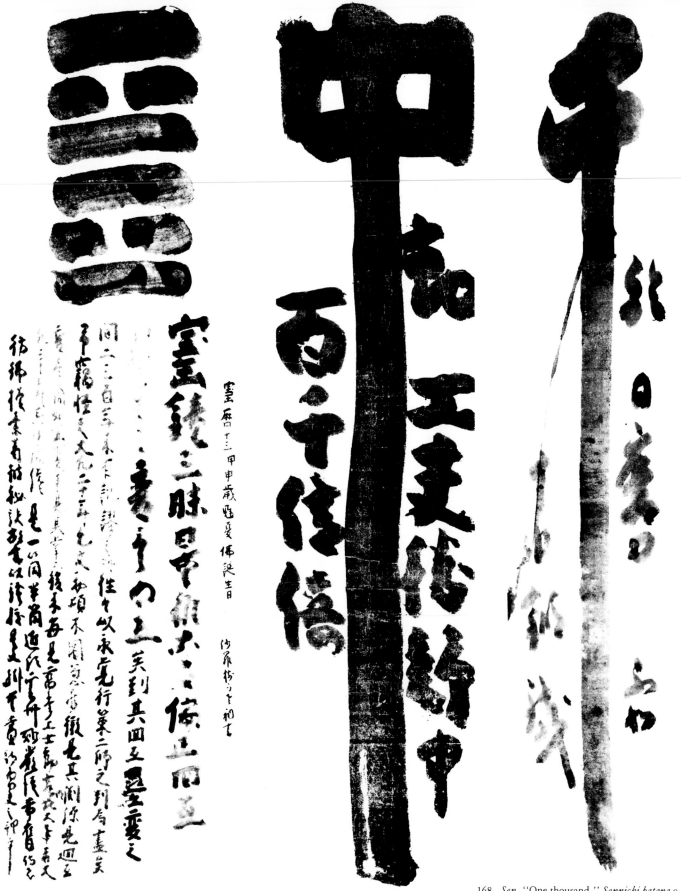

166. The *I Ching* hexagram *Li* (*ri*), "The Clinging." Hakuin's Zen interpretation of Confucian symbolism.

167. *Chū*, "in the midst." *Dōchū no kufū jōchū ni masaru koto hyakusen okubai*, "Solving kōans in action is a billion times harder than solving them in zazen."

168. *Sen*, "One thousand." *Sennichi katana o migakan yori tōka tetsu o kitaen ni shikazu*, "Ten days of forging the iron is better than a thousand days of polishing the sword."

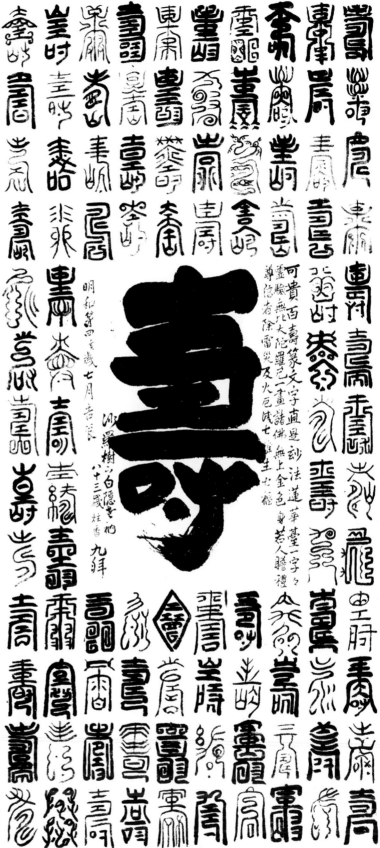

169.

One hundred forms of the character *ju* (longevity). This type of calligraphy was presented to older people on special occasions, for example, their seventy-seventh birthday. Hakuin was eighty-two when he wrote this for one of his lay followers.

171.

Toku, "Virtue." The accompanying inscription says: "If you pile up money for your descendants they will probably waste it; if you collect books for them, they probably won't read them. It is better to pile up virtue and pass it along. That will last for a long time."

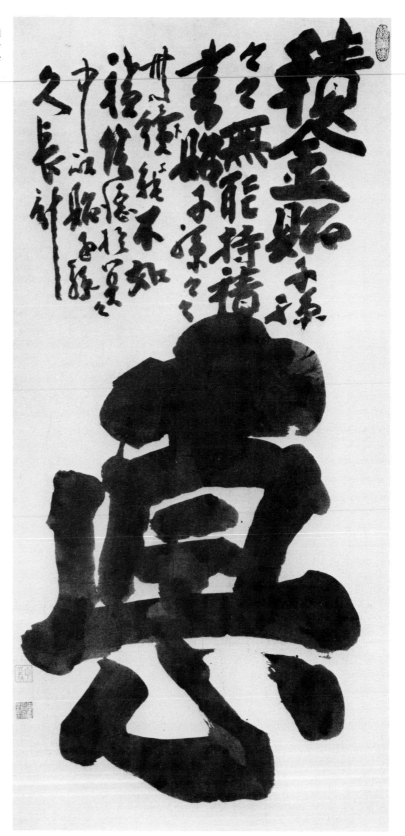

170. *Ji*, "Compassion."

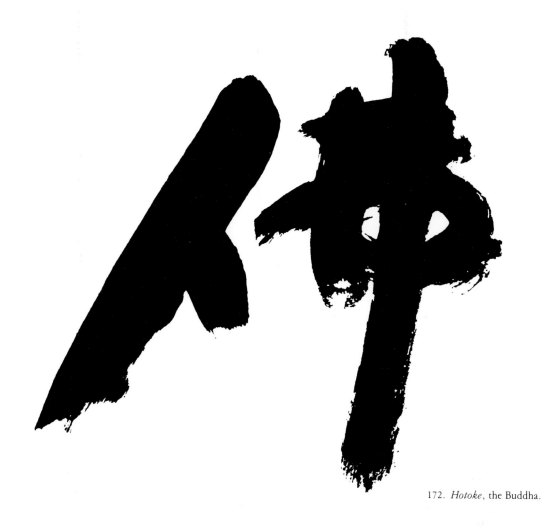

172. *Hotoke*, the Buddha.

JIUN

More than any other calligrapher, Jiun (1718–1804) epitomizes the ideals of sacred calligraphy of the East. He was the first scholar of Sanskrit in Japan, established his own school of Siddham calligraphy, and his Chinese characters are prized as masterpieces of Zen writing.

Jiun was born into a samurai family near Osaka. At a very early age, his father died and Jiun was placed in a Shingon temple to be raised. When he was eighteen he went to Kyoto and began study of the Chinese classics; sometime later he lived in a Zen monastery for three years. In 1798 he took over the abandoned monastery Koki-ji in Kawachi, making it the headquarters of his school.

Continuing to study, write, and teach up to his death, Jiun also established Unden Shintō, which stressed the essential identity of Shintō and Esoteric Buddhism.

Jiun had an eclectic mind and combined many elements in his calligraphy. He practiced both Siddham and Japanese calligraphy every day. Although his characters appear rough and clumsy, they are genuinely pure and refined with no taint of worldliness. Jiun generally used a rather dry brush for his calligraphy and liked to write large, bold characters. His calligraphy is simple, direct, vigorous, a wonderful mixture of Esoteric Buddhism, Shintō naturalism, and Zen enlightenment.

173. *Hito*, "Person." *Hito wa hitoto narubeshi kono hito to nari ete kami tomo nari hotoke tomo nari*, "You must become a real person; when you become that kind of person you become a god, you become a Buddha."

174. *Ichi Butsujō*, "One Buddha Vehicle." Many teachings with a single aim: enlightenment.

175. *Tsuki*, "Moon." *Tenjō senmannen tsune ni waga ko-kochi o terasu*, "The moon in the heavens for millions of years, always illuminating our minds."

160 SACRED CALLIGRAPHY

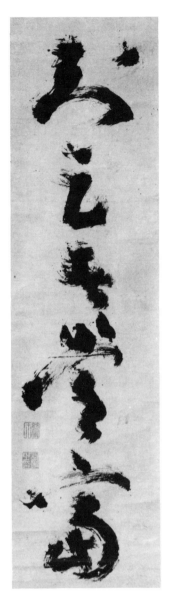

176. *Chisoku sha jōfu*, "Contented people are always wealthy."

177. *Nichinichi kore kōnichi*, "Every day is a good day." A famous saying of the Tang Dynasty master Ummon (Yunmen; 864–949).

178. The Zen staff of Fuke (P'u-hua, c. 850), a famous Chinese eccentric. The inscription says: "Come this way and I'll smash your conceits."

179. Siddhaṃ calligraphy: a. A-SA-VA, three syllables that encompass all mantras of the Womb Matrix; b. A-VI-RA-HŪM-KHAM, a mantra of Dainichi (Vairocana); c. the *kōmyō* mantra with OM, A, and HŪM in large letters; d. BODHIMAṆḌALA, the place of enlightenment.

179a.

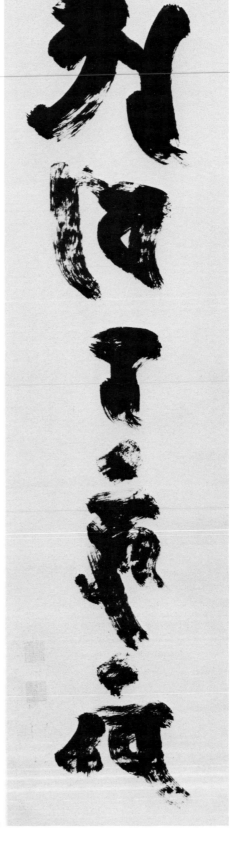

179b.

179c.

179d.

180. *Buji*, "No action."

SENGAI

Sengai (1750–1837) is Hakuin's only rival as a Zen painter. A native of Mino Province, he was ordained at eleven years of age, and set out on a pilgrimage eight years later. After practicing here and there, he was installed as abbot of Shōfuku-ji in Kyushu, Southern Japan, when he was around forty. Sengai retired a little over twenty years later and devoted the remainder of his life to painting, calligraphy, and meeting with his many visitors. He rarely refused a request for a painting or calligraphy—although once out of exasperation he stuck his head out of his window announcing, "Sengai is not home today"—so he produced an extraordinary number of works. Like Hakuin, Sengai had a humorous outlook on life coupled with a wide range of interests.

His calligraphy is cursive yet generally legible. Sengai's dislike of pomp and display can be seen in his flowing, natural characters.

181.

Kissako, "Go and have some tea." Jōshū (Zhaozhou; 778–897) once had two visitors. He asked them, "Have you been here before?" One said no. Jōshū said, "Go and have some tea." The other said yes. Jōshū told him, "Go and have some tea." When asked about this, he said, "Go and have some tea!"

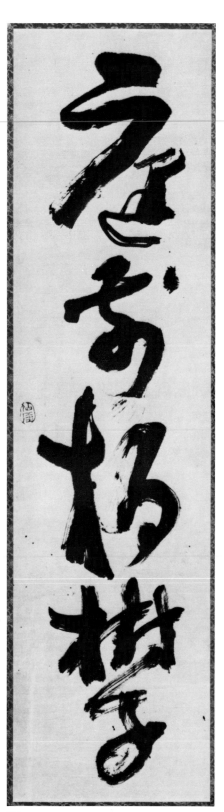

182.

Teizen hakujushi, "The oak tree in the garden." This is Jōshū's reply to the question "Why did Bodhidharma come from the West?"

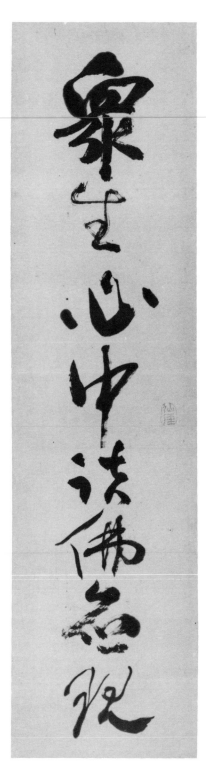

183.

Shujō shinchū shōbutsu ōgen, "Within the hearts of all sentient beings all Buddhas are manifest."

184. *Hon rai muichibutsu,*
"Originally not one thing."

185. *Shinge muhō mammoku
seizan,* "There is no law out-
side the mind; all around blue
mountains."

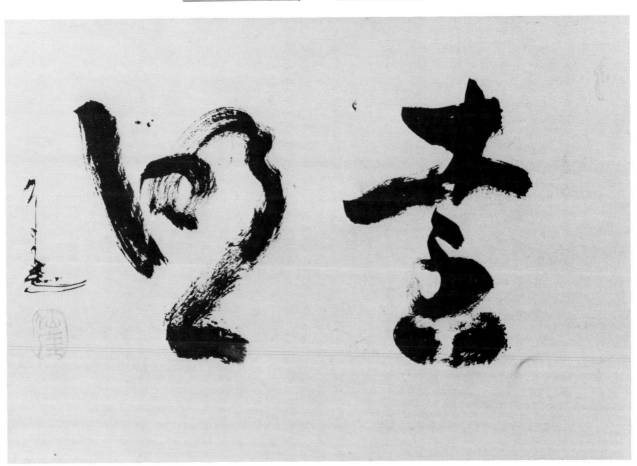

186. *Tōmei,* "Far and clear."

187. One of Ryōkan's poems:

> Shaggy hair past the ears,
> A worn-out robe resembling white clouds and dark
> smoke.
> Half drunk and half sober,
> I return home,
> Children all around, guiding me along the Way.

188. *Ten chi*, "Heaven and earth."

RYŌKAN

Ryōkan (1758–1831) became a monk at about twenty years of age and spent the next twenty years as an *unsui* (wandering monk) before returning to Echigo (present day Niigata), his native province in a remote area of northern Japan. Although he lived in a mountain hermitage, he enjoyed visiting the local villages to play ball with the children, drink saké with the farmers, and compose poetry with his friends. In his old age he fell in love with the beautiful young nun Teishin.

Ryōkan once said he disliked only two things: "poetry by a poet and calligraphy by a calligrapher." He meant, of course, pretentious stylized works by professionals. His own calligraphy is extremely fine and pure, delicate but not at all weak. Unfortunately, since specimens of his calligraphy have become very valuable, many skillful forgeries have been made and it is believed that out of one hundred pieces signed "Ryōkan" only one will be authentic.

天上大風

190. *Ichi ni san*. "One, two, three" (left), and *i ro ha*, "a, b, c," written in response to a farmer's request to have something anyone could read. The simplest possible characters written in the most profound style.

189. (Previous page) *Ten jō dai fū*, "To heaven on the great wind." This was written for a child's kite. Sad to relate, it seems that the children were used by an unscrupulous person to acquire some of Ryōkan's calligraphy. Also, the signature is apparently a forgery, added by another's hand to "authenticate" the piece and make it more valuable.

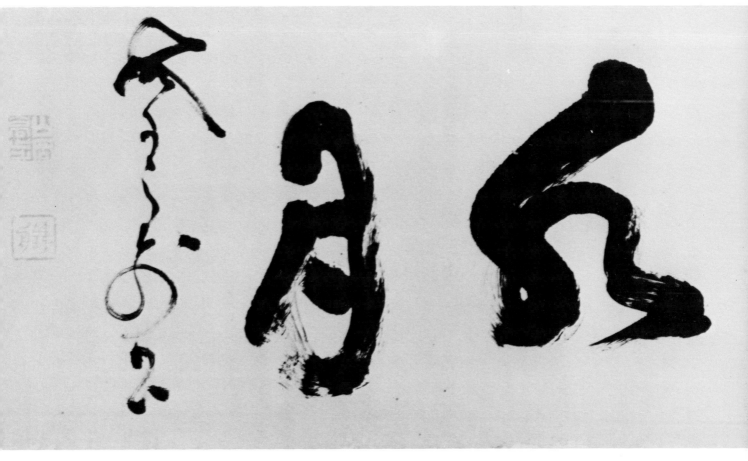

191. *Suigetsu,* "Moon and water."

TESSHŪ

Tesshū (1836–1888) was born in the capital city of Edo (now Tokyo) but was raised in Takayama. At an early age he began practicing swordsmanship, calligraphy, and Zen. As a young samurai, Tesshū became involved in the turmoil surrounding the last days of the military government and played an active role in politics. After the Meiji Restoration in 1868 he held a number of government positions, finally becoming secretary and advisor to Emperor Meiji in 1877. His dōjō, the Shumpūkan, in Tokyo was a famous training hall for swordsmanship, calligraphy, and Zen, and a large number of the prominent figures of the era practiced there. A huge and powerful man, Tesshū is one of the few people to be recognized as a master of all three disciplines.

His calligraphic method may be described as "no-method"—he did not depend on certain materials or any particular style. However, before that stage can be attained, he insisted, one must have a sound foundation in the basics. New students were assigned the single one-stroke character *ichi* for three years (swordsmen were told to practice the straight cut for a similar period). He also devoted a part of each day to shakyō.

192. (Left), *tora*, "tiger," and (right) *ryū*, "dragon."

193. *Gyatei gyatei haragyatei harasamgyatei boji sawaka*, the *Heart Sūtra* mantra.

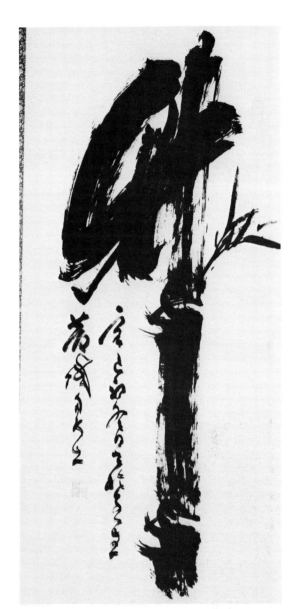

194. Calligraphy combined with painting; the character *take*, "bamboo."

195. Shakyō.

196. Examples of *kaō*, special signatures used by Zen priests, samurai, and other cultured people. The designs are quite fanciful, with only a vague relation to orthography, and were mostly for decorative purposes.

HANGING SCROLLS

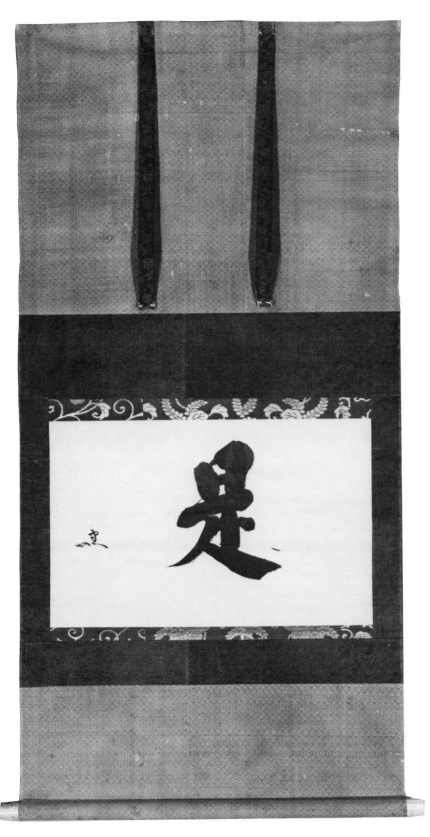

Kakejiku, hanging scrolls, are an essential element of the tea ceremony. An appropriate piece of calligraphy, by a past or present master, is mounted on fine paper or brocade and hung in the alcove of the tea room. The guests will examine it closely, noting the style of calligraphy, content, and display.

197. *Kore*, ''This.'' Calligraphy by Kōkōsai (d. 1835), sixth grand master of the Mushanokojisenke school of tea.

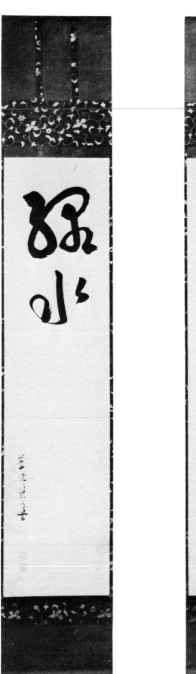
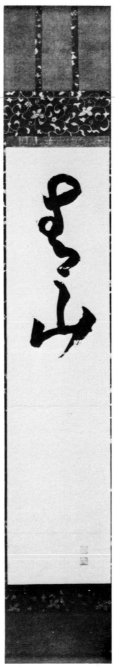
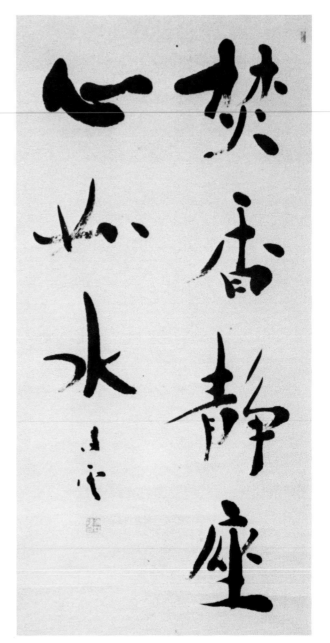

199. *Takiko seiza shin nyo sui*, "Lighting incense, sitting quietly, a heart like water." Calligraphy by Ari Ryūhō.

198. A pair of scrolls to be displayed side-by-side in June. They read: *seizan* (r) and *rokusui* (1), which is best translated into English as "Green mountains" and "Blue water," although both the top characters can mean either green or blue. Calligraphy by Seigan (1587–1661).

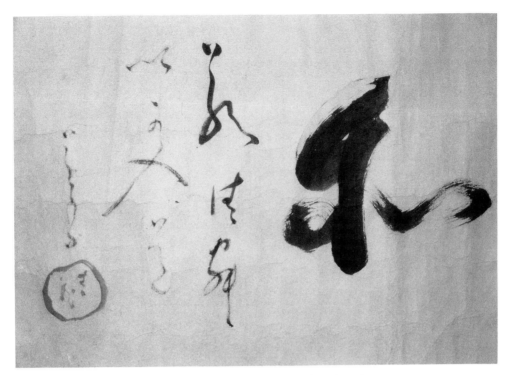

200. The spirit of tea: a. *Wa*, "Harmony—this pure quality will guide us along the Way," by Mamiya Eshū (1871–1945); b. *chaka*, "Tea and cakes." The inscription is: "Jōshū [said,] 'Go and have some tea.' Ummon [replied,] 'A sweet cake.'" The story about Jōshū was given above (p. 164, no. 181), the question asked of Ummon was: "What is the subject all the Buddhas and Patriarchs discuss?"

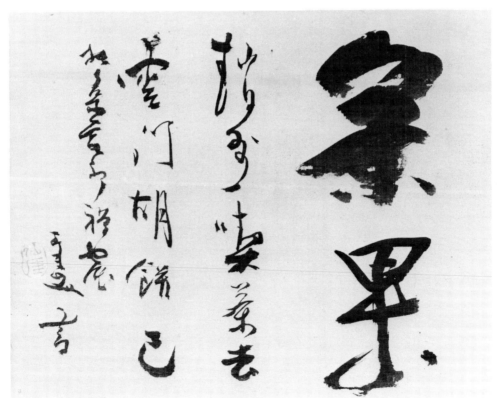

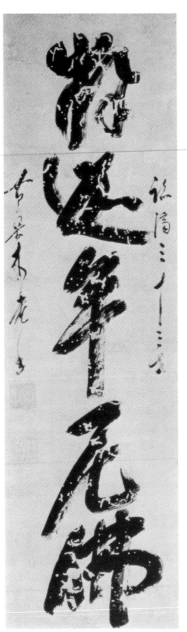

201a.

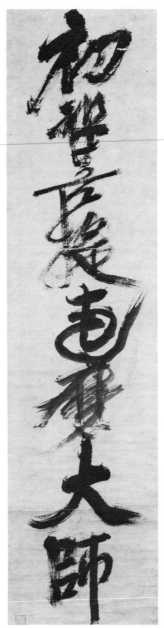

201b.

201c.

201. *Myōgō* of the Zen sect: a. *shaka muni butsu,* "Śākamuni Buddha," by Mokuan; b. *shoso bodai daruma taishi,* "The First Patriarch, the Great Teacher Bodhidharma" by Ikkyū; c. *namu jigoku daibosatsu,* "Hail to the Great Bodhisattva of Hell!" by Hakuin.

MYŌGŌ: THE HOLY NAME

Just as a seed character is as real as the deity it represents, the name of a Buddha, Bodhisattva, or Shintō god written in Chinese characters is an object of veneration equal to, if not superior to, its image. To his usual signature the calligrapher adds *haisho* or *kinsho,* which means "respectfully written by."

202a.

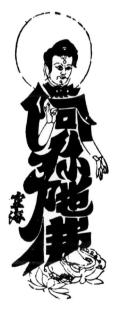

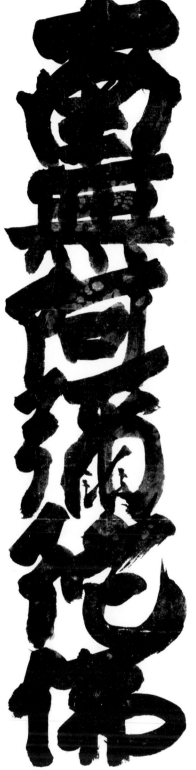

202b.

202c.

202d.

202. The most common *myōgō* is the chant of the Pure Land sect, *namu amida butsu*, "Hail to Amida Buddha!" a. "Sword-cut Myōgō," in stylized "razor-cut" script; b. picture of Amida attributed to Kūkai; c. *namu amida butsu* by Hakuin; d. *namu amida butsu* by Jiun.

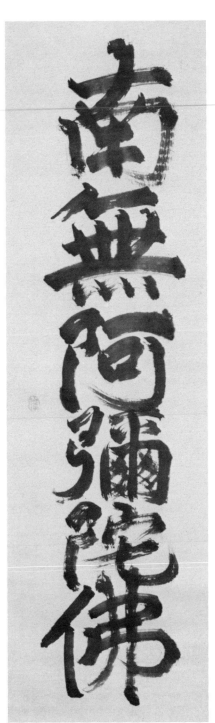

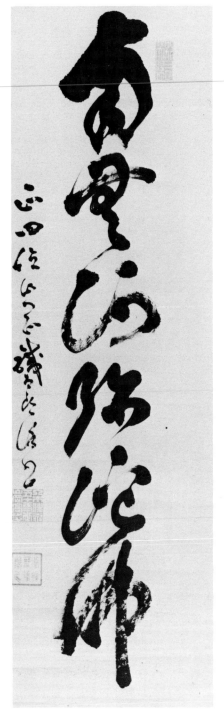

203a. 203b. 203c.

203. *Namu amida butsu* by: a. Sengai; b. Ryōkan; c. Tesshū.

204. Zen interpretation of the seed character of Fudō Myōō,
HĀṂMAṂ, by Hakuin.

205a.

205b.

205. *Taisei fudō myōō*, "The Great Saint Fudō Myōō," by:
a. Hakuin; b. Sengai.

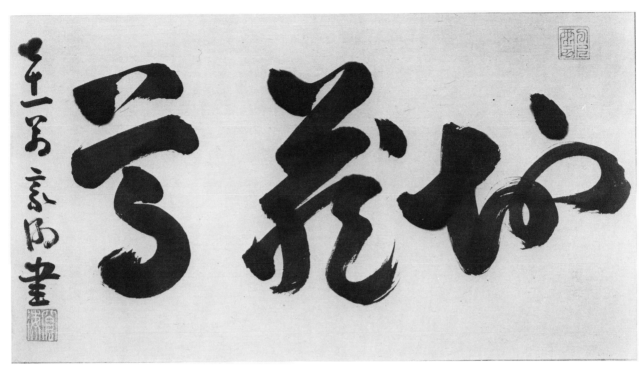

206a.

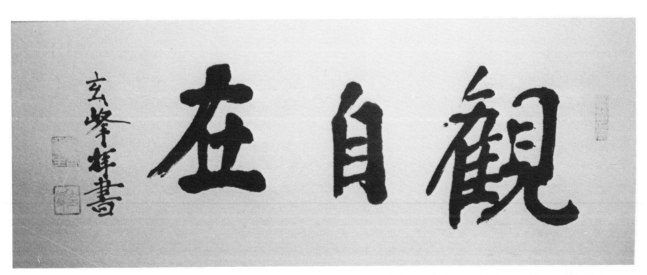

206b.

206. Two *gakuji myōgō*: a. *jizō son*, "Respect the Bodhisattva Jizō," by Gōchō (1794–1835); b. *kanjizai*, "Kannon Bodhisattva," by Gempō.

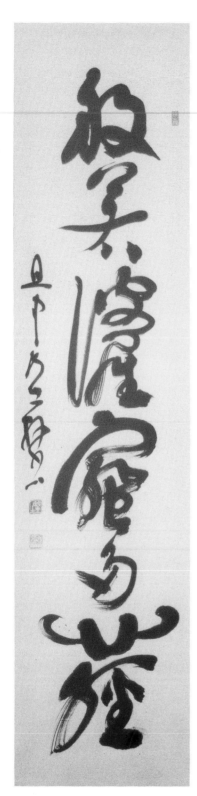

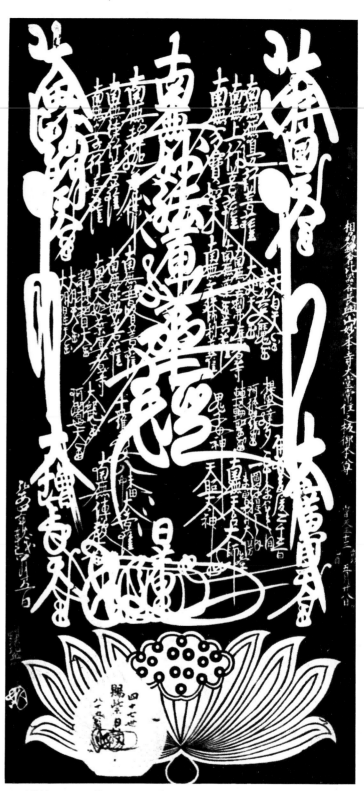

207. Since the title of a sacred text is thought to contain the essence of the teaching, often just the title is brushed and venerated rather than the entire sūtra. *Hannya Haramita Shingyō*, *Heart Sūtra* title, brushed by Terayama Katsujō.

208. Nichiren sect calligraphic maṇḍala: "Hail to the Lotus Sūtra of the Wonderful Law" appears in the center; the names of Buddhas and Shintō gods are brushed in distinctive Nichiren calligraphy.

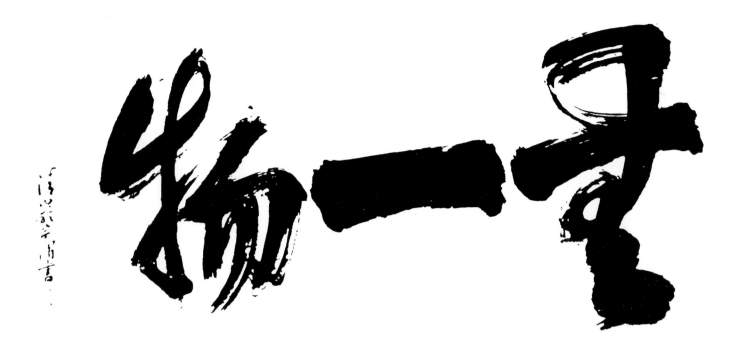

209. *Muichibutsu*, "Not one thing," by Seigan.

ZEN CALLIGRAPHY MANUAL

Since the method of Zen calligraphy is "no-method" there is no standard procedure. A very good approach, however, is practiced by the Hitsuzendō Society led by Terayama Katsujō.

After a period of zazen, a cover is taken out to protect the floor. A stack of old newspaper is placed on the left and one sheet is put down in front of the calligrapher, held down by two weights (*bunchin*) in opposite corners. The inkstone and large brush are placed on the right. The sample to be copied is put just above the inkstone. In Hitsuzendō training, samples of Tesshū's calligraphy are used, but any of the many examples given in this book may be employed.

It is best to sit Japanese-style on the heels (seiza) since this keeps one's center of gravity in the tanden. If this is impossible you may stand over a table; sitting in a chair is least advisable. Prior to beginning, the calligrapher makes a deep bow. Filling up the brush with ink, the calligrapher holds it above his or her head—"in the world of *mu*," as Zen calligraphers explain—and takes a deep breath. Holding the brush firmly, he brings it down to the lower left-hand corner and draws a diagonal stroke across the paper. An alternative would be to write *ichi*, "one," in one of the styles given on pages 188–189. Either the diagonal stroke or *ichi* should be written slowly, as if one were moving with a heavy sword.

Next an *enso*, "Zen circle," should be brushed (see examples on pages 190–194). After brushing an *ichi* and an *enso*, other individual *ichijikan*, "one-word barriers," can be written. There are many examples given in this book; favorites include *mu* ("nothingness"), *dō* ("The Way"), and *yume* ("dream"). For the stroke order and proper construction of other characters (there are 2,000 *kanji* in common use) consult the bibliography, which lists several excellent textbooks on Sino-Japanese calligraphy.

Write each stroke with bold, flowing movement. The swordsman Miyamoto Musashi composed each character as if he were facing a deadly enemy. Chinese calligraphers termed this the "Battle of the Brush": the paper is the battlefield, the brush is the weapon, the ink is the armor, the inkstone is the castle, and the supreme com-

mander is the heart and mind of the calligrapher. Some Zen calligraphers unconsciously imitate what they are writing, roaring like a dragon or cascading like a river. To conclude the training session, make several clean copies on white paper, and then once again bow. After the clean copy pieces have dried, the calligraphy should be hung in your room or other appropriate place for daily reflection—study the calligraphy for your strengths and weaknesses.

At first it is essential to copy famous pieces of calligraphy by different masters in order to familiarize yourself with the brush, the flow of ink, and the feeling of the characters. After many years of repeating the basic techniques, experimenting with different materials, and deepening your practice, your calligraphy can take any direction.

210. The proper method of sitting and bowing for Zen calligraphy at the beginning and end of a training session.

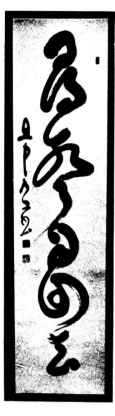

211.

211. *Jin sho ji e ko,* ''Call the name [of Kannon] and evil will depart,'' a verse from the *Kannon-gyō,* by Terayama Katsujō. The characters should be linked together in an organic flow.

212. The secret of Zen calligraphy: *Kokoro tadashikereba sunawachi fude tadashi,* ''If your mind is correct, the brush will be correct.'' By Tesshū.

213. Arrangement of the Japanese syllabary (*hiragana*) as a Buddhist poem. Kūkai is popularly credited with both the invention of the syllabary and this poem. It reads: *Iro wa nioedo chirinuru wo waga yo tare zo tsune naran ui no okuyama kyō koete asaki yume miji ei mo sezu,* ''The colorful [flowers] are fragrant, but they must fall. Who in this world can live forever? Today cross over the deep mountains of life's illusions and there will be no more shallow dreaming, no more drunkenness.''

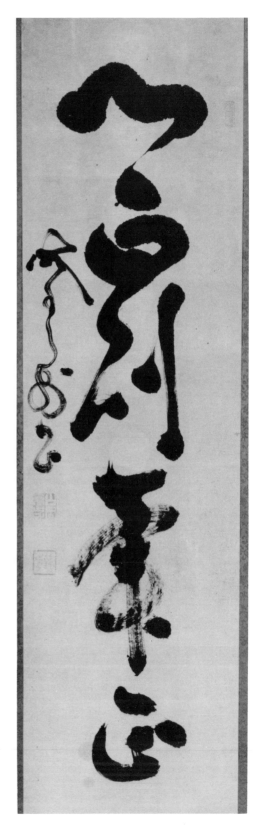

212.

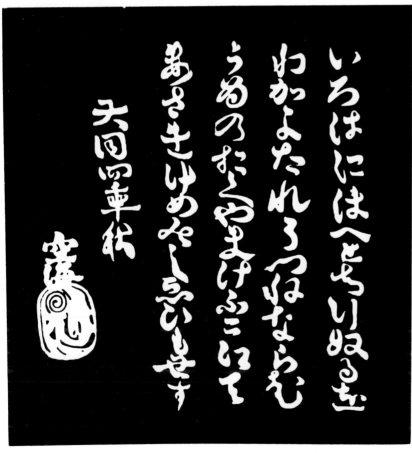

213.

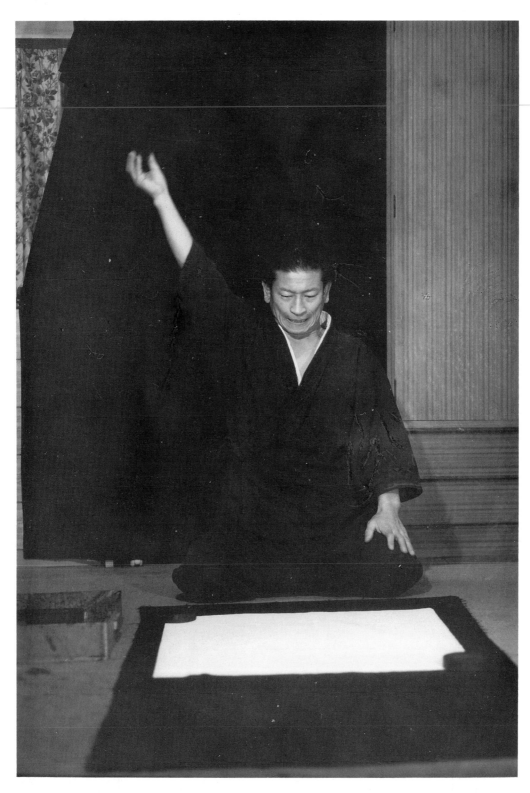

214. Professor Terayama demonstrating the raising of the brush prior to the first stroke of Zen calligraphy. He takes a deep breath and raises the brush towards heaven while keeping his lower body rooted to earth. At the apex, in the realm of "emptiness," he pauses briefly and then brings the brush down into the realm of "fullness," the world of form. The paper is securely anchored by weights and the inkstone is to the calligrapher's right.

215. A good way to hold the brush, perpendicular to the paper, firmly but not too tightly held.

216. Professor Terayama halfway through the brushing of *mujibō*, the single stroke of *mu*. This is typically the first element practiced in Hitsuzendō, followed by the brushing of an *ichi*, an *ensō*, and then other large single characters.

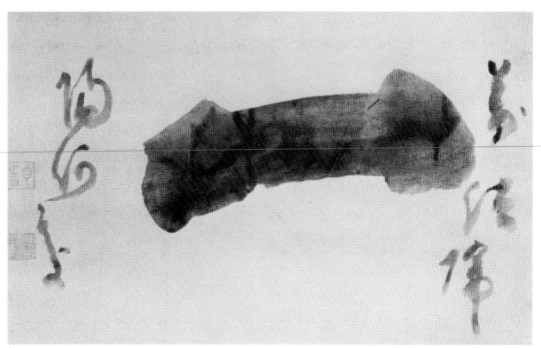

217. By Hakuin: "All things return to the One."

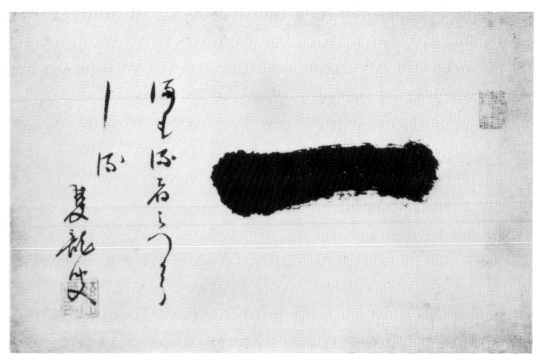

218. "First, a seeker of the Way must know himself," by Jiun.

ICHI

For Zen calligraphers the single-stroke ichi is equivalent to the A of Siddham or the *Heart Sūtra* of shakyō—the simplest yet most profound aspect of the discipline. As mentioned previously, beginners should spend at least three years concentrating on this stroke. The *raku-hitsu*, the instant the brush first comes into contact with the paper, reveals the state of mind of the calligrapher. It will remain weak and dispersed as long as there is something even slightly amiss in the attitude or bearing of the calligrapher. Draw ichi from left to right with full strength at the beginning and end.

219a.

219d.

219b.

219e.

219c.

219f.

219. *Ichi* by: a. Saichō; b. Daitō; c. Ikkyū; d. Hakuin; e. Jiun; f. Tesshū.

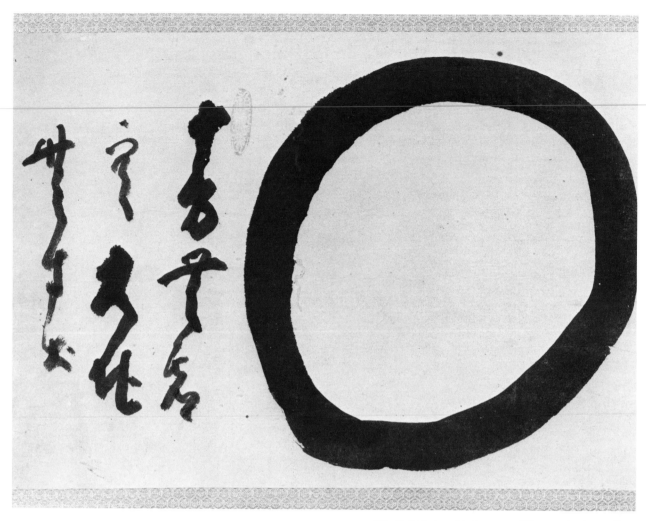

220. By Hakuin, with the poem: "No space in the ten directions; not an inch of the great earth."

ENSŌ

Ensō is the circle of infinity, symbol of simplicity with profundity, emptiness with fullness, the visible and invisible. It sometimes forms a moon, sometimes a rice cake.

Usually the circle is begun near the bottom of the left-hand side and the ink is thickest there. Al-though the shape is the simplest imaginable, each circle is different. Some are almost perfectly round and others are quite lopsided. The shading of the ink also greatly influences the effect of the character. In your practice it is good to write one ensō each session.

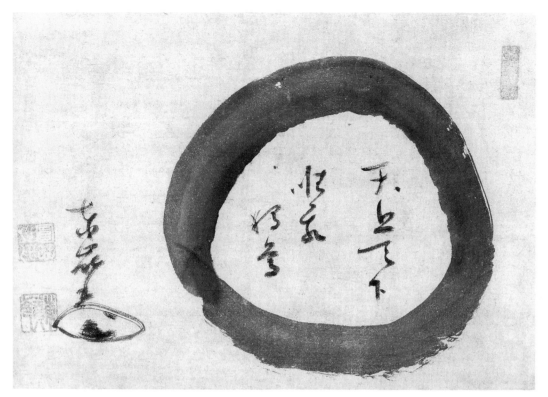

221. By Tōrei. The calligraphy in the center reads: *Tenjō tenge tada ware dokuson*, "In heaven and on earth I alone am the Honored One." This was Buddha's declaration at his birth; all of us have a similar Buddha within and the aim of Zen training is to make that unique enlightenment manifest.

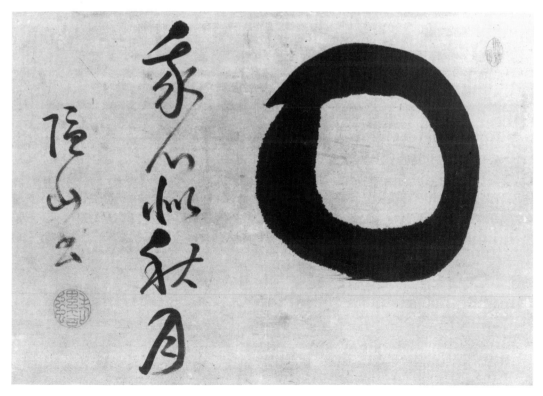

222. Moon *ensō* by Inzan (1751–1814). The inscription is a line from a famous poem by the legendary Zen eccentric Hanshan: "My heart is like the autumn moon."

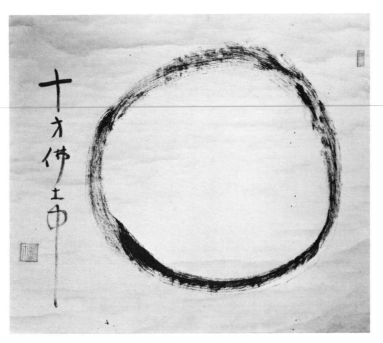

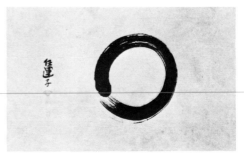

224. By Eun (1598–1679), 184th abbot of Daitokuji.

223. By Jiun, with the inscription: "In the midst of the Buddha Land of the Ten Directions."

225. *Ensō*/rice cake by Sengai. "Eat this and have a cup of tea."

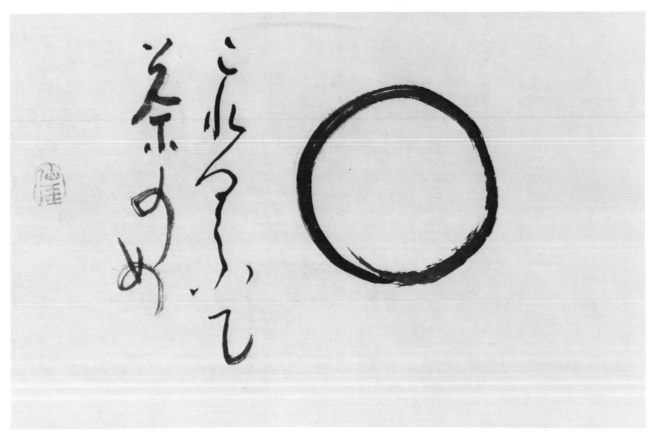

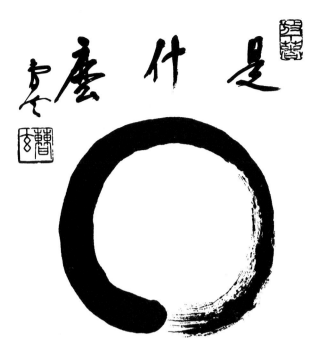

226a.

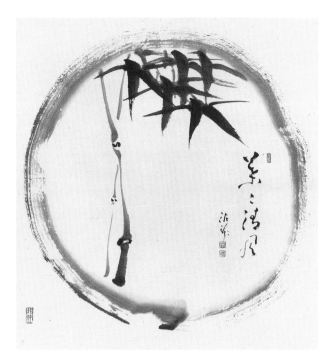

226b.

226. Three modern *ensō*: a. By Ōmori Sōgen (1905–1994). "What is this?" b. By Deiryū (1895–1954), this *ensō* is a window to the world of Buddha-nature. The inscription says: "A pure breeze rustles the leaves." c. By Dokusan (1869–1938). The four characters accompanying this *ensō* read: "water-moon-pine-wind."

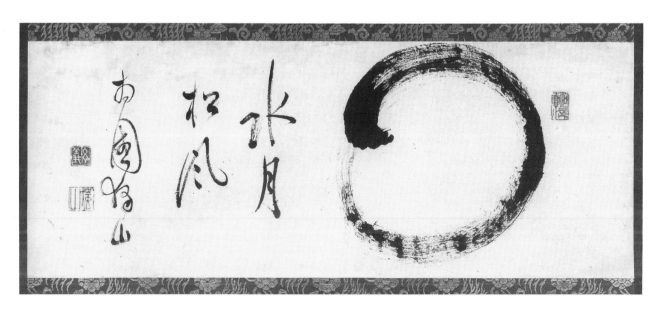

226c.

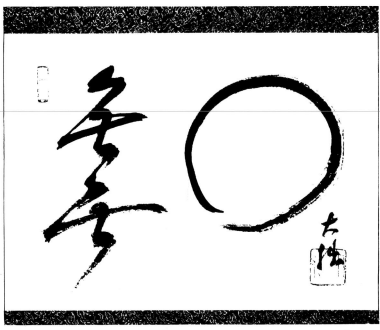

227. *Ensō* by D.T. Suzuki (1870–1966), the Father of Zen in the West: *Mu-mu*, "Not-nothing."

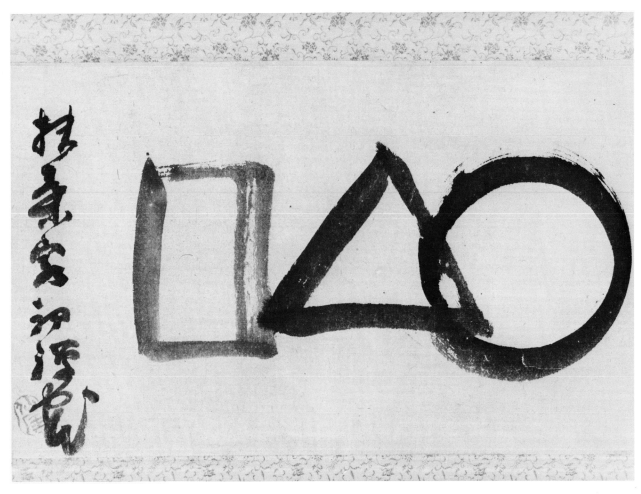

228. Circle, triangle, and square, by Sengai, perhaps the most famous Zen painting in the world.

229. Two simple single-character calligraphies: a. *Hana*,
flower, by the homeless monk Gōryō (1768–1819).
Famed as a calligrapher, Gōryō, who slept mostly out in
the fields or under temple eaves, refused money for his
brushwork but would exchange pieces for rice and saké.
b. *Dō*, the Way, by Gempō, age ninety-one.

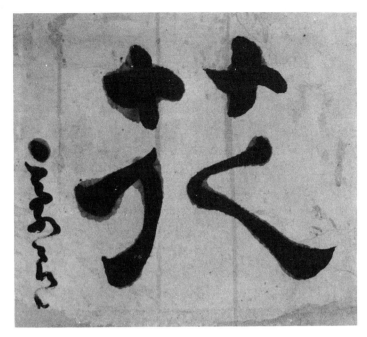

229a.

229b.

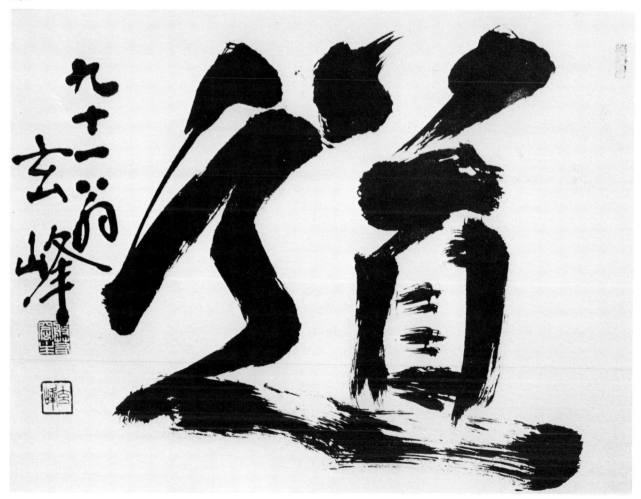

230. *Ai*, Love, brushed by Ueshiba Morihei (1883–1969), the Founder of Aikidō.

FOR ONE WHO HAS CONQUERED THE MIND,

बन्धुरात्मात्मनस्तस्य

THE MIND IS THE BEST OF FRIENDS,

यनात्मैवात्मना जित:।

BUT FOR ONE WHO HAS FAILED TO DO SO,

अनात्मनस्तु शत्रुत्वे

HIS VERY MIND WILL BE THE GREATEST ENEMY.

वर्ततात्मैव शत्रुवत्॥६॥

FOR ONE WHO HAS CONQUERED THE MIND,

जितात्मन: प्रशान्तस्य

PARAMĀTMAN HAS ALREADY BEEN REACHED

परमात्मा समाहित:।

FOR TRANQUILITY HAS BEEN OBTAINED.

शीतोष्णसुखदु:खेषु तथा

TO SUCH A PERSON HAPPINESS & DISTRESS,

मानापमानयो:॥७॥

HEAT & COLD, HONOR & DISHONOR ARE THE SAME.

BHAGAVAD GITA

231. East-West calligraphy by Jill Bell.

EPILOGUE

We have seen how sacred calligraphy has developed through the centuries in the countries of the East, and how it is being done at present. What are the possibilities for the future? Now that

Zen, Esoteric Buddhism, Tantra, Yoga, and Taoism, are becoming established in the West new modes of expression are gradually emerging. The interaction between oriental master and

occidental student is producing purer, more universal methods of practice, beyond East and West. We must familiarize ourselves with the old ways without abandoning our modern perspective. As the present Dalai Lama has said concerning the ancient traditions, "What has value should be retained; what has not must be discarded."

This book is now in its third edition and over the years I have been increasingly gratified and, to be honest, surprised at how widespread many of the images presented in this book have become in the western world—reproduced on dozens of book covers; employed by scores of graphic designers to enhance catalogues, record covers, sign boards, and T-shirts; used as flash by tattoo artists; hung in galleries as fine art; even borrowed to serve as Rorschach inkblots on personality evaluation tests. There are also now a number of accomplished practitioners of Sacred Calligraphy, an art that is no longer limited to the East.

232. "Flying," Chinese character calligraphy by the American calligrapher Stephen Addiss.

WHERE TO OBTAIN THE NECESSARY EQUIPMENT

Brushes, ink, and ink stones for Chinese and Japanese calligraphy can be found in most large cities. Brushes and ink for Siddhaṃ, Tibetan, shakyō, and Zen calligraphy, fine paper, and other necessary materials can also be obtained by mail order. For further information please contact:

Ziji Bookstore
2019 Tenth Street
Boulder, Colorado 80302
U.S.A.

(303) 449-6219

233. Sacred Calligraphy tattoos: (top) *om mani padme hum*; (center) all-powerful ten monogram; (bottom) *āḥ* seed syllable. The calligraphy on the sides is Khmer magic script. Tattoos on Tim LaMount by Mike McCabe.

CREDITS TO THE ILLUSTRATIONS

142. a. *Shū chū zō jitsugetsu*, Ann Marks Collection; b. *Ittai un*. From the Christopher Luce Collection, U.S.A.; c. Genshin collection.

143. a. Zen maṇḍala. From the Ryūtakuji Treasury, Japan; *Shū iu mu*. Private collection.

144. Nantembō calligraphy. Courtesy of the Trouveroy Collection.

146. *Jōzai ryōjusen*. Courtesy of the Shoka Collection.

147. *Kyozan*. Courtesy of the Umezawa Art Museum.

149. *Dōshitsu*. From a private collection, U.S.A.

150. Mt. Fuji painting and inscription. Author's collection.

151. *Ichigyō mono* of two Zen sayings. From Konnichi-an, Kyoto.

152. *Jikishi ninshin*. From a private collection, Japan.

153. *Kan*. From a private collection, U.S.A.

154. Calligraphy by two Buddhist nuns. a. Ryōnen, from a private collection. b. Rengetsu, from the Christopher Luce Collection, U.S.A.

155. *Sho aku maku sa shu zen bu gyō*. From the Shinjū-an Treasury, Kyoto.

156. *Bukkai hairiyasuku makai hairigatashi*. Courtesy of the Okayama Art Museum, Japan.

157. *Ikkyū*. Courtesy of the Fujita Museum, Japan.

158. Painting of Bodhidharma with *san* by Ikkyū. Courtesy of the Okayama Art Museum.

159. *Sho aku maku sa shu zen bu gyō*. Eisei Bunko, Japan.

160. *Sangai muan nao hataku no gotoshi*. From a private collection, Japan.

161. *Hōgejaku*. From Eisei Bunko, Japan.

162. *Katsu*. From a private collection.

163. Dharma lineage of Daitokuji. From Eisei Bunko.

164. *Kumo osamatte sangaku aoshi*. From a private collection, Japan.

165.–170. Courtesy of the Tanaka Collection, Japan.

171. *Toku*. Courtesy of the Gitter Collection, U.S.A.

172. *Hotoke*. From a private collection, Japan.

173. *Hito*. From a private collection.

174. *Ichi Butsujō*. From a private collection, Japan.

175.–176. From a private collection, Japan.

178.–179. From a private collection, Japan.

180. *Buji*. Courtesy of the Idemitsu Art Museum, Japan.

181.–184. From Eisei Bunko.

185.–186. Courtesy of the Idemitsu Art Museum.

187. One of Ryōkan's poems. Courtesy of Sōgen Publishing Company.

188. *Ten chi*. Courtesy of the Nezu Art Museum, Japan.

191.–193. Courtesy of the Hitsuzendō Society.

194. Calligraphy combined with painting. From the Zenshō-an Treasury.

195. Shakyō. From the Zenshō-an Treasury, Japan.

196. Examples of *kaō*. Courtesy of Haga Shoten Publishing Company.

197. *Kore*. From a private collection, Japan.

198. A pair of scrolls. From a private collection, Japan.

199. *Takiko seiza shin nyo sui*. Courtesy of the Sasaki Sōhō Collection, Japan.

200. The spirit of tea. a. Author's collection. b. Courtesy of the Idemitsu Art Museum.

201. a. *shaka muni butsu*. From the Kaifukuji Treasury; b. *shoso bodai daruma taishi*. From Tokugawa Reimei-kai, Japan; c. *namu jigoku daibosatsu*. Courtesy of the Tanaka Collection.

202. c. *namu amida butsu* by Hakuin. Courtesy of the Tanaka Collection; d. *namu amida butsu* by Jiun. From a private collection, Japan.

203. a. *Namu amida butsu* by Sengai. Courtesy of the Idemitsu Art Museum.

204. HAṂMAṂ. From Eisei Bunko.

205. *Taisei fudō myōō*. a. Courtesy of the Shoka Collection; b. Courtesy of the Idemitsu Art Museum.

206. a. *jizo son*. Courtesy of the Gitter Collection, U.S.A.

207. Author's collection.

208. Nichiren calligraphy. Courtesy of Haga Shoten Publishing Compoany.

209. *Muichibutsu*. From a private collection, Japan.

212. *Kokoro tadashikereba sunawachi fude tadashi*. From a private collection, Japan.

213. Japanese syllabary. From the Zentsuji Treasury.

217. "All things return to the One." Courtesy of the Fuse Art Museum.

220. Hakuin *ensō*. Courtesy of the Shoka Collection.

221. By Tōrei. From a private collection.

222. Courtesy of Belinda Sweet.

223. "In the midst of the Buddha Land of the Ten Directions." From a private collection, Japan.

224. By Eun. From a private collection, Japan.

225. *Ensō*/rice cake by Sengai. Courtesy of the Idemitsu Art Museum.

226. b. Tim Girvin Collection. c. Richard Ross Collection.

228. Circle, triangle, and square, by Sengai. Courtesy of the Idemitsu Art Museum.

229. a. Author's collection.

230. Love. Courtesy of K. Ueshiba.

231. East-West calligraphy. Courtesy of Jill Bell.

232. "Flying." Courtesy of the Shoka Collection.

233. Courtesy of Mike McCabe.

SELECT BIBLIOGRAPHY

General works on the development and history of scripts.

Anderson, Donald M. *The Art of Written Forms*. New York: Holt, Rinehart & Winston, 1969.

Clayborn, Robert. *The Birth of Writing*. New York: Time-Life Books, 1974.

Clodd, Edward. *The Story of the Alphabet*. Revised edition. Detroit: Gale Research Company, 1970.

Coulmas, Florian. *The Writing Systems of the World*. Oxford: Basil Blackwell, 1989.

Daniels, Peter T., and William Bright, editors. *The World's Writing Systems*. Oxford: Oxford University Press, 1995. An exhaustive 800-page study of all the world's scripts. Includes an entry on "The Calligraphic Beauty of Asian Scripts" by John Stevens.

Diringer, David. *The Alphabet*. Two volumes. Third revised edition. New York: Funk & Wagnalls, 1967.

Diringer, David. *The Alphabet: A Key to the History of Mankind*. Topsfield, Massachusetts: Newbury Books, 1977.

Diringer, David. *Writing*. New York: Frederick Praeger, 1967.

Gaur, Albertine. *A History of Writing*. London: The British Museum, 1984.

Gelb, I. J. *A Study of Writing*. Revised edition. Chicago: University of Chicago Press, 1963.

Jackson, Donald. *The Story of Writing*. New York: Taplinger Publishing, 1981.

Jean, Georges. *Writing: The Story of Alphabets and Scripts*. Discoveries edition. New York: Harry N. Abrams, 1992.

Nakanishi, Akira. *Written Characters of the World*. Kyoto: Shokado, 1974.

Works on Indian and Tibetan Calligraphy

Douglas, Nik. *Tibetan Tantric Charms and Amulets*. New York: Dover Publications, 1978.

Gallop, A. T. *Golden Letters: Writing Traditions of Indonesia*. London: The British Library, 1991.

Gordon, Antoinette K. *Tibetan Religious Art*. New York: Paragon Book Reprint Corp., 1963.

Govinda, Lama Anagarika. *Foundations of Tibetan Mysticism*. London: Rider and Company, 1963.

Gupta, S. P., and K. S. Ramachandran, editors. *The Origin of the Brahmi Script*. Delhi: D. K. Publications, 1972.

Khanna, Madhu. *Yantra*. London: Thames and Hudson, 1979.

Lambert, H. M. *Introduction to the Devanagari Script*. London: Oxford University Press, 1953.

Lauf, D. I. *Sacred Tibetan Art: The Heritage of Tantra*. Berkeley and London: Shambhala Publications, 1976.

Mahadevan, Iravatham. *The Indus Script*. New Delhi: Archeological Survey of India, 1977.

Mookerjee, Ajit. *Yoga Art*. London: Thames and Hudson, 1975.

Mookerjee, Ajit, and Madhu Khanna. *The Tantric Way: Art, Science, Ritual*. Boston: New York Graphic Society, 1977.

Nagao, Gadjin. "Siddham and its Study in Japan," *Acta Asiatica*, 21:1–2, October 1971.

Rambach, Pierre. *The Art of Japanese Tantrism*. Great Britain: Macmillan London Ltd., 1979.

Rao, S. R. "Deciphering the Indus Valley Script," *India and Foreign Review*, 15 November 1979.

Shamasastry, R. *The Origin of the Devanagari Alphabets*. Benares, India: Bharati-Prakashan, 1973.

Trungpa, Chögyam. *The Art of Calligraphy: Joining Heaven and Earth*. Boston: Shambhala Publications, 1994. Includes many examples of Tibetan script written Zen-style with Chinese brush and ink.

van Gulik, R. H. *Siddham*. New Delhi: Mrs. Sharada Rani, 1980.

Woodroffe, Sir John (Arthur Avalon). *The Serpent Power*. Sixth edition. New York: Dover Publications, 1974.

Zwalf, W. *Buddhism: Art and Faith*. London: The British Museum, 1985. This book contains striking illustrations (many in color) of Buddhist texts composed of a variety of scripts and styles.

In Japanese see the following books by Tokuyama Kijun, all published by Mokujisha in Tokyo:

(1) *Aji to shingon* [The Siddham Letter A and Mantras], 1987.
(2) *Bonji* [Siddham], 1974.
(3) *Bonji hannya shingyō* [Sanskrit *Heart Sūtra*], 1984.
(4) *Bonji no kakikata* [How to Write Siddham Script], 1985.
(5) *Bonji shuji shū* [Collection of Siddham Seed-syllables], 1989.
(6) *Bonji techo* [Siddham Handbook], 1976.
(7) *Boron* [Bhrūṃ], 1980.
(8) *Hannya shingyō techō* [Handbook on the *Heart Sūtra*], 1986.
(9) *Monji butsu no sekai* [The World of Letter-Buddhas], 1978.

General works on East Asian Calligraphy

Billeter, Jean Francois. *The Chinese Art of Writing*. New York: Skira/Rizzoli, 1990. The most comprehensive and interesting study of Chinese calligraphy in English.

Chiang, Yee. *Chinese Calligraphy: An Introduction to its Aesthetics and Technique*. Third edition, Cambridge, Mass.: Harvard University Press, 1973.

Fu, Shen. *Traces of the Brush: Studies in Chinese Calligraphy*. New Haven: Yale University Press, 1977.

Fu, S., G. Lowry, and A. Yonemura. *From Concept to Context: Approaches to Asian and Islamic Calligraphy*. Washington, D.C.: Freer Gallery of Art, 1986.

Gotze, Heinz. *Chinese & Japanese Calligraphy Spanning Two Thousand Years*. Munich: Prestel-Verlag, 1989.

Hwa, Khoo Seow, and Nancy L. Penrose. *Behind the Brushstrokes: Tales from Chinese Calligraphy*. Singapore: Graham Brash, 1993.

Lai, T. C. *Chinese Calligraphy: An Introduction*. Seattle: University of Washington Press, 1976.

Lai, T. C. *Chinese Seals*. Seattle: University of Washington Press, 1976.

Ledderose, Lothar. *Mi Fu and the Classical Tradition of Chinese Calligraphy*. Princeton: Princeton University Press, 1979.

Lindquist, Cecilia. *China: Empire of Living Symbols*. Reading, Mass.: Addison-Wesley, 1989.

Rosenfield, John, and Y. Shimizu, editors. *Masters of Japanese Calligraphy 8th–19th Centuries*. New York: Asian Society, 1984.

Tanaka, Kaido. *Nihon shakyō sokan* [Directory of Shakyō in Japan], Tokyo: Sogensha, 1971.

General works on Zen Calligraphy

Addiss, Stephen. *The Art of Zen*. New York: Henry N. Abrams, 1989.

Addiss, Stephen. *Ōbaku: Zen Painting and Calligraphy*. Lawrence, Kan.: Spencer Museum of Art, 1978.

Fontein, J., and Money Hickman. *Zen Painting and Calligraphy*. Boston: Museum of Fine Arts, 1970.

Hisamatsu, S. *Zen and the Fine Arts*. Tokyo: Kodansha International, 1971.

Stevens, John. *The Essence of Aikidō*. Tokyo: Kodansha International, 1993. Includes examples of calligraphy by Ueshiba Morihei.

Stevens, John. *The Sword of No-Sword: The Life of the Master Warrior Tesshū*. Boston: Shambhala Publications, 1989. Includes many examples of Tesshū's brushwork.

Stevens, John. *Lotus Moon: The Poetry of the Buddhist Nun Rengetsu*. New York: Weatherhill, 1994. Includes illustrations of Rengetsu's calligraphy.

Stevens, John. *Three Zen Masters: Ikkyū, Hakuin, Ryōkan*. Tokyo: Kodansha International, 1993.

Stevens, John, and Alice Rae Yelen. *Zenga: Brushstrokes of Englishtenment*. New Orleans: New Orleans Museum of Art, 1990.

Suzuki, D. T. *Sengai, the Zen Master*. Greenwich, Conn.: New York Graphic Society, 1971.

Suzuki, D. T. *Zen and Japanese Culture*. Princeton: Princeton University Press, 1959.

Tanahashi, K. *Penetrating Laughter: The Art of Hakuin*. Woodstock, N.Y.: Overlook Press, 1984.

For the practice of Zen calligraphy, see:

Bjorkesten, Johan. *Learn to Write Chinese Characters*. New Haven: Yale University Press, 1994.

Fazzoioli, Edoardo. *Chinese Calligraphy*. New York: Abbeville Press, 1987. These two books offer practical instruction in the composition of Chinese characters.

Ōmori, Sogen and Katsujō Terayama. *Zen and the Art of Calligraphy*. London: Arkana, 1990. This book gives detailed instructions for the practice of Hitsuzendō, the Art of the Zen Brush.

INDEX OF PROPER NAMES

The numbers appearing in italics refer to page numbers on which the entry appears in a caption to an illustration.